Management
for the Small
Design Firm

Management for the Small Design Firm

Handling Your Practice, Personnel, Finances, and Projects

LESSONS FOR ARCHITECTS AND INTERIOR
DESIGNERS FROM FELLOW PROFESSIONALS

Jim Morgan

WHITNEY LIBRARY OF DESIGN
an imprint of Watson-Guptill Publications/New York

Editor: Micaela Porta
Designer: Areta Buk
Production Manager: Hector Campbell

Published by Whitney Library of Design,
an imprint of Watson-Guptill Publications,
a division of BPI Communications, Inc.,
1515 Broadway, New York, NY 10036.

Library of Congress Cataloging-in-Publication Data

Morgan, Jim, 1934–
 Management for the small design firm: handling your practice,
 personnel, finances, and projects / Jim Morgan.
 p. cm.
 Includes index.
 ISBN 0-8230-2967-0
 1. Architectural practice—United States—Management. 2. Design
 service—United states—Management. I. Title.
 NA1996.M67 1997
 720'.68—dc21 97-7826
 CIP

Manufactured in Singapore

First printing, 1998

1 2 3 4 5 / 02 01 00 99 98

To my Pratt students who challenged me, in many cases much too politely, to teach professional practice so that it spoke to their condition.

Acknowledgments

Perhaps there are those who, having spent fifteen years or more teaching something, think that they can rely totally on their own insights when writing a book about that topic. I'm not one of them. The contribution of the seventeen designers, who generously and candidly participated in the dialogues reported here, is what gives this volume whatever authenticity and enduring value it may prove to have. I am grateful to these professionals, who usually had much more pressing issues to deal with at the time, for the privilege of extended discussions—in some cases held over several days. By the way, it is interesting to note that while this book has been in preparation, several of these practices have undergone significant change. Design practice management is a more dynamic discipline than it is often perceived to be.

To be candid myself, I must also thank faculty colleagues in the Interior Design Department at Pratt Institute for inadvertently inspiring this book. When they decided, over my strong objection, to shrink our two-semester course in professional practice and contract administration into one (in order to allow students more time for CADD studies), I unhappily taught the new, cramped version once or twice, then took early retirement (after twenty-seven years there) and used the newfound time to prepare this book.

It is important to recognize the contribution to my understanding of professional practice from yet another source: the twenty or more ASID-sponsored seminars that I led all over the United States and Canada in the eighties based on my earlier book, *Marketing for the Small Design Firm*, also published by Whitney Library of Design. I learned a great deal from the entrepreneurial vigor (I'd even call it courage) of the hundreds of "decorators"—self-taught design practitioners—who attended them. They helped me to see that the most effective marketing tool any designer can have is enthusiastic former clients.

Finally, I am deeply grateful to Micaela Porta, my editor, for her encouragement and gentle but firm guidance—indeed, her management skills—through the challenging process of bringing this publication project to a successful conclusion.

Contents

Introduction

Thoughts on Management for the Small Design Firm

Management is that often intangible organizing presence that focuses everyone involved in a common task and enables them, together, to accomplish their agreed-upon mission. Management may be benign or not, effective or not, bearable or not. Nonetheless, it is an essential factor in getting our design projects built.

Although designers and architects seldom encounter this discipline as students—and often only passively in their apprenticeship days—there is no reason why the principles behind productive management as they apply to our fields can't be studied and mastered before we begin practice. Unfortunately for most design professionals up to now, that option has been only obliquely available, and seldom adequately absorbed, before we stepped into that quagmire otherwise known as "opening our own office."

Here are some of the other biases that shape this book:

- Women have an important contribution to make in humanizing and broadening the applications of the design professions over the next century; it is no accident that more than half of the people interviewed for the design-practice dialogues in Chapter Five are female practitioners.
- Design management can be pursued effectively only in an honest and straightforward fashion; that prescription reflects the author's commitment to Quaker beliefs and process, a three-hundred-year-old way of doing business based entirely upon the Golden Rule.
- Architecture and interior design are two utterly contiguous professions, equal in value to society; for the good of each, they ought to be carried on in harmony, not with the petty sense of rivalry that in recent years has diminished possibilities for cooperation.

For whom is this book written, therefore? Primarily for students and recent graduates such as those I taught at Pratt Institute for twenty-seven years, thus its conversational style. I hope to encourage young peoples' interest with positive, instructive narratives about how seventeen established architects and interior designers have developed their practices. But there's an old story about a homiletics professor in a seminary who tells his students, "When you are preaching to a congregation that includes both chambermaids and the Prime Minister, put your sermon in terms the chambermaid can understand—and then you will be sure the Prime Minister gets it as well." So this book is also lovingly crafted for those colleagues who, as principals of small design firms, face management challenges every day.

What Exactly Is Management, Anyway?

Everyone is scrambling these days to define and explain the word "management." For product-related businesses, a vast literature now exists. For service businesses, however—particularly architectural and interior design firms—"management" is still open to creative interpretation. Consider the following three objectives as one architect's definition of it:

BUILDING TRUST AMONG ALL MEMBERS OF THE PROJECT TEAM

Comprehensive short-term community building is our primary task as managers of the construction process. We are charged with assembling and running a large team—one that has probably never worked together before—in order to carry out a job that has no exact precedent. Building "community" means drawing people closer together as they work on that job by encouraging collaboration and cooperation among them, not allowing inadequate or misleading communication to confuse and pit them against one another.

GETTING PEOPLE TO HAPPILY DO WHAT YOU NEED THEM TO DO

There is no question that people can be forced to work together—for a while at least—if you can live with dismal levels of productivity and rampant demoralization. But then, the chain gang never was an appropriate model for building anything more complicated than a county road. Recognizing the sophistication of design-office employees—and contractors, for that matter (today even HVAC subcontractors have mechanical engineering degrees)—the necessity for participatory decision making should be obvious to every design manager.

PROVIDING A VISION OF WHERE YOUR BUSINESS IS HEADED

As owner of a small business, you have the privilege of running it however you please. Yet when you take on contracts to carry out complex work for others, and especially when you employ others, you're obligated to operate your firm so that it won't go broke without notice. That's why it is essential to have a reasonably clear vision of your financial prospects for the near future. But there is also the opportunity to provide your colleagues and clients with an inspiring image of the goals and objectives toward which you are all striving.

Robert Gutman's thoughtful book, *Architectural Practice: A Critical View,* should be studied by anyone reading this one. In the January 1990 *Architectural Record*, he noted that American architects, those running larger firms at any rate, "have learned to run their practices as businesses. Management and marketing effectiveness are considerable accomplishments in the architectural field. It is too bad that even when well-managed offices generate a good design, they are still derided by many architects, largely because the idea of having to sell a firm's talents and organize production runs counter to the idea of the architect as an artist."

In order to deal comprehensively with management responsibilities, the book takes two complementary approaches. The first four chapters offer lessons in basic management skills: Practice Management (largely the issue of bringing work into the firm), Human Resources Management, Financial Management, and Project Management (both inside the office and during construction administration). The design-practice dialogues in Chapter Five represent the business experience of fifteen active design and architectural firms and include material relating to each of the chapters. The combination of these two approaches is intended to convey both a broad range of management concerns and the strategies by which imaginative practitioners deal with them.

> The chain gang never was an appropriate model for building anything more complicated than a county road.

Why Differentiate Design Management from Other Specialties?

Although this book concentrates on the two professional disciplines with which I am familiar—architecture and interior design—its content applies directly to related specialties such as urban design; landscape architecture; industrial, furniture, lighting, graphic, and exhibition design practices; even food and clothing design studios. Perhaps it will prove useful to owners and managers of nail and hair design salons, too, which are, after all, small businesses offering creative services. In any case, the intent here is to offer a broad, commonsense understanding of design management rather than advanced, technical information.

Design management, like that appropriate for small retail and service companies, has a great deal to do with running the business in a sound financial fashion. Viability for them all depends on paying bills and meeting other obligations in a timely way. This requires the owners' active attention to building and sustaining a fiduciary (which simply means trustworthy) structure capable of weathering the uncertainties to which small employers are, for various reasons, subject over time.

Design management, like that practiced by building contractors and small manufacturing companies, has a lot to do with seeing that demanding technical work is carried out to specifications on time and within budget limits. In fact, this is the central responsibility of our professions, even though realizing these goals is often complicated by bewildering code requirements as well as by unanticipated delays due to delivery problems or the complex interaction of different trades at work on the jobsite.

Design management (as is the case for practitioners in our sister professions, such as law) depends for long-term success on consistently meeting the client's expectations as the projects we are doing with them proceed to satisfactory completion. Long-term success means that we are not only dependent on those clients for further commissions but also for their goodwill in the marketplace: for referrals to their own circle of acquaintances and for positive recommendations when we give them as references to inquiring prospects.

However, there is an additional and unique dimension that affects design firms: Design management must foster an atmosphere of creativity among colleagues and staff if the office is to satisfy its own criteria for professional distinction. This has less to do with permitting designers to pursue visually stylish schemes than with encouraging fresh thinking at all stages of the design process, including aspects that are normally seen as routine matters, such as specifications and construction administration.

Each time a project goes through the office, a good design manager encourages constantly renewed enthusiasm for reexamining and reconceptualizing all of its design elements. In other words, to quote architect Randy Croxton, "Effective management is a precondition for sustained creativity." In a sense, then, it is the design manager's privilege to serve as "spiritual leader" for those working together on his or her project.

Architect Randy Croxton on Management and Creativity

Management is seen as anti-creative by our design-focused culture.

Self-awareness is the essence of management.

Management requires an overview: See the whole, get results.

Management is integral to process.

Dynamic management allows for spontaneous, creative response to change.

Active management focuses on creative strategies, values, and objectives.

Sound management is a precondition of sustainable creativity.

Do Designers Need to Pay More Attention to Management?

Almost everyone interviewed for this book noted, sooner or later, that he or she had not been exposed to the discipline of design management while in school. Worse than the lack of opportunity to learn about it, some said, was the cultural bias fostered there: "Management is for drones, not for a sensitive, talented person like me."

In most design schools, a majority of students are certain they will someday have an office of their own. Yet when a course in professional practice is offered, few students bother to take it if it's an elective, or to take it seriously if it's required. Within the field of design education, the fact that professional practice involves running a small business continues to be ignored, as though the study of design must be pursued for its own sake or else it is somehow corrupted and debased. Who says that management can't be creative?

For anyone who is serious about design firm management in the nineties—whether student or practitioner—the collected issues of *Progressive Architecture* magazine from February 1994 to December 1995 are pure gold. During that time, under the leadership of architect Thomas Fisher (who had been appointed as *PA*'s editorial director as of January 1994), what had been a flaccid, vacuous mailbox clogger became a tough, lean probe exploring sensitive questions within the architectural profession, a startling resuscitation of its long-dormant claim to be "progressive." Almost every issue offers a well-researched lead article whose title alone stimulated thought: "Can This Profession Be Saved?" (February 1994); "The Intern Trap: How the Profession Exploits Its Young" (July 1994); "Government Hoops: The Trials of Pursuing Public Work" (February 1995); "The Schools and How They Are Failing the Profession" (September 1995); and "Who Makes What—and How We All Might Make More" (December 1995) are just a few examples.

In early January 1996, as people were awaiting the 43rd *PA* Design Awards issue, the magazine was asphyxiated—throttled, strangled, choked to death. That's the only way to describe its sudden, merciless demise. There's no way, however, to describe the loss it meant for the design profession's already neurasthenic culture.

It is often stated during keynote speeches at conventions of professional societies that the proper role of designers and architects, given their education and technical training, is to be leaders of the construction industry. That is invariably followed by the rhetorical question, "Why, then, aren't we more respected?" Why not indeed? How can people innocent of any preparation for executive responsibility (except perhaps for the occasional "natural manager") ever hope to provide leadership for even their own employees, let alone for the tough, pragmatic building business?

In fact, building and interior construction both require exceptionally complex human interaction. Not only that; they represent the most sophisticated sort of manufacture: production of "one-off" esthetic creations on a huge scale, demanding expenditure of money far beyond the gross annual income of the individual participants. Fiduciary accountability itself profoundly affects the project team's interplay. As every experienced designer knows, client management largely consists of offering endless reassurance over the course of a job that the client's money is not being squandered.

Beyond that, the legal constraints and technical challenges inherent in many of the projects we carry out are significantly greater than those associated with normal business arrangements. Think about it: As our designs are built, we take in stride revisions and substitutions that would easily torpedo a deal for, say, a shipment of perishable goods or the sale of a fifty-story skyscraper. Every day, our management skills, however inadequately we may have mastered them, are all that keep us from plunging into chaos as we carry out our professional role in the marketplace.

The proper role of designers and architects is to be leaders of the construction industry. "Why, then, aren't we more respected?"

Participatory design, as architect Mike Pyatok practices it, involves lots of client contact. Whether helping a community-based development group lay out their units or digging in with them at a ground-breaking, he's there to make sure these low-income housing units satisfy the needs and desires of their future occupants.

What matters most in the end, however, is the human cost of incompetent design management. A great deal of emotional discomfort, often pain, could be avoided if design executives understood how to maximize cooperation among the various parties involved in carrying out their work. This problem occurs not only during construction administration but also within our own offices. What ought to be stellar examples of human collaboration and creativity—design studios—too often witness deplorable episodes of personal abuse. Sad to say, much of it is either caused by or indirectly encouraged by executive mismanagement.

How Does Downsizing Affect Architects and Designers?

As "globalization" comes to dominate the planet's economic system, its structure and consequences are gradually becoming clear.

The "world-trade-without-barriers" movement is pressing its case on three distinct fronts, none of which are national governments capable of significantly regulating, or even taxing, at the present time:

- growth in the economic power and political influence of transnational corporations
- growth of world trade in conventional arms
- growth of a worldwide electronic network where traders speculate in market adjustments of national currencies.

Nowadays, national and regional economies everywhere in the world are severely affected as so much available funding—"adventure capital"—flies off to take advantage of opportunities in these global markets. Local investments, including relatively liquid instruments such as municipal bonds and small-business stocks, have a great deal of trouble competing with the huge and, in some cases, lightning-fast returns promised by overseas investments. Interest in market-rate real estate and construction deals, which can take years to put together and then many more to pay off, has disappeared. In a few places where "strong" governments offer impossibly good terms, speculative real estate

development still flourishes; Kuala Lumpur and Shanghai, for instance, have been booming. But local building activity elsewhere tends to languish for lack of motivated investors and developers, with available design work limited mainly to renovation of existing properties.

Thus, the current downsizing and inactivity in the building business in the United States is a function of new forces that are different from those to which we've become accustomed in past business cycles. It looks as though, in the not too distant future, there will be a few extremely large architecture and design firms, with the rest of us—hundreds of thousands of professionals—barely surviving as sole proprietorships and partnerships. In that context, when we look at the effect of computerization upon our professions, there is no question that future small-office practice will never be as prolific, will never again offer the employment possibilities it did in the second half of the twentieth century. In effect, the major design-management issue of the early twenty-first century may be how to survive in the face of increasingly limited income opportunities.

This leads to still another very serious management issue. The Internal Revenue Service has taken an uncompromisingly negative position toward the use of what many design managers call "consultants," individuals who sit at workstations in design offices every day yet receive no benefits, no Worker's Compensation, and have no taxes withheld from their paychecks. When these consultants have federal ID numbers of their own (meaning status as an established firm), as do the engineers on whom we depend, and prepare their assignments outside the office, managing their own financial affairs as practitioners themselves, then the matter is at least handled cleanly. This issue is discussed in further detail in Chapter Two.

Is Computerization the Solution—or Just the Next Problem?

The computer-networked, decentralized design practice, as championed by interior designers Nina Hughes and Janice Stevenor Dale, presents an attractive alternative to offices as we have known them; that is, rows and rows of drafting boards occupied by people who expect a paycheck every two weeks. In the new scenario, data flows into one's cozy office by fax, modem, and telephone. The designer or architect processes this material rapidly, based on his or her professional skill, and sends it on to the client, who promptly wires payment back. Moreover, the product of this activity—the contract documents—is said to be verifiably better than what hands pushing pencils laboriously turned out in the past.

One regrettable consequence, however, is that there will be far fewer entry-level jobs available from now on. One theme echoing through the design-practice dialogues in this book is that a smaller senior-status staff is much more productive than one consisting of a large number of people, many of whom are learning, as drafters, the mysteries of how buildings actually get built. Few principals today go anywhere near a computer-aided design and drafting (CADD) station. Almost all recent design and architecture graduates are CADD-literate, yet most of them have still to master the technical skills needed to prepare competent working drawings. How are they ever going to gain that depth of experience if they face the prospect of endless freelancing, shuffling from one firm to the next as projects wind up—that is, if there *is* another job available for them?

The computer, it seems, is fragmenting the design process into even more solitary work than we may have imagined it would be when we were students. Is "electronic camaraderie" a viable substitute for life in the drafting room, however unproductive that may have been?

It looks as though there will be a few extremely large architecture and design firms, with the rest of us barely surviving as sole proprietorships and partnerships.

A smaller senior-status staff is much more productive than one consisting of a large number of people.

What Is the Future for the Design Professions?

Sadly, from the interviews conducted for this book, it appears that it is almost impossible to operate a small design practice without depending on a working spouse to help provide, in some fashion, a viable family income. In other words, most people do not earn enough as designers and architects—as principals of firms, that is—to be able to afford an independent economic existence, let alone to sustain a family. Yes, they probably could bring in more business through aggressive marketing, and reduce operating expenses through more vigilant financial management. But what a commentary it is upon the state of our culture that nowadays—to say nothing of the future—these respected professions simply are not capable of carrying on their work without heroic measures.

Is it fair that those who focus their practices on low-income housing must in effect finance the design work themselves because of the unwillingness of government agencies to pay for the design work as it's done, in the standard commercial manner? And, is it acceptable that, as a consequence, employees in those offices usually are denied anything like the benefits and security enjoyed by the bureaucrats who oversee those socially desirable projects? I recently enjoyed an amicable and productive relationship as a client with Harden Van Arnam, Architects and Phoenix Builders, Inc. We jointly created Friends House in Rosehill, a Manhattan residence for fifty formerly homeless people with AIDS. I now find myself deeply angry with the inefficient, inequitous process by which public-financed, low-income housing is built, at least in New York City.

Indeed, the long-term prospect for positive growth of the design professions is not hopeful. What does one say to students who pick up this book expecting an upbeat assessment of their prospects, such as, "If you work hard, you'll be sure to prosper"? Now that, due to computerization and at least short-term economic stagnation, there seem to be so many more design graduates than there is work for them to do, the message cannot be optimistic without qualification. True, if you're one of that ambitious, overachieving ten percent of the usual graduating class, with good computer skills and intense commitment to learning the practical details of your chosen design discipline, the possibility of someday "hanging out your shingle" is about the same as it has always been. It's purely a function of an overriding will to succeed, as well as an expression of innate entrepreneurial drive.

For the rest, with due respect for their potential, the best advice still seems to be what I suggested in an article published in *House & Garden's Building/Remodeling Guide* for March/April 1981, "Architecture School: Liberal Education for the Eyes." Already aware of limits on design-related employment, I urged graduates to consider taking their skills in solving problems three-dimensionally and in expressing those solutions visually, and applying them to some construction-related field (contracting, renovation, building supplies, mortgage banking, journalism, etc.), or to some other work altogether, confident that design training would make a valuable difference in how they were perceived by employers or customers.

Looking back over almost three decades at how my own students have responded to the marketplace, I find that diversification characterizes the pattern of career development chosen by many. They have often prospered in unexpected ways and are no less happy than their classmates who have stayed in the design field. Mastering management skills, however, has been just as important for the success of the nondesigners as it has been for the others.

As the result of collaboration by four architects who served as clients, general contractors, and designers, a venerable New York City building is now the elegant home of fifty formerly homeless people living with AIDS. Photo: ©Jeff Goldberg/Esto

Practice Management

Having a design
practice is a good deal
like operating a mom-
and-pop store.

How many times did your design professors tell you how important it is, once you begin to practice, that you run an efficient business? Probably never, right?

The joke on most of us is this: What happens after we graduate and open our own office is that we spend our days in a way that is much more like running the little shop down the street from the design school, where we bought the cigarettes and coffee that got us through charrette, than it is like spending our time in an artist's studio. No matter how appalling the notion may seem to you, having a design practice is a good deal like operating a mom-and-pop store: long hours on the premises; limits on mobility and lifestyle; ongoing concern for how to pay the rent; the need to "build traffic" by being friendly to everyone, including grouchy customers; constant requests for credit from customers and the related need to put off paying a lot of your own bills—in other words, worrying about cash flow most of the time. The only advantage for designers is that we don't have to worry about stocking a large inventory of stuff that may or may not sell.

In that context, operating your practice effectively becomes a more demanding activity than most young architects and designers expect it to be. Furthermore, it takes on a different cast depending on whether you are a principal, an employee, or a client of the firm.

From the principal's viewpoint, the main objective of the business is growth, particularly to be able to win larger and more interesting commissions as time passes. Of course, it is always devoutly hoped that bigger jobs will bring in such generous fees that the office will finally begin making a profit. The idea that expenses might expand even more rapidly than income when more complex assignments are taken on may not occur to owners of small design firms as they fantasize about fat times ahead. The truth is, if you don't make a profit on small jobs, you'll probably never make a profit.

Employees tend to have an entirely different daydream about what effective management means. They just want to be given an endless supply of interesting design projects. So "effective" translates into an expectation of smooth and predictable days, paychecks always on time, and gradually gaining expertise while working for your firm. Why should they ever wonder how that gets accomplished, especially if they also graduated from design school?

On the other hand, the client sees effective management as your firm's ability to meet both the project budget and the construction schedule impeccably. That's your job, isn't it? In most cases, as a businessperson, your client assumes that you are as serious about running the office as he or she is. The client also assumes that you'll deliver the completed project as agreed, even though the construction contract is not directly with your office, and the contractor's bills may or may not be paid on time.

For all of these players, the underlying assumption is of a stable, businesslike operation. To achieve that state, the principal must accept the assessment H. H. Richardson is said to have made of the architect's three most important functions: "Get the job, get the job, get the job." Effective practice management boils down to bringing work into the office on a regular and, if possible, predictable basis. Everything else will tend to take care of itself if you maintain positive cash flow.

Therefore, the main task for you, the design executive, is to tell everyone you know (and lots of people you don't yet know) the good news about your firm: that as an office, you are the best! It must be as enthusiastic as that—anything less won't cut through the skepticism and cynicism that high-powered, ubiquitous commercial advertising has instilled in our society. You need to create chances to share your commitment to excellence with others, whenever and however you might influence a prospective client. Enjoy the privilege of having both professional and entrepreneurial status in your community—go ahead, flaunt it! Far from resenting it, your peers at the Rotary Club enjoy it when you to flash a bit of Frank Lloyd Wright's style now and then. Structuring your life around the creative promotion of your business ought to—and can—be fun.

Analyzing Your Firm's Strengths and Weaknesses

You can't go out and confidently drum up business for the office if you're not sure what you've got to sell. That's why, more than anyone else, the principal in a design firm must take the hardest look at what his or her outfit brings to the marketplace. Needless to say, any effort to distinguish yourself from the competition—to find a niche, as marketers love to say—begins with the same analysis. Croxton Collaborative, for instance, did this by focusing on "environmentally conscious design," as they describe their specialty.

Believe it or not, the esthetics of your design philosophy don't matter a bit in this context. For the most part, potential clients simply want to see beautiful results. It's your job to deliver those results; that's why they're willing to hire a designer in the first place. Even if they are attracted by your design reputation, that's not what matters most to them.

The analysis you must undertake has to do with much more mundane factors than esthetics. You can control some of these factors once you've examined them; others may be beyond your control.

- First look at your practice's finances. Just how healthy is the business?
- Are productivity and associated costs of doing business carefully monitored?
- How about your reputation for reliable project management? Can you boast of always being under budget, with the job done on time?
- Do you give client service top priority?
- What is the firm's attitude toward specialization?
- How favorable to your practice are trends in the local and national economy?

Good financial management is critical to business success, and we devote Chapter Three to this subject. Architectural business consultant Glenn Garrison finds this generally to be the weakest link at small design firms. Likewise, nothing appeals to clients like a sound reputation for getting the job done on time and under budget. So, among other things, Chapter Four considers project management. For example, architect William Koster's practice, which specializes in updating small-town Carnegie Library

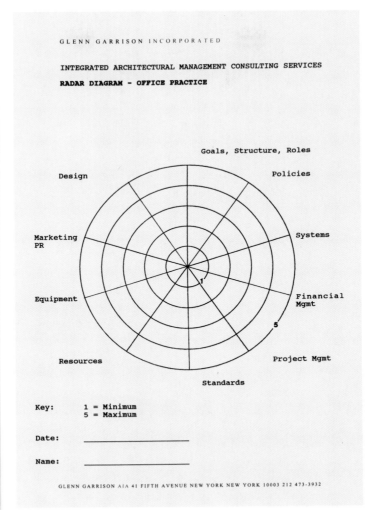

GLENN GARRISON INCORPORATED

INTEGRATED ARCHITECTURAL MANAGEMENT CONSULTING SERVICES

RADAR DIAGRAM - OFFICE PRACTICE

Goals, Structure, Roles
Design
Policies
Marketing PR
Systems
Equipment
Financial Mgmt
Resources
Project Mgmt
Standards

Key: 1 = Minimum
 5 = Maximum

Date: _____

Name: _____

GLENN GARRISON AIA 41 FIFTH AVENUE NEW YORK NEW YORK 10003 212 473-3932

Glenn Garrison's "Radar Diagram" offers a quick, comprehensive way to assess your firm's strengths and weaknesses. However, it doesn't take the place of a thorough business analysis that examines—based on past experience and your project records—the office's financial health and its ability to meet clients' schedule and budget requirements, among other things.

"Do I really have to waste time on a business plan?"

buildings, recognizes that "these projects are budget driven." He provides his clients with three separate cost estimates as the job progresses through design, each successive one more detailed. In addition, he finds that computerized drawings help to solicit precise bids from contractors, thus making it possible to meet clients' budgets consistently. For her part, interior designer Nina Hughes emphasizes her firm's commitment to meeting the client's schedule. "It's what drives this client-centered company," she says.

The reason to address these factors through self-analysis of your firm is that they inform and shape your business plan. You may ask, "Do I really have to waste time on a business plan?" Actually, for architects and designers, being able to plot the course our business is likely to take over the next six or twelve months should be appealing. Unfortunately, though, our antibusiness bias often gets in the way of such rational behavior.

A business plan has two great virtues. First, it allows you to chart expected income and expenses over a specified period; this is easily done using a spreadsheet program such as Excel or Lotus 1-2-3. If you work with an accountant, he or she has no doubt urged you to make this a regular practice. The main benefit is that it alerts you to cash-flow problems *before* a crisis hits your firm. Are you going to have periods of paying out more money than you can reasonably expect to have received by that time? Obviously, given architects' and designers' congenital optimism, difficult financial situations can be ignored, even on a cash flow diagram. The other major benefit of a business plan is that it makes clear how much more money needs to be brought in to achieve and maintain positive cash flow. For designers and architects, this is where marketing begins.

More than any other factor, your office's financial strength determines the amount of time that you, as a principal, can put into promoting it. Because promotion time is a nonbillable executive expense, the time you spend telling people about your office has to be supported by income that is already assured. Thus, successful marketing grows out of the office's overall business picture; it cannot be a program imposed on your business by an expert.

Marketing as an Executive Function

Even though you've had dozens of charming MBAs tell you they would be only too happy to take on the chore of promoting your firm to the world, that's probably not the best choice for you, especially if you think it will spare you—the principal—from having to do any of it yourself. You need to be candid, however shy you are, in telling others about your work. Accept your responsibility for doing this. It's your job, whether you are a sole proprietor or a partner. Architect Mike Pyatok is someone who has learned to enjoy promotional activity; when making presentations for low-income housing to nonprofit groups, he turns them into performance art.

Marketing is a key area in design practice, where personal discipline is needed to carry on a successful, stable business. In this case, personal discipline means mastering all of the inhibitions—intellectual and psychological—that may have kept you from vigorously promoting and assertively selling your professional services in the past. By intellectual inhibition, I mean that notion that if the work your firm does has intrinsic value, then the world will automatically recognize it and come knocking at your door. Interior designer Judith Stockman speaks for many professional colleagues when she asks, "Why isn't being creative enough?" Even if that was true in the days of Charles Bulfinch and Thomas U. Walter, it hasn't applied in our competitive economy for at least a century, as H. H. Richardson understood only too well. Then there is the matter of personal shyness, a not uncommon trait among designers and architects. It's not enough to say "snap out of it!" It may be necessary to find and carry out a psychologically effective therapy in order to overcome what might be called "pathological diffidence," otherwise this shyness could destroy your practice. William Koster remembers that in his early days as an architect, he often vomited before making presentations to prospective clients. He worked hard to get over it.

One way to sublimate these fears is to use that energy in a positive way by preparing an appropriate marketing plan. For our purposes, doing the marketing plan is actually easier than monitoring what happens after you begin to use it.

"**W**hy isn't being creative enough?"

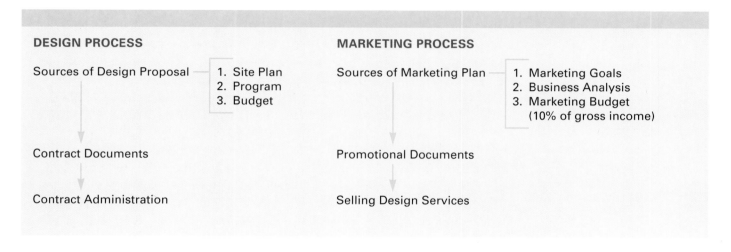

DESIGN PROCESS

Sources of Design Proposal — 1. Site Plan
2. Program
3. Budget

Contract Documents

Contract Administration

MARKETING PROCESS

Sources of Marketing Plan — 1. Marketing Goals
2. Business Analysis
3. Marketing Budget
(10% of gross income)

Promotional Documents

Selling Design Services

If you answer the following six questions clearly, you'll have the material to fashion a workable one-page plan for promoting your office, especially if this is the first time you've ever tried to do it:

- Why do you want more business?
- What kind of jobs are you qualified to do—both type and scope of work?
- Under what terms do you want to work?
- In what geographical area are you willing to work?
- How are you going to look for prospects?
- How much time and money can you spend to pursue that search?

Once a marketing plan that meets the needs and limitations of your practice has been prepared, studied (criticism by people experienced in marketing services is always useful), and accepted by everyone who will be involved in carrying it out, then you begin by identifying leads or prospective clients. Adequately formulated, your marketing plan should tell you precisely whom to seek. That is, by clarifying what your firm can do best and in what specific region, you only have to find the individuals and companies within it that need your expertise. The importance of specialization in marketing your professional services will be discussed next; obviously, the more tightly you define your specialty (or specialities), the more effectively you can search for those who might profit from employing your office.

The process of reviewing various sources of information to uncover the identity of potential leads and build prospect lists is something that any bright, interested assistant can do. Instead of purchasing mailing lists, make your own computerized lists. They are particularly effective because they can be easily manipulated and kept up-to-date. Combined with mail-merge capabilities, they make the outreach task far less onerous than it was in the past. In addition, features that monitor progress on each lead and remind you when to follow up—common to programs like ACT!—are crucial for marketing success.

Specialization or Diversity? An Executive Decision

Before going on with the details of how you promote a firm, this is a good time to emphasize the importance of specialization in the effective marketing of professional services. Designers and architects, so taken with the joy of solving whatever problem comes along, often fail to notice that the rest of the business world tends to specialize in doing one thing as well—and therefore as profitably—as possible. Few other businesses besides ours have multiple focuses (and some of the huge holding companies that have tried to do so have had painful experiences in the process). Experience makes for profitable operation—it's as simple as that. Inside contacts, mastery of the jargon particular to a field, peer exchange on the latest refinements—they all contribute to success. Interior designer Lee Stout's practice is an example of that: By devoting his attention to a set of core clients, mostly in the interior furnishings field, not only has he created a healthy business, but he also enjoys enviable status as a designer among those clients.

So, what is a firm that's eager to take on every new design challenge supposed to do? It might consider *multispecialization,* a way to enjoy the pleasures of a diverse practice without suffering its ups and downs. In effect, multispecialization for architects and designers is simply a conscious form of diversification. Instead of waiting for the new challenge to sail in over the transom, you and your colleagues decide which new fields you want to master, maybe going back to an area of interest that you enjoyed exploring in a job three or four years ago, and to which you could return with genuine pleasure.

Consider *multispecialization,* a way to enjoy the pleasures of a diverse practice without suffering its ups and downs.

Cleverly designed promotional materials like the spiral-bound set of postcard-sized project photos above, which includes brief captions describing each low-income housing job, can generate marketing benefits far greater than their cost. The secret lies in getting them into the right hands.

Architect Garth Sheriff's multifaceted practice is a vivid example of how an architect can not only pursue three specialties—housing, small commercial jobs, and custom residential—simultaneously but also be involved in political, nonprofit, and fund-raising endeavors as well. As Sheriff makes clear, it's up to you to decide how openly you share this spectrum of activities with potential clients for a specific type of work.

Prior experience in a new specialty, however limited, is useful because it provides a framework on which to hang the new knowledge and information that you and your associates must acquire. It is important to build your credibility when dealing with people who know everything there is to know about their own businesses. You need to document your expertise, emphasizing how your design skills address the well-known problems within the prospective client's field; do this with handouts that can readily be inserted into the kit or packet of public relations materials you already have prepared.

Keeping up with the latest trends in fields other than design can be stimulating and enjoyable. Getting involved in trade shows and seminars, and writing articles for journals that cater to those fields are valuable ways to create an aura of interest in the prospects' everyday business concerns. In each case you should attempt to convey your firm's skills, experience, and potential.

Follow-Up and Client Cultivation

The essential ingredient of effective promotion is the systematic following up of leads. It begins with calls to the identified organization to determine who is the actual decision-maker there; the exact spelling of his or her name, title, address; and other basic facts. The resulting letter of inquiry must be followed up by a call no more than ten days later. That probably will generate another letter with its subsequent telephone call, and so on, until either you have the opportunity to meet with the decision-maker or a significant associate to talk about your services, or they tell you to lay off. This may involve six months or more of attention to that prospect; it illustrates why architects and designers can pursue only a limited number of leads, and why even targeted direct mail is probably not a suitable promotional technique.

Now, who actually does this work in a small design office? The principal actively leads the effort, deciding how intensively certain leads are to be pursued and reviewing progress of the effort daily. In fact, most of the actual work is done by an administrative assistant, who may or may not have design training. He or she keeps close track of the various leads being pursued and should always be prepared to report on them. By the way, everyone on the staff should be encouraged to talk up the office whenever they get

a chance. Putting business cards into the hands of even part-time staff members is well worth the cost of printing them—and it builds commitment.

An associated task is to be sure that any and all names you give as references are people who will respond enthusiastically to questions about the quality of your firm's work. Most designers, however, are brilliant at ignoring the yearning that former clients (at least, the happy ones) have to express the love they feel toward an architect or designer who has served them well. In this phenomenon lies the potential for the most effective marketing of your services. Call it the "three lists" method. Here's how it works:

Make three lists of your former (possibly also current) clients.

- On the first list, put down six names of the most well connected of them, especially in the fields where you would like more jobs.
- On the second list, write down the six clients with the most business experience in general, as entrepreneurs or executives.
- On the third list, name the six people who seem to value your services the most, who genuinely appear to cherish you for your contribution to their well-being.
- Does any one name appear on all three lists? That's the person you call up and invite to lunch at the classiest restaurant you know that is appropriate to his or her taste.
- Once pleasantries have been exchanged, you ask this person if he or she would be willing to share, from the perspective of his or her business background, a frank appraisal of you and your office. (Don't ask the question if you are not ready to take this advice seriously, because the response may be a bit overwhelming.) Be ready to take notes. Don't waste your benefactor's time talking back or trying to offer excuses.

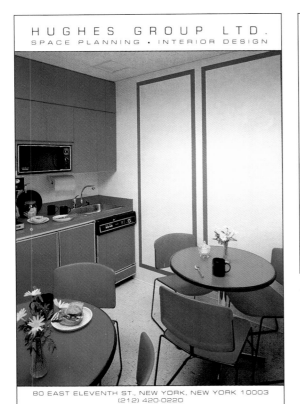

HUGHES GROUP LTD.
SPACE PLANNING · INTERIOR DESIGN

80 EAST ELEVENTH ST., NEW YORK, NEW YORK 10003
(212) 420-0220

GOOD DESIGN IS
a management
decision.

GOOD DESIGN MEANS
picking the right
consultant.

HUGHES GROUP LTD.
is dedicated
to helping clients
implement
their management
decisions.

GOOD DESIGN IS
IN YOUR
HANDS.

Photo: A. Kassabian
Offices: St. John, Oberdorf, Williams, Edington & Curtin

At the end of each year, Nina Hughes prepares a postcard making use of a recently completed project to remind former clients and friends that her firm is always ready to serve their design needs.

While it is important to consider this advice, it is not the main reason for this lunch. When your old client has finished sharing these observations, you ask whether he or she would be willing to help promote your firm among his or her business peers. If you've done a good job making your lists, the answer should be strongly affirmative. Then you offer to share whatever profit you might make off any job this person obtains for you. Chances are, when this old client learns how little profit you make on a typical job, he or she will offer to do it for free. And there you have the perfect marketing scheme for shy, overworked designers.

Warning: Observe the following two caveats scrupulously if you choose this course. First, if the prospect sent to you by this means is someone with whom you feel you cannot possibly work productively, then you must call up your old client and talk it over thoroughly before you say anything to the person who has been referred to you (this is a good practice whenever you decide to reject a prospect who has been passed along to you). Second, even though the old client has volunteered to do this work for free, be sure to send a gift, something showy (purchased wholesale), something that will enrich the environment you designed for him or her in the past, as a way of saying thanks.

Public Relations as a Marketing Strategy

Whenever the idea of publicity is mentioned, most designers and architects assume this means getting their completed jobs published in a national design magazine. However gratifying that experience may be for one's ego, it has little to do with productive integration of public relations into an office's marketing plan.

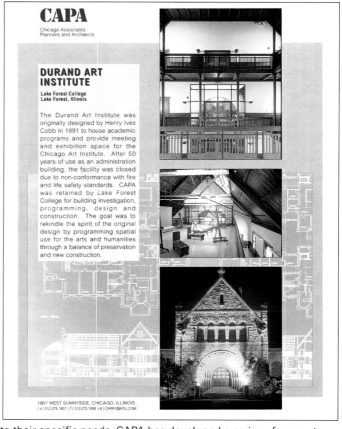

Prospective clients respond best to promotional materials that speak to their specific needs. CAPA has developed a series of computer-generated sheets that offer comprehensive information about the firm. The introductory section lists every possible kind of work that the firm can do; project description pages convey their problem-solving competence by combining tightly written text with attractive visuals.

Your marketing plan, remember, ought to tell you precisely *who* should be hearing from your firm; it is probably not other architects and designers. If publication of your work matters at all, it is when the material appears in trade journals and magazines that your potential clients read. Part of preparing to offer specialized design services is identifying the sources of information that people in the targeted business rely upon. There is an amazing range and amount of "technical literature" published by industries that most of us never think about. And contrary to the difficulty of getting published in the principal design magazines, editors of these specialized periodicals are quite pleased to receive good-quality photographs of newly designed facilities that may interest their readers.

It is hard to explain why print exposure affects people the way it does. But if your name appears in print (or if you are shown on television, however briefly), folks who knew you before suddenly treat you with new respect. That is the mystery of publicity, and from the perspective of promoting professional services, it can be extremely useful. But it only works if you don't take it personally. It is not about you; it's about getting more work, at higher fees than usual, for your firm. One of the magical effects of publicity is that prospective clients are more likely to consider themselves lucky that you'll take their "humble little job." That means they'll probably agree to higher fees than they might have without the publicity. And, in fact, they might not even have known of your office otherwise.

Make sure that copies of publicity mentions—as well as the brochures and other handouts your office prepares to describe its work—are distributed as widely and as quickly as possible. Whatever they may cost to produce, these things have little value sitting on your mailroom shelf. Judith Stockman, during the early years of her practice, frequently mailed reprints of articles about her work to as many people as possible. Contrary to what you may think, people who know you and think well of your firm will be quite pleased to receive a photocopy of an item mentioning you, especially if you enclose a brief, lighthearted personal note; in most cases, far from finding you pushy, they'll be charmed to be included in your mailing.

So consider a publicity program as part of your marketing plan if you feel the firm can benefit from greater name recognition in an area where you've chosen to market your services. Keep in mind that the more precisely you focus these efforts, both in terms of the specialty and the number of individuals working in it whom you seek to contact, the more likely it is to be cost-effective.

Selling Your Professional Services: A Crucial Executive Function

In many ways, promotion is the easy part of marketing. Once some person or organization that you've been pursuing expresses interest in actually working together, then you, as principal of your firm, have to "close the deal" with them.

For many designers and architects this ostensibly happy task is complicated by ambivalence about charging for their work. While there have always been greedy individuals among us, the attitude of most ranges from carelessness about making money to outright timidity when it comes to asking for compensation from those who have shown an interest in hiring us. For the latter, the issue is recognizing the value of your work. "If architects value what they give," says Garth Sheriff, "then they aren't going to be timid about collecting what's owed them."

In fact, one of the benefits of doing a thoughtful self-analysis of your firm's strengths and weakness ought to be a stronger appreciation for the value of what you produce. Furthermore, you can look at it purely from a business point of view: Architects and

designers direct the ordering and installation of vast amounts of manufactured material each year, a substantial part of the Gross Domestic Product. And from the owners' perspective, we lead them through a dazzlingly complex process—truly frightening to some clients—to a completed building or interior that actually does what we predicted it would do. Interior designer Janice Stevenor Dale believes that the designer or architect can truly be "captain of the team" by offering guidance not only to the client but also to others working on the job, for example, by providing authoritative contract documents.

> Most people sincerely want to do business when they come to you. Your job in the initial interviews is to be sure you reinforce their desire, not weaken it. There are two ways to make sure that happens.
>
> 1. When a prospect, especially a representative of a commercial or institutional entity, requests to meet with you, do some preliminary research. Ask if you can visit their existing facility in order to learn firsthand how their operation works. In addition, spend time learning about their standing in the field and their unique contribution. And don't forget to research their financial standing through business reporting agencies (such as Dun & Bradstreet). Do they pay their bills promptly?
> 2. During the interviews, use your recently acquired knowledge to ask questions about what they hope to accomplish by building this new project. By spending more time listening, trying to find out what is really on their mind, and less time worrying about showing your slides, you have a chance to create the impression that serving their needs is the most important opportunity you have ever been offered as a designer. If you can get that across, you'll get the job. "Personal chemistry," says interior designer Freya Block, "matters above all else."

What the potential client needs is assurance that, in your hands, the job will be completed on time and under budget.

What the potential client needs is assurance that, in your hands, the job will be completed on time and under budget. When you talk about the firm's qualities, stress technical and procedural experience. Expertise is always an issue: "Have you done what we need before?" For a designer or architect a different set of programmatic needs is far less challenging than it seems to the owner. It's up to you to convince this individual or committee that, based on your track record, "this project is a piece of cake—no problem," as Garth Sheriff puts it.

Methods of Compensation: A Brief, Direct Proposal

While there are many different ways to arrange compensation for design services, some seem to be fairer to designers than to others. From the standpoint of selling professional services, however, one method stands out as the most attractive to potential clients: the fixed fee. Look at it from the prospect's point of view. The complicated systems we usually propose—hourly rates, percentages, square-footage rates, and sometimes even combinations of these rates—are often confusing and may even seem slightly devious, particularly to inexperienced people. These options, which we may offer from the most scrupulous of motives, can make the already daunting process of commissioning a designer or architect downright scary. It's very much like buying a suit off the rack with a stated price versus going to a tailor to have one made at an indeterminate price. Only a few customers have the sartorial commitment to go through that drawn-out sequence without worrying about the final cost. From the client's accounting standpoint,

knowing exactly what the designer is to be paid from the start is by far the clearest and most attractive possibility.

Of course, in order to safely propose the lump-sum method of compensation, your firm has to have control of your costs of doing business. Tight financial management, as discussed in Chapter Three, is essential if a design practice is to avoid disaster when accepting fixed-fee contracts. It is crucial in this case that the scope of services be tightly inclusive, according to Nina Hughes, who finds that fixed-fee contracts with her corporate clients work out well. Any additional meeting time that creeps in as design and documentation work progresses will come out of your pocket.

On the other hand, assuming the fee situation is not especially competitive, there may be an opportunity to build in a substantial profit margin. Traditionally we determine what we charge as a function of our job costs—usually because we must do so. However, there are cases where, if we consider it from the client's point of view, a considerably higher amount than we would normally ask may be spent on design services. In specialties, such as domestic interiors and custom house design, it is often impossible to draw a contract tight enough to cover all potential problems and especially, the demands on the designer's time.

Thus, in return for the assurance of the lump sum, there is no reason why the amount requested by the designer cannot be generous enough to guarantee a profit on that job, perhaps to balance out those jobs on which—due to competition or government regulations—costs can barely be met. In effect, with a bit of shrewd calculation, there is no reason why the prospect who likes the idea of a fixed fee can't be offered one by the architect or designer that satisfies both parties. This is not an immoral proposition. After all, can anyone really calculate the value that our taste, talent, and skill add to a pile of building supplies?

It is a good policy in general to try to make your bills to the client as invisible as possible. Since the lump-sum fee (or any other type for that matter) is broken up into monthly payments, it is important not only to bill regularly but to meet your client's accounting schedules as well. The idea is for your monthly statement to arrive there just in time to be approved for payment before the bookkeeper begins preparing checks. Describe your services in ways that match the client's codes rather than your own. Anything done to make bill paying effortless—even automatic, if possible—is good business. Billing regularly and clearly, by the way, applies to residential design work just as much as it does to commercial jobs.

Negotiating the Fee

The most important element of any contract—after terms of payment—is the description of what the parties involved promise to do. In the case of standard designer-client contracts, their phased structure presents an enormous advantage to the professional. It offers an almost automatic opportunity to explain to the prospect how we do our work. More than that, it helps the prospective client understand how complicated our work is as it proceeds from conceptualization through technical development to administration of the project's realization by others. There are at least three profoundly different kinds of work here: the imaginative and speculative activity of an artist, the pragmatic and practical decision making of an engineer, and the complex operations management of a business executive—all to be carried out alone, assumes the potential client, by you the architect or designer. Awesome!

Yet, in the end, what matters more than striking a heroic posture is to use the contract discussions to get across to the other party the demanding complexity of

It is a good policy in general to try to make your bills to the client as invisible as possible.

Use the contract discussions to get across to the other party the demanding complexity of our work.

When you tell another business person, eyeball-to-eyeball, that you can't do the project for less than you've offered to and still make a reasonable profit, you are speaking his or her language.

our work. It is important to explain clearly how all the different tasks involved in completing one of our projects are done through the cooperative efforts of many players. This is also the time to emphasize how much collaboration on this scale *costs*. In other words, as you go through the various phases of the contract with your future client, use this chance to elaborate the value of spending money during the design phase in order to save it during construction, and later during the years of operations. Janice Stevenor Dale has given a good deal of thought to facilitating this process for her clients. For example, at the schematic design phase, she provides them with a "cartoon set" of the drawings—brightly colored images that spell out the different trades involved. As detailing proceeds, she explains how she has used "value engineering analysis" to make optimal choices of the many components that make up the project. By the end of the schematics, she says, a "triangle of values" has been established—that is, budget, schedule, and design, all approved by the client—that allows preparation of contract documents to go ahead smoothly.

Without a doubt, getting the "scope of services" paragraph right is the biggest issue in preparing a designer-owner contract. That's one reason why it is the first substantive section in the standard AIA and ASID contract forms. And if there is one major drawback to those forms as generally presented, it is that there is usually not a great deal of space in which to spell out exactly what services will be provided (implying, of course, what will not be done as well).

In preparing a draft contract the design executive can earn the firm a great deal simply by giving his or her full attention to stating clearly both the extent and nature of each service being offered: naming the spaces to be designed and then elaborating the firm's contribution in each case. If the full description ends up taking half a page or more of the contract document, so what? And be sure to take the time to explain each part of it to the individual who intends to sign the contract. This is the most effective way to justify your request for compensation that, on the surface, may seem excessive to someone unfamiliar with what architects and designers do. And it helps to clarify why we can be so sure of the final quality of what we propose to create long before it actually exists. There is another advantage to the careful preparation of the "scope of services" description. Planner Tom Forman sees it as a way to hold the edge in situations where another firm may be cutting its fee in order to break into a new type of work. He believes that by explaining in detail—as you submit the contract—what you're going to provide, the experienced design firm can make its case for adequate compensation.

Of course, the main reason why one strives to draft every contract with such a tight definition of services to be rendered is that, when the client decides to expand the extent of the project, you have the perfect opportunity to prepare a new contract, perhaps increasing the compensation should that seem worthwhile under the circumstances. At the very least, the additional work can be just as clearly spelled out so that your client understands once more, and with fresh appreciation, the intrinsic value of your professional services.

There still remains the hard part: coming up with a figure for your fee that adequately (which means profitably) rewards your firm while satisfying the client's expectations. These days many potential clients will have shopped around before sitting down to sign a contract with you, and they will have expectations that simply can't be met without sacrifice on your part, perhaps not just of a profit but even of a fee sufficient to cover your costs of doing business. You can confront the bargain hunter with a bottom-line figure that isn't speculative if you know precisely what your cost will be to do a specific job. When you tell another business person, eyeball-to-eyeball, that you can't do the project for less than you've offered to and still make a reasonable profit, you are speaking his or her language. That's what making a deal is about, after all.

On the other hand, when you are approaching a prospect who has a lot of money, big dreams, and no idea of how to realize them, you are justified in proposing a lump sum fee that more than covers your expenses. After all, you are the one who's going to make those fantasies come true. And how can you put a price tag on that kind of magic? Don't be timid, either, about using the small print of the contract to get maximum remuneration for such things as coordinating your consultants' work and carrying out the often demanding tasks of getting official approvals for the project.

Securing a Big Enough Retainer

As the firm's principal, your challenge is to make your clients feel comfortable about how the job is going to turn out, to build their confidence in your ability to meet their expectations. Proof that you are successful at this is the size of the retainers they give you. This is no joke; any designer who begins a job, especially for a first-time client, without having secured a meaningful retainer is foolish indeed.

The retainer (also called the initial or binding payment) is money that, as specified in the architect's or designer's contract, will be credited against future invoices for professional services on the project. It is not the same as a deposit or down payment, although as Lee Stout points out, interior designers sometimes get them confused. Deposits cover the required first payment (usually fifty percent) for furniture and other furnishings that the designer is purchasing for the client as part of the job. They have nothing to do with the design fee.

Why does obtaining this retainer for your services matter? First, having that money up-front bolsters the financial health of a practice and helps to ensure its stability. Second, by putting cash into the project as design begins, clients move beyond daydreaming to serious commitment; now they have something to lose.

As a matter of business practice, the idea of a firm throwing its human resources into work well before it can bill for the work amounts to granting credit to the customer in order to get the order. From the accountant's perspective, it's the same as opening a receivable account and creating a debt before anything else happens. In an economy fueled by credit cards as ours is, it may seem odd to raise the question. Where tangible products are concerned, easy credit obviously makes a big difference in selling them. But when professional services are involved, especially in a field such as ours where the actual product takes months if not years to be realized, to require the designer to work on speculation is worth questioning.

A number of the architectural firms interviewed for this book—specifically Cindy Harden and Jan Van Arnam, Michael Pyatok, and Roberta Washington—specialize in government housing contracts, which do not allow for retainers (and often involve extremely slow payment of invoices as well). For these architects severe financial stress complicates what is already a demanding specialty. Thus, their commitment to public service is made even greater by the economic consequences of that choice. Once a publicly sponsored RFP (Request for Proposal—the standard method by which government agencies and institutions award commissions) is assigned to an architectural firm, the project usually goes ahead. Unfortunately, it also means that the firm immediately begins lending money to that agency as it undertakes the design work at its own expense, waiting perhaps as long as a year for the first payment on the contract.

For those doing commercial or private practice, however, there is no such guarantee that the client will complete the job. And our phased contracts make clear that we will accept the termination of the project for reasons that have nothing to do with the quality of design services. For that reason alone, it is advisable for the designer to be ahead of

Any designer who begins a job, especially for a first-time client, without having secured a meaningful retainer is foolish indeed.

In a field such as ours where the actual product takes months if not years to be realized, to require the designer to work on speculation is worth questioning.

the client in terms of payments, in order to facilitate settling of accounts whenever and however the contract is fulfilled.

Since architects and designers are so often "stiffed" for that final payment, there must be a diplomatic way to get across to clients that better contract administration (the generic phrase for oversight of construction by the designer or architect) will be offered if it has already been paid for. Some designers rebate the retainer as the phases of the contract are completed, so that by the time contract administration begins, the initial payment has been repaid. However you choose to make the arrangements with your new client, it is essential for the health of your business to obtain a payment upon signing a contract and before beginning design studies.

Finally, the bigger the retainer you can get, the better! There are those who argue for a nominal sum that acts symbolically as a binder, say five or ten thousand dollars. Why not more if you can get it? The strongest argument for securing a retainer of at least ten percent of the contract comes at the end of the job. When the project is completed and it's time to send the final bill for contract administration (at the point when owners are often already swamped by higher than expected construction costs), you can mark it "paid." No client will ever complain about that.

Human Resources Management

People and the Designer

Many of us were drawn to architecture or design school largely because we looked forward to creating a world of our own devising on the drafting board without having to deal very much with other people. In other words, designers often prove to be introspective and self-absorbed individuals for whom normal human contact is less pleasurable than is fantasizing in private with pencil or, nowadays, computer mouse. Yet upon graduation almost every architect and designer dreams of the day when he or she opens an office.

So, as apprenticeship begins, it comes as a rude surprise for some of us to learn that practice consists of at least eighty percent human contact and, if you're lucky, maybe ten percent of the time spent on "design." Opening your own office, then, turns out to include a number of burdensome tasks, many of which fall into the category of human resource management.

The vast majority of professional design offices have few if any employees, of course, especially as computer technology has substantially increased a well-trained person's productivity. But that fact hardly relieves the principal of the need for daily human exchange; in many ways solo practice intensifies that situation. Especially if you have no one to help you, each day you must then face and constructively deal with suppliers, consultants, contractors, government, and—often the most exasperating of all—clients.

Thus, upon graduation design professionals are thrown into the human maelstrom, usually with no training whatsoever in how to handle people. "They never teach anything about management in architecture school," says architect Roberta Washington. "It seems to be sort of a 'trade secret,' and it's not easy to find out about on your own." That introductory course in psychology taken halfheartedly in school hardly makes a difference, since theory is of little use when dealing with a client and contractor locked in heated argument over whether or not that room was to have been painted that shade of green. Usually, by the time we hang out a shingle, whatever we've learned about the importance of keeping people happy has come from watching former employers cope with various human situations—and, too often, as Lee Stout points out, that's mostly valuable for learning how *not* to do it.

Therefore, managing people productively is as central to a successful practice as any other aspect of our work.

Upon graduation design professionals are thrown into the human maelstrom, usually with no training whatsoever in how to handle people.

Becoming an Employer

Think carefully before you hire anyone. There is such a compelling urge among design professionals not only to have a business address but also a staff that few ever really think it through. First, there's the perceived heightening of status among clients and peers to have someone else answering your telephone, particularly a mellifluous female voice with a crisp English accent. Then there are all the tasks we hate to do, from drafting or computer-aided design and drafting work to bookkeeping to writing proposals. Also, we hope, more substantial jobs will come to us if we're seen as "established."

Strange as it may seem, design professionals do set up offices intending to hire people without fully understanding that, in addition to the salary you pay them, they are, by law and custom, entitled to benefits that can actually double an employee's expense to the employer.

> In addition to the following financial obligations, bookkeeping costs increase substantially once you hire people because an employer is responsible for:
>
> - Filing reports and submitting funds withheld from employees' checks for federal, state, and local income taxes; frequency of filing and submitting depends on the size of the payroll
> - Filing reports and submitting funds withheld from employees' checks for Social Security and Medicare
> - Paying the employer's share of Social Security, based on the percentage of an employee's salary up to the maximum mandated for that year
> - Paying the employer's share of Medicare; i.e., 1.45 percent of an employee's gross salary
> - Paying Federal Unemployment Insurance
> - Paying State Unemployment Insurance in accordance with each state's regulations
> - Paying all or part of short-term disability insurance; deductions vary from state to state, as does the amount of coverage per person
> - Paying Worker's Compensation in accordance with each state's laws
> - Allocating each employee's share of fixed costs for the operation of the office
> - Optional obligations, which vary from employer to employer. These may include:
> Vacation pay
> Pay for sick and personal days
> Amounts paid toward long-term disability and medical, dental, and life
> insurance
> Amounts paid into employees' profit-sharing and/or retirement funds.

Despite the fact that contributions to several of the items listed above are withheld from an employee's salary, this set of obligations can add up to more than thirty percent of the firm's gross annual income. This helps to explain why architecture and design firms often try to hire workers on a consultant basis.

Employers are not required to pay these benefits when they hire consultants to do technical work on projects, especially if that work is done outside the office. By paying a consulting fee that includes none of the contributions listed above, the employer saves some actual cash as well as a good deal of bookkeeping expense. Out of what often is a higher hourly rate than a standard employee would be paid, the consultants must take care of all government obligations (federal and state taxes, Social Security payments, etc.) and, since Workers' Compensation is not included either, provide their own health insurance.

Mike Pyatok had practiced for several years before he began to build a staff. Hiring people to work for you adds a dimension of personal responsibility to running a design office that deserves careful consideration before it is undertaken.

J S D A TIMESHEET

Name...Week.............to............./97

Signature...Approval.................................

Social Security No...

Project Project No. Phase Sat Sun Mon Tue Wed Thur Fri
..

..

..

..

..

..

..

Marketing
..
Sickleave
..
Vacation
..
Holiday
..
Billable Hours
..
Non-billable Hours
..
Total Hours
..

Phase Code:
I Programming/Strategic Planning
II Conceptual Design
III Design Development
IV Construction Documents
V Construction Administration

Pyatok Associates
Employee Daily Timeslip

Employee Name: _____

Date: _____
Slip ____of____

Job#: _____Job Name:_____
Phase_____Hours=____
Description:_____

Job#: _____Job Name:_____
Phase_____Hours=____
Description:_____

Job#: _____Job Name:_____
Phase_____Hours=____
Description:_____

Job#: _____Job Name:_____
Phase_____Hours=____
Description:_____

Job#: _____Job Name:_____
Phase_____Hours=____
Description:_____

Total Hours Worked today: _____

Entered in Timeslips: ____Yes____No

Timesheets matter. Most small firms still ask employees to record this information on printed forms. Whether they are comprehensive, as is Janice Stevenor Dale's example, or more concise, similar to the Pyatok Associates's approach, is less important than making sure they are consistently kept up to date by everyone, including the principals.

Some design offices have tried to pass off most of their staff—people who come into the office daily and work there the entire time—as "consultants," but the Internal Revenue Service has actively prosecuted that practice as illegal. It is definitely not to the benefit of the employees to accept such an arrangement. And in the long run it has a detrimental effect on office productivity, as the "consultants" adjust their commitment to the work at hand to match their second-class status. Heavy reliance on student drafters and other part-time workers can have the same negative result, weakening office morale and productivity. As computerization takes hold in the design office, a number of the principals included in this book—interior designers Laura Bohn, Nina Hughes, Janice Stevenor Dale, and Judith Stockman, in particular—have chosen to reduce their staffing to a minimum rather than exploit individuals in this way.

Creating and Choosing Your Staff

It is a commonplace that in our professions the portfolio is what gets people jobs. Students in design schools such as Pratt Institute take courses specifically focused on helping them produce attractive collections of their design studio and thesis projects. In those courses it is stressed that the portfolio should speak for itself, that it should be concise and display a broad range of skills through the images chosen. Another skill-based test used in the past was simply to ask the prospective drafter to letter his or her name in the interviewer's presence; a carefully done rendition often won the job. But times have changed, and lettering skills are less relevant. The efficiencies possible through computer-aided design and drafting (CADD) have reduced the number of technical positions, and competition for these has increased dramatically.

Therefore, an employer seeking to build his or her staff for the long term learns to look beyond visual virtuosity and for abilities that more closely approximate the realities of today's design practice. The trend today, as expressed by Garth Sheriff and others interviewed, is toward a small senior-level staff that is both computer-literate and experienced in construction procedures.

In interviews with candidates, consider these characteristics as well.

1. Look for well-trained design technicians who also have effective writing skills. Few architecture graduates appreciate the demand in normal building process for clear, concise written language that conveys, along with drawings, the complexities of modern construction; the schools generally do not make much effort to prepare students for that reality.

2. Developed conversational skills (which, of course, some people possess naturally in abundance) also play a central role in professional effectiveness, particularly if the employer is looking for staff members who might themselves assume management roles in the future. Given the possibility that almost anyone in a design office could become a project manager sooner or later, the ability to set a variety of listeners at ease while effectively sharing technical information orally is crucial.

3. Another important consideration is emotional compatibility with others in the office and in organizations with whom the office normally has dealings. Gifts of personality (like verbal proficiency) are not just God-given; they can be developed. With appropriate care and training, many a shy, tongue-tied young design graduate has developed into a powerful public presence.

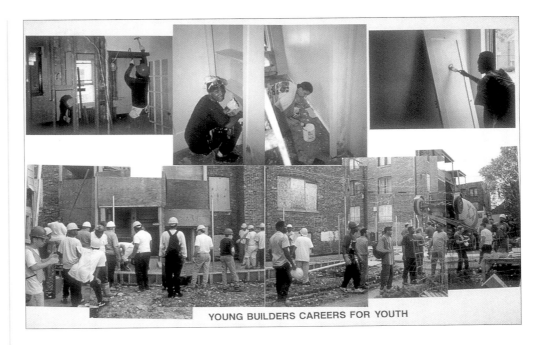

YOUNG BUILDERS CAREERS FOR YOUTH

While personality and verbal skills are important factors for an interviewer to take into account, a careful balance between them and design talent and training must be struck. Furthermore, the experienced employment interviewer learns to keep sexual attraction or other socially based considerations out of the decision-making process. This is not a trivial matter, because some job seekers, whether consciously or not, convey an interest in the interviewer that can affect the latter's judgment. Asking other colleagues to talk to the candidate in such cases can avoid later embarrassment.

Managing Staff Development

Motivating professional employees (and it is smart to consider everyone on your staff as professional) is a complex challenge. The social dynamics of a typical architecture or design office—full of intensely trained, sensitive people, many of whom have high personal expectations—need a good deal of attention. On the one hand, such individuals can readily be enlisted to work long hours together on competitions, for instance, even though the outcome is almost certain to be a disappointment (two hundred firms may enter, but only one will win). On the other hand, without strong leadership from the principals, that energy can turn into a nightmare of ego-based destructive behavior. Let's face it. Like most overeducated people, architects and designers need special care and handling. That's why a strong program of staff development makes good management sense.

Staff development consists primarily of ongoing training for all who desire it, whether offered in-house or by subsidized tuition for courses taken elsewhere. Whether it focuses on expanding CADD fluency, understanding such arcane technical issues as flashing and waterproofing details, or just mastering public speaking, learning opportunities in general ought to be supported by the leaders of the firm. By the way, it doesn't hurt if the principals also take an occasional brush-up course to set an example.

An atmosphere marked by intellectual curiosity, fascination with new ideas, and desire for deeper professional capability doesn't just happen in a design office; it is inspired and nurtured by those in charge. By having one of the firm's managers attend each brown-bag seminar at lunchtime, you send the message that continuing education is important.

For profitable results, it's a rare office that doesn't have to go after every possible lead.

There is no reason why everyone in the office can't be trained to represent its virtues to any potential client they come across.

One design office where one finds such a spirit is James Stewart Polshek & Partners in Manhattan. From the neatly kept bulletin boards filled with critical articles, notices of lectures and seminars, and construction shots of faraway jobs, to the firm's strong support of the local chapter of Architects/Designers/Planners for Social Responsibility, there is ample evidence of a culture of professional excellence flourishing there.

Of course, there are tangible practical advantages as well. By monitoring the interest in self-improvement shown by various staff people, the firm's principals can encourage them to sharpen specific skills that will strengthen the entire organization. This, in turn, may lead to promotion within the teams or departments to which those individuals are assigned. Croxton Collaborative has used such a process to identify people with leadership potential, since management responsibility tends to require more than the usual commitment to one's job.

Specifically, monitoring may reveal a willingness in certain staff members to take on marketing functions. In most design firms, that is seen as a marketing professional's work. Few designers are interested because it involves reaching out to prospective clients (odious enough), but it also involves *selling*, a task few of us can imagine in positive terms.

Yet, as anyone who has run a practice knows, promotion and selling of the firm's services are essential for success. In most cases, the bulk of the work comes in through referrals, and that's what keeps the business going. But for profitable results, it's a rare office that doesn't have to go after every possible lead. That work can be done by someone who has an MBA but who knows little of the design office's peculiar chemistry, or it can be done by a personable design professional who'll take the trouble to master the marketing process. In fact, there is no reason why everyone in the office can't be trained to represent its virtues to any potential client they come across.

Options for Organizing Your Firm

In the old days—say, in Chicago in the 1890s—there weren't many options for how a firm of architects might be set up. There was the chief, the "patron" as in the Beaux-Arts atelier; or perhaps there were partners, as at Adler & Sullivan. Then there was the chief draftsman, and even if that person was the young Frank Lloyd Wright, he had little say in how the firm was run. His job was simply to get as much work as he could out of the rest of the drafters. But as we know, and not just in this case, exceptional talent was also recognized, and had Wright played his cards that way, the firm might have become Adler, Sullivan & Wright. (Interestingly, Wright never seems to have offered anyone a partnership either, keeping those who stayed with him after 1932 contented with membership in the Taliesin Fellowship—whatever that meant.)

The principal of a growing firm today can keep ambitious and valuable young people around by using inducements that have grown out of the business experience of the past century. In fact, the structure of most substantial architecture and design offices has been deeply influenced by corporate practice. Organizational charts listing vice presidents in charge of specific functions—marketing, design, production, contract administration, human resources, and so on—are now commonplace among the top one hundred firms listed annually in national professional magazines. As Janice Stevenor Dale asserts, the reason for that is simple: Corporations are most comfortable dealing with other corporations.

It's true; an organization that has decentralized responsibility through layers of management has trouble communicating with one that has a couple of partners who share all the jobs or, even more curious, one that has a single principal who does everything. But when a design firm presents its "vice president of design" to a prospective client who is part of a corporate hierarchy, that makes an impression. In contrast, the likeliest clients

Firm Expectations

1. Your goals, in order of importance, should direct your financial plan.
2. Outline how each project fits into the firm's vision.
3. Goals and procedures should clarify exactly *how* work gets done and *what* outcomes are wanted.
4. Do not institute procedures that preclude creativity.
5. Goals should enhance group spirit and group responsibility.
6. Projects should be defined and their financial management considered *together.*
7. Have an overall understanding of project financial management with a proactive approach to dealing with individual financial issues.
8. Make your firm's design intent clear.
9. Maintain good communication with all parties in project work.
10. Monitor time management in all parts of practice to improve operations.
11. Clarify office systems.
12. Build time into schedules for developing projects.
13. Improve CADD equipment and other computer systems.

Compiled by Glenn Garrison, July 1995

The structure of most substantial architecture and design offices has been deeply influenced by corporate practice.

for the traditional design partnership may be people who started their own businesses and still exercise total control. The relationship between Peter Bohlin's firm and Microsoft chairman Bill Gates for the design of the latter's palatial residence is an example.

The use of the corporate model for setting up a design firm has occurred in response to the vastly more complex style of business we designers must cope with today. The arrangements found at Adler & Sullivan or at McKim, Mead & White at the time of planning for the Columbian Exposition of 1893 worked fine a century ago. As late as 1961, the Cleveland firm of Weinberg & Teare Architects was organized just as Adler & Sullivan had been, except that there was an individual who was designated as "designer." And the "designer" has become increasingly important as the twentieth century has moved along.

There have also been more philosophical sources for design firm structure. For instance, consider The Architects Collaborative, a loosely structured design team put together in 1948 by Walter Gropius from among his former students at Harvard's Graduate School of Design. Here the arrangement was never to be one of distinct departments, presided over by a designated vice president; rather, it was one of *teamwork.* This group of eight young partners, with their distinguished elder colleague as merely the first among equals, took on projects and worked them out together. As the complexity and frequency of commissions rapidly increased, they had to break themselves into smaller teams and take on employees who dealt only with specific projects. But instead of handling a job in the old hierarchical pattern of moving through the firm from department to department, TAC was a pioneer in the concept of having a job carried all the way, from programming to completion of construction, by the same small group of five or six professionals.

As CADD becomes ever more the operating mode for professional practice, project teams of two or three people seem the model by which even the most complex and enormous projects can be carried out most expeditiously. Glenn Garrison's experience in designing and overseeing the realization of Philip Johnson's dazzling accomplishments (IDS Center, the Crystal Cathedral, PPG Place) emphasizes the role of sophisticated management techniques like Total Quality Management (TQM) in facilitating the most effective possible use of CADD. In his best-selling book *Liberation Management,* Tom Peters points to the typical design office as a paradigm for future management thinking.

Thus, except to satisfy corporate clients who need the assurance of dealing with a firm where there are several twenty- or thirty-person departments, we have entered an era where personnel management in the design office boils down to working cooperatively with a small number of highly trained and self-aware individuals who, with their brilliant computer literacy, may well be able to do things at which the boss can only marvel. Cleveland architect William Koster puts it much more ominously: "The inability to deal easily with CADD makes practitioners over thirty vulnerable. It can be a dangerous trap."

Management Styles

Most of what architects and designers know about management they learned from the people they went to work for right after graduation. In addition, they are influenced by the way they themselves were raised as children. Finally, there are the popular books that offer "management secrets" in highly distilled form. Out of this largely unconscious melding of sources comes what might be called an executive's "management style."

Let's look at five such hypothetical approaches to directing other people:

- **The Aristocrat.** Distant and intimidating, the manager who operates this way never lets his or her guard down before subordinates, who in turn definitely understand the necessity for formal, subdued behavior in the presence of the "great leader." This is a pattern established perhaps as long ago as the early nineteenth century, when the "patron," in whose atelier Beaux Arts students were privileged to work and study, set a grandiose tone in order to generate suitably noble design solutions. More recently, the courtly atmosphere of Taliesin comes to mind as a relevant example. Today, eminent individuals still can be found worshipping at the altar of Architecture, behaving as royalty before both their associates and their clients.

- **The Bully.** On the other hand, there's the executive, perhaps raised by a father who practiced stern physical discipline, who believes that no one will do a decent day's work if they're not hounded. This driven soul, having watched production in the drafting room pick up after one of his shouting episodes, makes sure that no one on his staff ever dreams of thinking for himself. It's sad, but this inhumane approach seems to work, at least in the case of one eminent New York designer who reduced even his most self-assured employees to quivering robots—and cheerfully admitted doing so, in the name of getting exquisite design work out of them.

- **The Buddy.** Perhaps to compensate for experience under a teacher or employer who bullied his way to perfection, this executive can be too considerate of staff for his own good. This is a person who goes out of the way to be friendly in the office and for some reason needs to win approval from everyone. Unfortunately, if that person is either unsure in technical matters or in executive decision-making, then the possibility of resentment growing among subordinates must be faced. Therefore, management by friendliness that stems from insecurity, rather than from easy self-confidence, may be worse than more stern modes of leadership.

- **The Sphinx.** Sometimes a very shy individual with management responsibility finds that his or her inarticulateness serves as a useful tool. When subordinates

approach such an executive and are uneasy about their request for some reason, the silence that greets them often leads them to say more than they had originally intended, and perhaps to take on more responsibility than they may have wanted. So, in its way, this can be an efficacious management technique. If used constructively, it fosters employee self-investment in the firm's work and facilitates a sense of accountability that generates useful solutions to all kinds of problems, not just in design.

- **The Mentor.** When a manager is mature enough to put subordinates' welfare, both as developing professionals and as human beings, on the same level as business considerations, genuine nurturing is possible. Ongoing interest in those individuals' lives—their families, travel experiences, and cultural pursuits—is expressed in a sincere but dignified way. This avoids the overly familiar behavior of the buddy approach yet conveys the executive's genuine interest. Conversations between the mentor and the less experienced professional are more likely to have fruitful results than talk based solely on topics, such as sports, that are normally shared by peers.

Basics of Good Management

In the design field, executives ought to be as capable technically as those whom they supervise.

A GOOD MANAGER IS AS SKILLED AS HIS OR HER SUBORDINATES

In the design field, it is accepted that executives ought to be as capable technically as those whom they supervise. In fact, emphasis on studio courses in professional schools is justified for this reason. Without wholehearted sympathy for the commitment to design quality that young professionals usually bring to the job, the design executive runs the risk not only of alienating his subordinates but of watching production plummet as their resentment and anger grow. By helping them see how program or budget limitations can be turned to advantage in design, however, the executive gains respect. One problem facing design management at present is its frequent ignorance of and sometimes disdain for the CADD techniques that younger people have mastered. Since these offer so much economic potential for design practice, the wise manager will follow suit as quickly as possible. Nina Hughes is that rare design principal who grasped CADD's potential for herself and then urged her young associates to master it as well.

A GOOD MANAGER NEVER ORDERS ANYONE AROUND

When one is given authority over others, the human tendency to feel justified in pushing people around is well documented. It is very easy to see "them" as lazy, stupid, worthless slobs who are only interested in a paycheck. Sadly, there are design executives who—for reasons that no doubt say more about them than those assisting them—are stuck in this rut. Intimidation—especially of self-aware, highly trained, ambitious young people—works briefly and only when used sparingly and for good reason. In other words, while the rare temper tantrum by the boss will be forgiven in a design office, reliance on it as a management tool is foolish. If there ever was a context in which workers are essentially equal to the leaders, it is in design and architecture. Thus, it makes eminent good sense for the manager to treat staff as he or she would wish to be treated by them. Happily, a number of those interviewed for this book operate on that basis. Lee Stout, Ellen Galland, Tom Forman, Kirsten Childs, and Randy Croxton, among others, expressed a strong commitment to creative collaboration with their design colleagues.

Collaboration is the reality of modern-day design practice, however many schools continue to focus on individual solutions to problems.

A good manager takes the time to explain fully instead of merely saying, "That's wrong; do it this way."

A GOOD MANAGER USES RATIONAL RATHER THAN EMOTIONAL MEANS

If shouting at people who work for you is unproductive, so is emotional manipulation, even if this is a bit harder to prove. The manager who relies on seductive behavior, emotionalism, or even sexist remarks to cajole coworkers into doing tasks they may not relish soon destroys any respect those individuals may have brought to the relationship. Of course, one need not behave in a cold and unresponsive manner in order to practice rational management techniques. Design and architecture graduates generally have no trouble understanding whatever complications a manager may face in a difficult situation; enlisting their cooperation through straightforward explanation and discussion of options usually works fine. It just requires the manager to focus on the problem to be solved before assigning someone else to do it. It's a much better way to get results than by pleading, flattering, or flashing coy smiles.

A GOOD MANAGER ALLOWS SUBORDINATES TO DEFINE THEIR OWN JOBS

When your employees are as talented and self-motivated as most design graduates, the smartest strategy is to offer maximum opportunity for self-management. Obviously each individual's maturity determines the limits of that freedom. The point is, however, to give young persons a sense of responsibility, much as design studio projects do (even though constraints of budget and schedule normally present in office projects usually mandate cooperation with others). As illustrated by two of the larger, more complex firms presented in this book, Chicago Associated Planners and Architects and the Croxton Collaborative, collaboration is the reality of modern-day design practice, however many schools continue to focus on individual solutions to problems. For employees, learning to define their own tasks in terms of what colleagues and even outside consultants are doing is part of the self-management process. Managers will find that relying on an employee's sense of what ought to be done promotes increased involvement, and this, if carefully monitored, contributes to overall office productivity.

A GOOD MANAGER OFFERS CONSTRUCTIVE CRITICISM AND GENEROUS PRAISE

It is possible to direct someone's work in a very economical way by just saying what needs to be done—no explanation and no encouragement. On an assembly line, that may be appropriate; in a design office, it is not. As Lee Stout so clearly expresses it, opportunities for teaching abound through careful explanation of why the logical path an inexperienced drafter may be following on a drawing is leading to problems. That is, a good manager takes the time to explain fully instead of merely saying, "That's wrong; do it this way." Part of that process is to recognize, when appropriate, that the younger person may have gotten onto the wrong track due to enthusiasm or inventive thinking that nonetheless deserves commendation. The vigor that many new graduates bring to their first professional job needs to be sustained and developed, not suppressed by a project manager. If the manager feels threatened by such energy, then that's a different problem altogether.

A GOOD MANAGER PAYS ATTENTION TO STAFF MEMBERS' PERSONAL ATTITUDES

Staying alert to how your employees feel about their jobs is not done by becoming intimate with them. It requires a delicate balance, especially in the informal ambiance of most design offices. Yes, one may well socialize with them and show great interest in their concerns, but there are practical limits to personal involvement that must be observed by an executive, especially when it comes to sexual or financial entanglements. If you don't know what those limits are in a particular situation, ask someone outside the office whom you trust. On another sensitive matter, don't simply shrug off colleagues who are habitually late for work or are often absent. Let them know you are

ASSUME NOTHING

INVOLVEMENT IN
THE ARTS
COMMUNITY
- Installation?
- submit work in shows

Fewer Restrictions

Discuss travel and other
inspirational activities
through slide presentation, etc.

Do some competitions
or other less client/
contractor driven
projects to regain
the liberty of
exploring ideological
visions & experimental
ideas.

Expand vacation
time

Patience
is a virtue

More hours in a day

RISK SOMETHING

TAKE ON NEW
CHALLENGES

BE THOUGHTFUL

One of Glenn
Garrison's techniques
for making sure that
everyone in a firm
he's working with gets
to put in his or her
opinion on how well
the office is doing is to
pin up large pieces of
paper and then ask
them all to write their
comments, more or
less anonymously,
under each category
of the operation that is
being discussed.

concerned, and ask if there is any way you can help. That's usually enough to trigger an emotional flood that, once released, enables everyone to better understand the problem behind the tardiness or absences.

A GOOD MANAGER HELPS COLLEAGUES BE PRODUCTIVE

Because design offices rely so heavily on collaboration, whether organized into departments or project teams, everyone has an interest in working together to maximize productivity. Mike Pyatok has discovered that while he is teaching in Seattle his daily calls to his office in Oakland, during which he talks at length with the entire staff, have increased most individuals' sense of involvement in their work. In addition, he encourages a spirit of cooperation throughout the firm by bringing the entire staff together for meetings that spotlight current jobs, recently completed ones, and even marketing prospects. This kind of communication is essential if these professional-level employees are to have a sense of pride in being part of the business. No matter how hierarchically the firm may be organized, and no matter whose stamp goes on the drawings, everyone in an architecture and design office has a responsibility for the quality of work. That calls for an effort by management to keep up office morale and interest, sponsoring, in effect, an internal public relations program.

A GOOD MANAGER KNOWS HOW TO LET PEOPLE GO GRACIOUSLY

No doubt about it, this is the toughest management task of all. When work-load projections indicate a need to reduce the staff, tough decisions must be made about whom to let go.

These should be based upon a policy or set of criteria worked out previously. Once the choice is finalized, the manager who will meet with the affected staff member should be prepared for an emotional appeal that may be difficult to resist. That executive may express sympathy, but he or she must be decisive. Staff cutbacks—multiple layoffs, especially—must be well planned, because rumors travel through the drafting room at the speed of light, with great potential for staff demoralization. In that case, a candid officewide statement is called for. On the other hand, individual firings based upon inadequate performance, tardiness, or excessive time out of the office sometimes bring relief to people who have grown uncomfortable or unhappy in their jobs.

Managing Everybody Else, Especially Clients

Strictly speaking, management implies control over people, either because you pay them or because you can help them accomplish a goal of their own. Obviously, that covers employees as well as consultants, suppliers, contractors, and construction managers, all of whom are covered later in Chapter Four, Project Management. What matters here is that it also includes clients, because completing the job successfully is something they most assuredly want.

The question of how one defines "client control," however, is a complex one. Some designers believe they must have total control over design decisions—thus essentially overriding the client—in order to get good esthetic results. Others insist that good results are possible only with full client participation in design and everything else. Most designers find themselves muddling along somewhere in between, wrestling with awkward problems posed by client requests while struggling to get other needed information from them, not to mention overdue payments for services rendered.

This form developed by Freya Block is a simple means for documenting basic information about clients, and potentially for making statistical comparisons over time.

CLIENT INFORMATION

I. NAME
 ADDRESS
 PHONE
 BUSINESS
 ADDRESS
 PHONE

II. NAME
 ADDRESS
 PHONE
 BUSINESS
 ADDRESS
 PHONE

III. REFERRED BY

IV. TYPE OF JOBS/SCOPE

V. RATE

VI. SQUARE FEET

VII. ESTIMATED BUDGET

VIII. CONSTRUCTION BUDGET

IX. FURNISHINGS BUDGET

X. DESIGN FEE

XI. EVALUATION

XII. REMARKS

FREYA BLOCK DESIGN, INC. 236 West 27th Street NY, NY 10001 212.924.3813 fax 212.727.8036

Strategic Planning Questionnaire

On the following pages, please identify all personnel in your department or subgroup, including yourself by functional title (i.e. Vice President, Manager, Supervisor, Analyst, Clerk, etc.) and by name (as appropriate) including consultants and temporary personnel. Also, please provide an organizational chart of your department's structure.

In order to facilitate the remodel, some groups may be relocated in phases. Identify only those people who will be relocating to the new office in Orange.

Please provide personnel headcounts and forecasts in the columns provided for the fiscal years indicated. In the equipment/files columns indicate which pieces of equipment occur within each workstation or office, by equipment item name only. Use the provided equipment worksheet form to thoroughly detail the electrical and telephone requirements of each piece of equipment. Provide one equipment worksheet for each type of equipment item; if items are "typical", provide just one worksheet for each different type of equipment.

Name...

Title...

Department...

Telephone Number...

Signature...

Conferencing Needs

How many meetings involve people within your department?

How many people are involved together at any one time?

Should this meeting involve a table?

Can your department share meeting spaces with others? Y N

If you prefer to share with another particular department, please name

What is the average length of meetings?

How often do you utilize the meeting space per week?

Please list any audio/visual equipment you require to support effective conferencing.

...

...

Any other special requirements?

...

...

Reception Area Needs

Does your department require close proximity to main reception?

Does your department receive outside visitors?

How many visitors per week does your group receive?

How many seats for guests or associates should be provided?

Copier/Printer/Shared Equipment Needs

Does your department have a copier? Can it be shared? Y N Y N

How many shared printers does your department support?

Adjacencies

Within your department area, are there any subgroups which need to be located close to one another; please note which subgroups should be near which other subgroups.

...

...

...

Outside of your department, are there other departments or subgroups of other departments which you need to be near; please outline below.

...

...

...

Please outline below your department's security requirements.

...

...

Please outline any special communications requirements: microwave dishes, modem to out-of-state central computer mainframe, etc.

...

...

Please identify the number and size of files located for general departmental use in your department; please check appropriate categories (see attached):

Files (lateral or vertical)	30" 36" 42"	2 3 4 5	Quantity	Future Quantity
......................
......................
......................

Personnel Needs

Functional Title/Name	96	98	00	Type	Equipment/Files
........................
........................
........................
........................
........................
........................
........................
........................

Auxilliary Needs

Functional Room Name	96	98	00	Size	Equipment/Files
........................
........................
........................
........................
........................

end of strategic planning questionairre

Participatory planning is by now an established process for those working with corporate clients. Survey worksheets, such as these developed by JSDA, enable space planners to efficiently gather the information upon which an accurate program can be based.

In fact, when you spell out the issues involved in delivering the completed project, the client is an important player in most of them: budget and schedule, programming, design decisions, project information, project approvals, cost estimates, and, of course, payments to both designer and contractors.

Consider the expectations entertained by most clients (sometimes known as "the three fantasies") as they approach a design professional, especially for the first time:

- the esthetic expectation
- the economic expectation
- the schedule expectation.

In short (and this is only a slight exaggeration), by hiring you the trusting client expects to acquire an object (building, interior, garden, product, etc.) so beautiful that his or her friends will gasp in amazement, one that costs almost nothing and be ready by next week. Is it any wonder, then, that people often feel disappointed with what they actually get when they work with design professionals?

Management of the client begins with the designer's attempt to get the biggest possible retainer or down payment.

Paul Rudolph and Lewis Mumford on Dealing with Clients

In 1959, the Jewell Arts Center designed by Paul Rudolph had just been completed at Wellesley College. As a member of the Master's Class in Architecture at M.I.T., I was taking a course in analyzing and interpreting architectural values with Albert Bush-Brown, our history professor. For my term paper, I was to examine and write about the Jewell Arts Center. It was a good excuse to visit Wellesley, so off I went.

Later that semester, the M.I.T. graduate architecture class was invited to Yale by our peers for a weekend tour of the many "masterpieces" recently erected on that campus. The Friday evening party was held at the studio of Paul Rudolph, then Dean of Art and Architecture there. The studio, which featured a two-story space with a cantilevered staircase that had no railing, was stunning in itself.

But what captured my attention was a beautiful presentation model of the Jewell Arts Center. I decided to study it for differences from what I had seen of the built structure. I began taking notes. What a fabulous opportunity to impress Bush-Brown! Soon I was oblivious to the party swirling around me.

Suddenly I was aware of someone watching me. It was Paul Rudolph. He came over and asked why I was so involved with this model. Naturally, he was fascinated with my assignment and launched into an extended monologue (a number of my classmates gathered around) on how hard it had been, working with a forty-two person client "committee" (faculty specialists, department heads, administrators, trustees, etc.), to pull the project off with even minimal architectural clarity. Now I realize what he meant was how hard it had been to impose his design scheme upon them.

I was amazed to learn of this side of design practice and went back to Cambridge with my first hint of design management. As a result I've never been able to say that I entered the profession "with no clue" about dealing with clients. But it was the only clue, since none of my teachers at M.I.T. ever said a word about them that I can recall.

The only exception had occurred a year earlier when, in one of his lectures as a visiting professor on Frank Lloyd Wright, Lewis Mumford had surprised us by excoriating him for having run off with Mrs. Cheney in 1909, thus violating the client-family's integrity. It was a sobering accusation that I've never forgotten.

Obviously, the more experienced and thoughtful the client, the less likely such fantasies will be clouding his or her mind at the start. Yet it is in the nature of the process that, to some extent, unreal expectations are present in *every* client's mind during the handshake after the contract is signed (let's hope one *has* been signed!).

Clearly, at this moment, management of the client begins with the designer's attempt to get the biggest possible retainer or down payment. No doubt to the lay reader this sounds utterly crass. To the seasoned practitioner, however, it represents the degree of trust and faith the client actually has in the designer; without that commitment nothing can be accomplished, neither literally nor figuratively. The retainer or down payment is the money the designer needs to be able to begin work. Why should the designer begin the project by financing the client's "dreams"?

No matter how designers feel about esthetic control, they would agree that the most essential aspect of "client management" is persuading clients to pay in a timely fashion bills for both design and construction services rendered according to signed contracts.

Financial Management

Profit and the Small Design Firm

Financial management is not just about hoping to make a profit this year; it's about being *sure* you make a profit this year. Believe it or not, this discipline can be applied to small design firms.

Making an annual profit, however small, is essential to the sustainability of any small design firm. During the early years of an office's existence, it is easy to rationalize one's failure to earn more than it costs to run the place. That works for maybe three years. After that, the failure to have at least a little bit of money left over at the end of the year (and not just for Christmas shopping) begins to corrode even the most indomitable designer's spirit. Regardless of how much fun it is to design on your own, sooner or later having your own office can turn into an emotional albatross as the debts pile up and the money to pay them off never quite materializes.

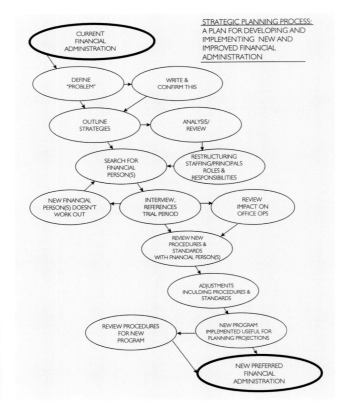

STRATEGIC PLANNING PROCESS: A PLAN FOR DEVELOPING AND IMPLEMENTING NEW AND IMPROVED FINANCIAL ADMINISTRATION

Glenn Garrison's strategy for improving the financial management of a small design firm requires focused and dedicated attention from its principals, preferably with the guidance of an accountant or other business consultant in order to make sure that the hard questions—the ones that habitually never get asked—are addressed and resolved.

There's nothing like having strong and readily accessible credit to provide relief from constant concern about unpaid bills. Needing to arrange repeated short-term loans to meet pressing expenses is a rotten way to spend your professional life, let alone your life as a human being. Eventually, as many of the designers and architects profiled in this book have done, you come to realize your value in the marketplace and, therefore, to insist that your efforts be appropriately compensated.

The reality is that a design firm is no different from any other kind of business: If it doesn't earn some sort of profit, the enterprise will not prosper and, very likely sooner than later, will close its doors for good. "Profit matters enormously," asserts Lee Stout. "That's what allows my firm to continue to exist." Yet, do most designers or architects understand this when they bravely set up their first studio? We all know the sad answer to that question. In part it is the result not just of inadequate business training offered by design schools but also of their culture. This esthetically-biased ambiance willfully ignores the future commercial challenges students will face, even though most students expect to have their own practices. There is little exposure given in the classroom to the demands of operating a small business (virtually all design practices meet the government's definition of a "small business," that is, one having fewer than 250 employees).

In addition, these well-known fantasies of architects and designers tend to obscure for them the realities of business:

- The focus on the designer as a "star" whose instant fame will insulate him or her from pragmatic considerations.
- The passion that architects and designers have for elegant surroundings and objects that, even when purchased with trade discounts, require a healthy income.
- The well-known self-delusion about the market's response to design talent: "If I've got a dramatic design philosophy, then prospective clients are certain to recognize it and flock to me."
- The tendency of architects in particular to want certain commissions so badly that they practically give their time away to secure them.

All of these weaknesses contribute to a situation where young people entering our professions are almost totally unaware of the financial minefield into which they, aspiring practitioners, are venturing.

What It Takes to Finance a Design Practice

Two architects are chatting at a party: "What would I do with a million bucks?" one responds to the other's idle question. "Why, I guess I'd just keep on practicing until it was all gone." The truth is that ready access to outside income, such as a trust fund or a working spouse, may well be the only way to guarantee that your office will flourish. While most of those interviewed acknowledge the importance of a working spouse to their practice, no one claimed the benefit of inherited money. Unfortunately, the other options for acquiring capital aren't nearly as easily achieved as these. Basically they come down to borrowing it, having another business that subsidizes the office, or, possibly, supporting the practice off of the income from real estate developed along the way.

For most architects and designers, the concept of "capitalization" is a mystery. Perhaps they've heard of other businesses operating with a certain level of available capital, but few connect that idea to running a design practice. So it's not inappropriate to state here

For most architects and designers, "capitalization" is a mystery.

A Five-Phase Colloquial Assessment of Financial Viability: How's Your Business Doing on This Scale?

Getting Rich
Making Money
Making a Living
Barely Making It
Going Broke

Source: William Koster

that *capitalization* is simply having assets against which a business or institution can borrow when necessary in order to finance its work or create more wealth. In turn, *collateral*—money in a bank account, property, or some form of credit—is that which bankers or others are willing to accept as a guarantee that whatever loans they make will be covered in case the borrower can't repay the debt as promised. A business's *demand* for capital is that portion of its annual expenses not covered by reliable sources of income. An important financial management issue is how much a business must pay in interest to activate, or borrow against, its capital.

There are two ways to look at how much capital is required for a design practice. The first one, qualitative in nature, depends on how far away from desperation you want to operate. In other words, having no prearranged capital is fine if you don't mind running madly around begging clients to pay their overdue bills, as Frank Lloyd Wright had to do when he was getting ready to sail off to Europe with Mrs. Cheney in 1909. Or else you can calculate how much money you'll need in order to pay the rent and meet payroll for thirty days, or maybe six weeks, and that's your necessary capital. Not a whole lot.

The other, more conservative, way to determine how much capital is necessary is to consider your business's financial needs over a full year. Take your annual cash flow (total amount of income minus all expenses), perhaps based on the average of several recent years; take the worst-case accounts-receivable scenario (money owed to you) that you've experienced and perhaps increase total cash flow a bit for comfort's sake. That's how much money you should be able to get your hands on readily, thus avoiding the emotional self-abuse that accompanies short-term borrowing.

This figure is no doubt considerably bigger than your previous calculations, probably disturbingly so. But if you intend to run your practice, rather than having it run you, this is the amount of capital you should set out to establish for the firm.

Capital Formation and Maintenance

William Koster insists that a working spouse is the only realistic possibility that today's architects and designers have for creating capital. Several of those profiled here referred to a supportive husband or wife as crucial to allowing their business to exist; Freya Block, Ellen Galland, Nina Hughes, Mike Pyatok, and Judith Stockman all gratefully recognize a debt to their spouses for allowing them to practice in a way that eliminates the need for accumulated capital and, as a result, much of the need to make a profit. Pyatok, practicing in the low-income housing field (notorious for how badly and how slowly its design specialists are paid), is particularly straightforward about the crucial financial role that his wife, Fern Tiger, plays in enabling him to continue doing this badly needed work. He also notes that his tenured professorship at the University of Washington helps to keep his office going as well.

Ellen Galland's firm, Rockwell Associates, carries out its daily operations in this storefront setting, a former bakery in Evanston, Illinois, that she purchased and renovated with a partner. It provides her practice with low-rent space while income from the rest of the building helps to stabilize its finances.

Real estate development for one's own account is actually a practical alternative for architects and designers. Chicago Associated Planners and Architects (CAPA), Tom Forman's firm, has used this approach to provide a substantial operating cushion for its professional departments. CAPA owns not only its own three-story office building but many other properties (primarily housing) that furnish income to the business. In this case, their senior partner and owner, Ed Noonan, has devoted a great deal of his professional time to acquiring and operating this portfolio. Architect Ellen Galland, having made a much less ambitious commitment to building development, nonetheless counts on the income from the building she renovated several years ago with a partner to stabilize the fortunes of her firm. Her office pays its "landlord"—the real estate partnership—a modest $450 each month toward rent for a substantial amount of space; in turn, the easily affordable rent benefits her other business, the practice. There are disadvantages to this arrangement, of course, since it introduces property management complications. However, both Forman and Galland seem to feel that these are readily accommodated within the existing structure of their firms.

Setting up and operating multiple businesses is another option that may be considered by an established firm. Garth Sheriff, the Los Angeles-based architect, sees himself as simultaneously involved in several different areas, not all of them necessarily income-producing ventures. He has created SYNTHESIS, an outfit that specializes in building "home theaters"— residential film-screening facilities—for Hollywood moguls. While this company has no direct relationship to his firm, one of its favorite architects just happens to be Sheriff + Associates.

Actively saving money out of your current income is obviously an alternative, although not an option Americans seem to favor these days. Janice Stevenor Dale is an exception; she began to capitalize her own firm while still working for another office by socking away a sizable portion of each month's paycheck. Recently, contemplating a need to move to a new and larger space, she recapitalized; this time it was her firm, JSDA, that made regular deposits. Another exception is Lee Stout, who considers himself a "compulsive saver."

For the student who looks forward to having his or her own office someday, the prospect of continuing to live simply for several more years while putting away as much income as possible from an apprenticeship job may seem unacceptably stringent. Furthermore, the demand nowadays upon graduates to pay back student loans as rapidly as possible makes the challenge even more daunting. Still, self-investment is the surest way to achieve what is every design student's dream.

Whatever else may be said, long-term reinvestment of a firm's profits is necessary to enable a practice to flourish. In the early years at least, any profit realized needs to be plowed back in, that is to say, turned into "independent capital"—money you can access without asking a banker for permission. It takes a lot of discipline to keep hands off it when emergencies strike, but it's essential that you do so. In any case, these funds make the best collateral when applying for a short-term loan. And whatever interest you then pay is deductible as a business expense.

Borrowing Money and Meeting Debt Obligations

Ever wondered why bankers don't line up hoping to lend money to design practices? It's not that they don't like talking to us. (I remember a small-town banker who genuinely seemed to enjoy my frequent visits—each time seeking a short-term loan to keep my rural architectural practice, and my family, afloat.) We're unattractive to money lenders for the same reason our professions are so easy to get started: We have no tangible assets. No substantial machinery to repossess, no inventory to auction off, no contracts that might be sold to others. Just drawings, specs, and dusty design-study models. On top of that there's our unpredictable earning pattern. Those designers and architects who have recurring or ongoing commissions—bread-and-butter clients—seldom call on bankers for help. The rest of us, unfortunately, usually can't do much more than tell the lender, "It looks like it's going to be a good year." And often, when we have a contract that could generate income over the next year, we can't be sure when the job will actually go ahead and when we can bill for the contract-document phase, traditionally the biggest chunk of the fee.

Bankers are always being accused of lending money only to those who don't need it. But look at that from the lender's point of view: Banks are in business to earn interest on the loans they make. If it's reasonably clear from the start that a prospective borrower will have difficulty repaying the loan, why make the deal? Don't forget, there are federal regulations that constrain banks from making questionable, especially unsecured, loans. When Tom Forman talks about working with accountants in order to "show good paper to bankers and real estate investors," he's expressing the necessity for documentation that convinces money sources the firm is operating on a profitable basis and can therefore readily manage debt obligations.

Suppose, based on your record of promptly repaying prior short-term loans and on your general reputation in the community, that you've managed to get a line of credit. Fabulous, all your troubles are over. Wrong. Roberta Washington is a practitioner who learned that the hard way. She knew it rationally, but only after beginning to draw on a $30,000 credit line did she really came to understand that the true cost of the loan is a lot more than its face value. The challenge to an already underfinanced business—to pay back both principal and interest on such a loan in an orderly fashion—can be devastating.

Everyone recognizes how hard it is to put money aside from current income to meet debt obligations. First of all, regular repayment of formal debts like bank loans is essential. When you get the check from the bank, you might as well just deduct the first month's payment and send it back immediately. However you have been handling your bookkeeping

up to now, it's time to adopt conservative accounting practices and stick to them. If you can't do that easily, then hire a part-time bookkeeper who can, and follow the bookkeeper's advice, no matter how painful it is. Should a windfall come along, don't even think of "profit"; use the money to pay off those debts! Who can enjoy designing with such a burden of debt poisoning the mind?

The Business Plan: Crux of Sound Financial Management

Having evoked the horrors of badly financed design practice, it's time to discuss the solution: the business plan. It is rare that design firms have a plan, so if you've never heard of this concept, don't be surprised. On the other hand, for professions so deeply committed to planning for the welfare of others, it's distressing to recognize how little we care to apply that principle to ourselves.

When Freya Block was taking a continuing education course with American Women's Economic Development (AWED), she had to prepare a business plan for her practice, but she soon put it aside. It's no wonder that we resist thinking ahead about how our firms might develop. We can't be sure when the next job is coming in, let alone trying to predict how things will be going a year from now. The uncertainty of project acquisition seems an insurmountable obstacle to predicting the future health of our firms.

In the group of small design firms profiled in this book, William Koster is really the only practitioner who makes rigorous use of a business plan. He is very clear that managed growth is an essential function of the design executive. To him, that means preparing and updating the firm's business plan regularly.

While your business plan may vary in its details, essentially it contains projections of the firm's expected income and its expenses over the next one or two years. This plan is a comprehensive spreadsheet that tries to predict every aspect of your firm's finances. It attempts to state amounts of income that can be expected over the chosen time span, based upon premises that you determine. As a result, the plan also helps you to anticipate what levels of expense are possible after desired profit percentages (perhaps no more than five percent) have been deducted. Yes, profit must be taken off the top if this process is to be meaningful.

The business plan concerns itself less with the specifics of individual commissions that you may be pursuing than with their potential dollar value. Thus, it translates marketing specifics into income projections, just as—on the expense side—it turns fixed obligations, promotional initiatives, staffing patterns, space needs, equipment acquisition, and so on into figures that can be weighed against income possibilities. The latter, of course, are the most difficult to predict.

To accomplish this, the business planning process draws heavily upon analysis of how and when money has come into your firm in the past. For instance, on the average, how long has it taken for fees from each stage of multiphase contracts to be received? What percentage of design contracts signed have been carried through to completion? It asks how much it costs you to operate your office—per employee, per hour, per project, etc. Although your accountant can probably carry out such an analysis most efficiently, only the firm's principals can decide what it means for their future.

William Koster has figured out a system of probabilities that enables him to make three levels of income prediction: his *best-case* scenario (the most optimistic); the *worst-case* picture; and the *most likely* one, somewhere in the middle, based on his experience of how events and forces beyond his control have actually affected his business in the past. He does this for up to three years into the future, adjusting the results every quarter or

The business plan concerns itself less with the specifics of individual commissions that you may be pursuing than with their potential dollar value.

so as emerging reality shapes and alters his data. He then shares this information with his board of directors, who help him plot the firm's next marketing steps.

He admits that the act of projecting future growth and/or development can create illusory results; it is full of opportunities for overly optimistic conclusions. But by accepting the possibility that almost everything can go wrong, he is always aware of how bad things could turn out. With that in mind, Koster has a pretty good idea of what his most conservative financial course of action should be; by never allowing expenses to exceed that projection, he consistently avoids the short-term consequences of what for other small design firms might be "unpredictable disasters," those requiring wholesale staff reductions practically overnight.

In fact, one of the important positive results of such planning is that it creates an atmosphere of job security in a firm that helps young associates to flourish. While others may not practice such elaborate projection, many of those principals interviewed made clear that providing their colleagues with stable future prospects was of great importance to them. The question therefore remains: Would it not be wise for small-design-firm principals to institute and maintain a program of business planning to make sure that the prospects of everyone in the office, especially their own, are assured? Consider seeking the answer in *Creating Business Plans for Dummies,* a straightforward guide by Paul Tiffany and Steven Peterson (see the Select Bibliography).

Obtaining Professional Advice on Financial Management

As designers and architects, we are part of a large and prosperous community of professionals whose common interests are significant in number, despite our various disciplines. Our social and civic lives tend to symbolize that affinity, as we find ourselves attending religious and service organization meetings, school and municipal governance sessions, parties and sports events with psychologists, lawyers, physicians, and accountants, among many others.

This kinship naturally leads to exploring useful and mutually beneficial business relationships. Since a large proportion of these folks may well engage in real estate-related investment activities, both residential and commercial, they are inherently interested in your services. At the same time, in addition to promotional opportunities, your social and community activities offer you a unique opportunity to select and engage (perhaps even through bartering) competent yet compatible financial advisors for your firm. It's a great way for people like us to overcome those deep-rooted inadequacies in financial management.

Obviously, the field most germane to this need is accounting. Of course, many small design firms already have formed productive relationships with accountants, especially regarding preparation of quarterly and annual tax reports. It is difficult nowadays to run even a kitchen table-based business without professional tax advice. Even so, there are many single-person design and architecture studios still doing their own taxes, no doubt in a desperate attempt to save money. For them it is entirely possible that a tax accountant will save them more than the fees charged. Besides, it is an important first step toward effective financial management.

Speaking of tax reporting, consider Schedule C, the "Profit or Loss From Business" form for sole proprietorships, which is included in the Internal Revenue Service's 1040 package. For the designer or architect who practices alone or with a few employees—as the vast majority of us do—Schedule C is a godsend. It is an opportunity for the small design firm to write off almost all of its operating expenses, that is, to deduct them from its before-tax income. This is not blind altruism; small businesses are the backbone of

For the designer or architect who practices alone or with a few employees—as the vast majority of us do—Schedule C is a godsend.

By carefully documenting what you spend over the year, you should be able to substantially reduce your business's taxable income, perhaps even show a deficit.

our national economy, and without such a provision, which minimizes the effect of double taxation on them, many would not continue to operate. By carefully documenting what you spend over the year, you should be able to substantially reduce your business's taxable income, perhaps even show a deficit. Deductions include contributions to Keogh and other profit-sharing plans. If your firm does make a profit, of course, then you are subject to self-employment tax (Schedule SE). Ask your accountant for guidance on documentation techniques that meet IRS standards.

Beyond help with tax forms, the accountant can offer guidance on matters of cash flow and credit maintenance. It turns out that almost every business has financial problems, because few who go into business do it with adequate training in handling money. You will no doubt learn that the troubles you bring to your accountant are not unique to architecture and design firms. Once an analysis has been made, the solutions that are likely to be offered probably could be applied to almost any professional or service outfit. And they will be answers already proven, many times over, to work for a small business like yours.

This brings us back to the business plan. Clearly, once a firm's bad financial habits have been identified, the accountant will urge action to correct them not only for the moment but permanently. How better to do that than to draw up a business plan with his or her help? This is the most valuable contribution an accountant can offer you: assistance in projecting the future development of your firm. If you could do it yourself, you'd probably go into the business of advising other professionals, as Glenn Garrison has. Furthermore, this professional will keep after you to review and update your plan every time a tax document is due, even if you forget about it. The next time you talk to your accountant, you might want to discuss this with him or her.

Accountants are not the only ones from whom to seek financial advice. Tax attorneys are a thriving breed, especially for businesses with more complex—or what might be called "creative"—tax-reporting needs. Almost any lawyer, particularly those who work with small businesses, can open the average architect's eyes to the basics of managing money. Randy Croxton has had ready access to an attorney since his practice began, a resource that he has used largely for informal consultation on contractual matters. Early on, this lawyer advised him to push "for as large a retainer as possible and when bills sent to the client aren't promptly paid, stop work."

Experienced small-business owners in virtually any category are another source of information on practical finance. Few of us ever think to consult former clients for whom we may have designed commercial facilities in the past. It's been my experience that often these business veterans look at the way we operate our practices and bite their tongues rather than upset us with their incredulous reaction. Yet when approached respectfully, they are thrilled to comment on how we might get our financial act together. These individuals, often grateful for the pleasure our work has given them, may also be happy to introduce us to colleagues in their business circles, an entirely new pool of prospective clients, as detailed in the Chapter One, Practice Management.

Professional Insurance and the Small Design Firm

In the eighties, when the cost of professional insurance was skyrocketing, it was the number one topic of discussion among small-office principals. That portion of their fixed expenses was simply out of control, and many feared that if things continued in the same direction, they would have to close their offices. The good news is that those days appear to be over; some of the firms interviewed for this book report that the cost of their insurance has dropped steadily since the early nineties.

Part of the problem that caused premium prices to rise steeply during this period was that only a limited number of insurance companies were willing to write policies for architects and designers. It has taken time, reports Jan Van Arnam, for insurers to realize that the number of claims upon them is much lower than feared back in the eighties. Premiums are lower now, too, because many firms have had no claims filed against them. "It's cheaper now," adds Cindy Harden, "since there are fewer baseless lawsuits, and because some states have relaxed their rules. Besides, the AIA is trying to shorten the period during which architects are liable."

In discussing its policy options with its broker, Chicago Associated Planners and Architects (CAPA) discovered that, since approximately half of its work is in the planning field, their premium could be reduced significantly. CAPA's Tom Forman finds consulting with his insurance broker on a variety of matters, including contract formulation, to be one of the most effective sources of financial management guidance. Insurance companies, he finds, "are finally getting around to training us, their clients. It's a matter of managed risk."

While availability of insurance has eased considerably for architects, interior designers still have very few sources of professional insurance. Janice Stevenor Dale feels that insurers do not fully understand that the professional scope of interior-design practice is much broader than in the past. When they do, she says with a smile, "I'll happily pay the larger premiums that will surely result." At the moment she is getting her policy through the International Interior Design Association (IIDA); coverage is also available through the American Society of Interior Designers (ASID).

For small design firms, the basic professional coverage is Errors and Omissions (E&O) insurance, generally for a maximum of $1,000,000. Liability insurance and Worker's Compensation are the most frequently chosen additional coverages, according to several firms interviewed. Nina Hughes recommends, in addition to E&O renewed annually, an umbrella or "commercial package" that includes general liability insurance and a "completed projects clause," which protects a firm from lawsuits brought by users of facilities it has designed in the past. She can also easily obtain a rider on the commercial package to cover showhouse installations. Consulting a qualified insurance broker, however, is the only way for each firm to determine how best to meet its particular needs.

In fact, not every small design firm chooses to carry insurance. Although Garth Sheriff carries general liability insurance, his firm does not have E&O. Instead, he relies on a clause in his standard contract that limits his liability to the amount of his design fee. In addition, by putting all of his financial resources into his only residence, he is protected from losing everything through a lawsuit. To Garth, "money spent on insurance is money taken from profits." Some designers feel that having no insurance is insurance against being sued. In other words, clients and others will think twice before commencing litigation if they understand that a big settlement in their favor is not likely to result from it.

It is worth noting that most lawsuits or arbitration actions involving designers and architects are caused by disgruntled clients. Either they are withholding final contract payments and the professional is suing for recovery, or the owner is seeking recompense for what is claimed to be "unprofessional behavior." All too often this comes down to the designer's failure to visit the job often enough during the contract administration period or, during that time, to respond adequately to the client's emotional needs. This is definitely an argument for sustaining a "client-centered" practice.

In my own experience of assisting other architects to prepare for it, arbitration tends to work in the professional's favor. When all parties see documentation for a typical job—design studies, presentation materials, drawings, specs, memos and other correspondence—gathered together on one or two tables, the thoroughness of standard design practice is brought forcefully home to them.

Most lawsuits or arbitration actions involving designers and architects are caused by disgruntled clients.

Arbitration tends to work in the professional's favor.

Yet how much wiser it is to accomplish that effect by simply paying proper attention to your clients (especially if you don't like them) while their project is under way. Almost all litigious complications can be forestalled by sensible client management—giving your clients the same considerate service you yourself would expect from a professional upon whom you are depending. Remember, no amount of insurance can insulate you from the psychological discomfort and loss of time that accompany the simplest of legal proceedings.

Partnerships, Professional Corporations, and Other Options

For designers and architects, the decision to form a partnership or other type of joint practice appears to be a matter of taste. Without denying the benefits of partnership, most of those professionals who remain sole practitioners evidently do so out of a strong belief that it is best not to complicate one's business by sharing it with someone else. Some may have come to that conclusion as the result of ending an earlier partnership. In any case, it is fair to say that a majority of small design firms are individual enterprises, prospering more or less to the degree the owner succeeds in finding commissions and carrying them out efficiently.

Even so, it may be argued that shared responsibility for a business as demanding as design or architecture has a potential that deserves examination. What does a partnership actually entail? It is certainly simple enough to begin one. Signing an IRS form that names the partners and specifies their share of the profits and losses, as well as completing municipal registration when necessary, is all that is required. On the one hand, partnerships offer increased capital strength and multiplied energy for pursuing new commissions. On the other hand, they necessitate spending limits upon partners and complicate the firm's decision-making process. From a management perspective, however, these two constraints may not be disadvantages.

Design-practice partnerships are sometimes formed to put a junior professional into position to eventually take over a senior person's established business. In that case, a more elaborate agreement is appropriate. The same applies when one partner is supplying most of the new endeavor's capital and thus stands to suffer substantially greater loss than other partners should things fail to work out. In other words, except in the most modest circumstances, a written agreement prepared in consultation with an attorney and/or an accountant is advisable when making such a commitment.

There are now several legal instruments for practice organization that offer either or both limited personal liability for licensed professionals and the tax benefits of a general partnership. Beginning with Texas in 1991 and now offered by at least thirty-six states, Limited Liability Partnerships—L.L.P.s (and, to a lesser degree, Limited Liability Companies, L.L.C.s)—are proving attractive to architects and designers, whether the latter are licensed or not. Lembo-Bohn, for example, began as a general (or basic) partnership and eventually became an L.L.P. before it was dissolved in 1996. Similar to a standard corporation, an L.L.P. must file a simple certificate of formation that does not require it to reveal details of its structure, organization, or operations. In an article published in *Architecture* magazine (April, 1996) entitled "Limiting Your Liability," attorneys Barry LePatner, T. F. Hegarty, and J. A. Hill note, for instance, that depending on the state in which the business is primarily located, individual memebers may not be liable for debts or other obligations of the partnership. At this early stage in the use of L.L.P.s by licensed professionals, the amount and degree of liability varies from one jurisdiction to another, but it is always less than that of a general partnership; let your attorney and/or your accountant be your guide.

For some firms, the relatively old-fashioned S corporation is still the best bet. Freya Block, Laura Bohn (after her partnership ended), and Lee Stout, all interior designers who don't stamp drawings, chose to organize their businesses as type S corporations, a possibility available to small businesses like design firms. Glenn Garrison, an architect who offers consulting services to other architects, also has set up his firm as a type S corporation. The S corporation is unique in that profits—like those in a partnership—are taxed only once. In addition to avoiding the corporate income tax, shareholders can claim corporate losses on their personal income tax returns. *The Architect's Handbook of Professional Practice* (12th edition, AIA, 1994) provides detailed information on S corporations in comparison with other more common forms of business organization.

Finally, the professional corporation offers shelter from financial loss that, in years past, was unavailable to licensed professionals. As the law stood formerly, an individual certified by a state as meeting appropriate standards to practice one of the recognized professions was not allowed to compromise his or her responsibility as an accredited expert in any way. Now professional corporations have been recognized in most states. This type of business organization permits professionals, for normal commercial purposes, to protect themselves from bankruptcy without impairing their obligations under state licensing laws.

For architects and licensed interior designers, the professional corporation is an alternative to partnership; in most states, such a corporation may be organized by those licensed there to practice their profession. In a two-step process, the standard corporation papers are filed first, then application is made for professional status. It can take quite a while, and is definitely to be undertaken only with legal and accounting guidance. This is a full corporation with every dollar of profit taxed at the highest rate (thirty-six percent), yet it is the only way that professionals, should they desire to incorporate for other reasons, can do so.

Janice Stevenor Dale, a certified interior designer in California, is required by state law to stamp her own drawings. Thus, her firm could be set up as a professional corporation, which protects her assets and also—since she often deals with corporations—maximizes her clients' perception of her business standing. In this case, she fills all three of JSDA's corporate offices.

Croxton Collaborative is an interesting example of one firm's progress in its business status from sole proprietorship to professional corporation. Founded in 1978 by Randy Croxton as its principal, the firm's name was intended to convey an approach to design, not a way of organizing it commercially. After 1985, after Kirsten Childs joined the firm as a major presence there, Croxton Collaborative appeared to become a partnership, even though under New York State law it is not possible for a licensed architect to form a partnership with an interior designer. In 1997, after three years of preparation, Croxton activated it as a professional corporation. He wished to facilitate ownership transition and to insulate participating individuals from non-professional liabilities, such as leases on office space and equipment, and other business obligations.

Electronic Media and Financial Management

Here's where the computer has utterly transformed architectural and design practice. Virtually every firm interviewed benefits directly from the magic of computerized financial management. Of all the aspects of running a small design office, this is the one most revolutionized by electronic media over the past decade. Thanks to the computer accounting matters take much less time (a big plus), and design managers can control and even accurately predict productivity up to a year in advance.

BILLING RECORD FOR _____

invoice #	invoice date	description/ hours @ rate	category subtotal	invoice total	running balance

CNTRCTS.XLS

MONTHLY EXPENSE RECORD

employee:

period:

job	transpo	gas	food	supplies	photo	other	total

EXPNSREC.XLS

Something as straightforward as this form (left) for keeping track of when and for what amounts your clients have been billed can help to keep a small design firm's accounts in order, saving precious time when—perhaps years later—questions are raised about how its income was generated. Computerized bookkeeping offers a wide variety of forms (right) for documenting cash flow in the small design firm. One example is this "monthly expense record" chart that enables a project manager to keep an accurate account of the reimburseable costs associated with his or her current jobs.

The interviews in Chapter Five describe in detail how different firms use the computer for financial management. The following bookkeeping and accounting functions common to small design firms are now computerized:

- Timesheet processing, including billable-to-non-billable time ratios for all staff members, which simplifies productivity analysis.
- Payroll preparation, with checks written either in-house or, to further facilitate the process, by a payroll service (i.e., Paychex, ADP, etc.).
- Client billing on a monthly basis, including furniture-purchase invoices and, if required, detailed documentation of progress on their project.
- Monitoring of overhead, including expenses that small offices sometimes fail to manage adequately, such as petty cash and reimbursables.
- General bookkeeping, which includes the option of sending the accountant a disk of bookkeeping results for monthly or quarterly analysis and tax statements.
- Expense and income projections, including a range of possible income streams over a period of six to twenty-four months.
- Monitoring of marketing progress, including automated tickler files that remind you when it's time to make follow-up calls.
- Preparing reliable fee proposals, especially when they are based upon carefully kept records of income from past jobs.

According to architectural business consultant Glenn Garrison, the AIA began developing its financial management system in 1975. As part of that project, the Cambridge, Massachusetts, firm of Harper & Schuman was engaged to create computer software by which large firms might put the AIA system to use managing their affairs.

This method was so valuable, Garrison recalls, that for many years large high-profile firms like Kohn Pedersen Fox sent their accounting records to Boston for processing by Harper & Schuman, where they were then stored in a large computer.

Today, remote (and slow) processing like that has been superseded by a new generation of financial management programs (MS-DOS) based on Harper & Schuman's model ' but installed in powerful minicomputers located right in the firm's office. Both H&S and Semaphore, Inc., among others, now offer software that fulfills the comprehensive project and financial management needs of medium to large architecture firms, based on the AIA system. As Garrison points out, financial management in most design firms is actually a function of project management, because "offices are project-driven, after all."

Nevertheless, use of the AIA system is not widespread among firms with fewer than ten employees—eighty-six percent of all architecture practices in 1993. "To my surprise," says Garrison, "I find that many small design offices know nothing of the AIA's system. Instead, they put together various programs to satisfy their own management needs." When asked how a one- or two-person practice ought to evaluate management software it may be considering, Garrison says that the first criterion has to be price, then an assessment of its project load—"You may not need all the firepower that comes with the most sophisticated packages." In any case, he suggests that consultation with an informed expert makes sense before making any hardware or software investments.

GENERAL PURPOSE, LOW-TECH FINANCIAL MANAGEMENT PROGRAMS FOR SMALL DESIGN OFFICES

Program	Source	Function	PC/Mac Compatible
Excel	Microsoft	General-purpose home or small-business spreadsheet and graphics program	MS-DOS or Mac
Lotus 1-2-3	Lotus	General-purpose spreadsheet program	MS-DOS or Mac
Quicken	Intuit, Inc.	General-purpose family or small-business bookkeeping program	MS-DOS or Mac
Quickbooks Pro	Intuit, Inc.	Many business functions for the small design office, including cash-flow forecasting	MS-DOS or Mac
Timeslips	Symantec	Straightforward approach to automating timesheets, including invoice preparation capability	MS-DOS or Mac
ACT!	Symantec	Monitors marketing progress and includes tickler-file functions	MS-DOS or Mac

PROFESSIONAL-LEVEL ACCOUNTING PROGRAMS FOR DESIGN FIRMS

Program	Source	Function	PC/Mac Compatible
Harper& Schuman/ CFMS	Harper & Schuman, Inc., Cambridge, MA	Covers all record-keeping, invoicing, auditing functions	MS-DOS
MacArchitect	Arne Bystrom, FAIA, Seattle, WA	Specifically intended for use by small offices	Mac
Sema4	Semaphore, Inc., NYC	Comprehensive recordkeeping for small to medium design firms	MS-DOS
Wind2	Wind2 Software Inc., Fort Collins, CO	Multifunction accounting program plus business and project management capabilities	MS-DOS
Project 98	Microsoft	General project management capabilities	MS-DOS or Mac

Planning for Retirement

Is it important for designers and architects to be able to retire? Absolutely! Even though many of those profiled in this book insist that they're going to die hunched over the drawing board, it is a fully relevant financial management consideration to give yourself at least the *choice* of retiring when you reach the age of sixty-five or seventy. That applies not only to principals but to longtime associates who, upon reaching retirement age, deserve to have more than Social Security to count on after putting in years of devoted service with a small firm. Those who laugh off the idea of retiring—recalling that Frank Lloyd Wright was as busy as ever at ninety-two when he went, or that Louis Kahn died in the men's room at Penn Station in New York on the way home from a site visit to his incomplete parliament building in Dacca, Bangladesh—had better think again.

The major problem that the average designer or architect faces in later years is that his or her client base tends to dry up. When you think about it, a professional's clients tend to be about the same age as the person who serves them. Eventually those folks, who *have* been looking forward to retirement, move to a warmer climate and no longer call up with new assignments. Either that or, before they can retire, they die and are replaced by younger executives who have designers their own age in mind to do the new work.

In addition, there's the very real matter of debilitating illness that makes it difficult for us to be productive, no matter how much we might desire it. Any number of

Deciding Which Plan is Right for Your Business

In determining which retirement plan is most appropriate for your business, you'll want to consider a few key questions, including:

- Do you want a plan that is solely employer funded or one that is funded by employer and employee contributions?

- What percentage of compensation do you and your employees want to be *able* to contribute each year?

- How much does each plan require you to contribute to the plan on behalf of your employees?

- Are you willing to assume some additional administrative responsibilities and costs in exchange for more flexibility?

To help you compare the answers to these questions for all your plan options, we have developed this chart. Review it to see which plan combines the features that are most appropriate for your business.

Features	SEP-IRA *(Lower Cost Less Administration)*	KEOGH	SIMPLE-IRA	401(k) *(Higher Cost More Administration)*
Eligibility	Any self-employed individual, business owner, or individual who earns any self-employed income	Any self-employed individual, business owner, or individual who earns any self-employed income	Businesses with 100 or fewer eligible employees	Any type of public or private company; typical for companies with 25 or more employees
Key Advantage	Easy to set up and maintain	Highest contribution maximums	Salary reduction plan with less administration	Features such as vesting schedules and loans
Funding Responsibility	Employer contributions only	Generally, employer contributions only	Funded by employee elective deferrals and employer contributions	Primarily employee contributions and optional employer contributions
Annual Contribution Per Participant	Up to 15% of compensation, up to a maximum of $22,500 ($24,000 in 1997)	Up to 25% of compensation, up to a maximum of $30,000	*Employee:* Up to $6,000 per year (indexed) *Employer: Either* match contributions up to 3% of employee's compensation (maximum $6,000), can be reduced to as low as 1% in any 2 out of 5 yrs. *Or* contribute 2% of each eligible employee's compensation, up to $3,200	*Employee:* Depending on plan design, could be up to 20% of compensation, up to a maximum of $9,500 *Employer/employee combined:* Up to 25% of compensation, up to a maximum of $30,000
Access to Assets	Withdrawals at anytime. Withdrawals are subject to current federal income taxes and a possible 10% penalty (if the participant is under age 59½)	Cannot take withdrawals from plan until a "trigger" event occurs. A 10% penalty may apply if you are under age 59½, or under age 55 and separated from service.	Withdrawals at anytime. If employee is under age 59½, withdrawals generally may be subject to a 25% penalty if taken within the first two years of beginning participation and a possible 10% penalty if taken after that time period	Cannot take withdrawals from plan until a "trigger" event occurs. May offer loan provisions and allow withdrawals in certain hardship situations (Hardship withdrawals may be subject to a possible 10% penalty if participant is under age 59½.)
Vesting of Contributions	Immediate	May offer vesting schedules	Employee and employer contributions vested immediately	Employee contributions vested immediately; different vesting schedules available for employer contributions
Administrative Responsibilities	No employer tax filings	Form 5500	No employer tax filings	Form 5500 and special IRS testing to ensure plan does not discriminate in favor of highly compensated employees

Architects and designers who resist planning for their retirement do so in spite of a wide variety of programs available to facilitate such decisions. This chart, courtesy of Fidelity Investments, spells out four of the most popular ones, emphasizing the advantages of each to the small business owner.

> **T**here are a lot of reasons to provide yourself with the option of retirement, even if you turn out to be lucky enough to "exit sketching."

diseases—including arthritis, which can turn drawing into agony—can get in the way of our romantic intention to die with our designer boots on. Short of that, we must take into account the reduced level of energy that tends to come to most people in their early seventies and, with it, a loss of enthusiasm for the sort of pressure under which most design projects are produced.

In other words, there are a lot of reasons to provide yourself with the option of retirement, even if you turn out to be lucky enough to "exit sketching." The only realistic course is to do what most other self-employed people having been doing for years: establish one or more retirement funds and salt away as much as you can during these "peak income years," however ironic it may seem to consider what you may be earning now as the best you're going to do. Here's another item that calls for improved financial management, because the money to be invested will come essentially from your firm's profits.

There are a number of federal programs for small businesses that offer generous opportunities to put pretax income into retirement accounts. For self-employed individuals, the SEP-IRA and the Keogh programs (intended for both principals and employees of professional firms) are the easiest plans to administer. The 401(k) and the relatively new Savings Incentive Match Plan for Employees (SIMPLE-IRA) are plans designed for small businesses with employees. In general, taxes on contributions made to these programs are paid only when those funds are actually redeemed, presumably when the person is in a much lower income bracket (and after age fifty-nine and a half).

In addition to a variety of commercially available private programs, the AIA and ASID offer retirement programs to their members. Practitioners who also teach full time should investigate the possibility of setting up an account with TIAA-CREF (Teachers Insurance and Annuity Association College Retirement Equities Fund) through their university. This option offers a variety of self-vested retirement options to people involved in education and research.

One approach to retirement that doesn't seem to work well for owners of small design firms is selling your interest in it to junior associates. What is there to sell in most cases? Over the past few years, William Koster has been exploring the sale of his firm to his associates without much enthusiasm on their part. Ever candid, he asks, "Although one's business has great emotional value to the principal, can it subsequently produce enough income to allow the employees to afford paying for it? And if your associates don't have the same entrepreneurial instincts as you, the present owner, there's not much you can do to inspire them." If this is the solution to old age that you've been fantasizing about instead of building a retirement fund, better have a chat with your accountant.

Project Management

Taking the Client's Schedule and Budget Seriously

In the view of some architects and designers, it is regrettable indeed that clients care far more about having their job come in on time and within budget than they do about design quality. These professionals long to work for cultivated people whose taste and circumstances (meaning unlimited budgets and lack of pressing deadlines) permit total design freedom—for example, clients like Bill Gates, who commissioned a multi-million-dollar house in Seattle, or Richard Lewis in Cleveland, on whose estate Frank Gehry and Philip Johnson worked for several years.

The expectations raised by such publicity (and the self-delusion nourished by it) tend to obscure and compromise the reality that bringing each and every project in on schedule and under budget is the essence of professional practice; it's our main job. Obviously, it is our major management challenge as well.

Since the vast majority of commissions offered to us have a commercial or institutional basis, it is crucial to the client to be able to predict the availability of the completed facility. Both the cost of the money to build it and the financial implications of operating plans are functions of achieving occupancy on time and within budget. Satisfying that need is one reason that our professions, however beleaguered, still exist. Despite their claims of efficiency and financial control, design-build operations have been unable to overcome the value of having an independent architectural or design firm facilitate construction of complicated projects. In many cases, it is superior accountability that wins the job for the private-practice professional.

A track record of projects done promptly and economically is, then, essential for marketing credibility, particularly for the small design firm. To some it may be the most important question in their search for design assistance, more than the size of the office or its history of specialization. To virtually everyone else, it will be a significant element in the decision of which firm to choose. Bill Gates may even have taken it into account when he chose Peter Bohlin's firm (Bohlin Cywinski Jackson, in joint venture with James Cutler Architects), a rather small outfit, to design his house.

Documenting your firm's project-completion history in a convincing way isn't easy if you haven't done a lot of jobs similar to and at the same scale as the one your prospective client is proposing. But an authoritatively presented list of jobs finished at or under budget, no matter how large or complex, with backup references readily available, will go a long way toward making you look serious about meeting these essential client needs. Having project cost figures at hand, as well as offering contact information on your former clients reinforces an atmosphere of trust that encourages prospects to take you at face value.

A track record of projects done promptly and economically is essential for marketing credibility.

If your on-time completion record is somewhat less than brilliant, it may be less of a problem than a history of exceeding your budgets. In fact, maintaining the construction schedule is definitely harder than keeping on budget. Part of the problem is that delays can't be foreseen as easily as spending changes. Another is that time on the job is often lost in small, apparently unimportant ways—unimportant, that is, until they cause a crisis when a tightly scheduled installation of prefabricated or manufactured components can't proceed as planned. It is one of the challenges of modern construction that the building trades' contribution, largely a matter of handicraft work, must be smoothly integrated with the delivery of substantial factory-fabricated elements, often scheduled far in advance.

In any case, the need has long existed in the construction field for a time-accounting system as responsive and capable of getting results (and assigning blame) as those available for financial record keeping. My introduction to the challenges of intensive schedule maintenance came about twenty years ago, when I was hired by a small New York City architectural office to do nothing but track progress, hour-by-hour, on two complex jobs that were both going much too slowly. Weekly job meetings were not enough. The technique, as it quickly developed, consisted of little more than telephoning the respective general contractors (and, when necessary, subcontractors and suppliers) several times a day; politely obtaining promises of when a specific task would be done; then, inevitably, calling back later that day (or early the next) to get a new time by which that task, delayed for any one of a thousand reasons, would be carried out; and so on, day after day, until the projects were completed. All of this, averaging twenty-five calls a day, was recorded on a legal pad.

It worked because the people being called simply chose to get me off of their backs by doing what I requested before taking on some other obligation. That was in part because I never, no matter how frustrated, gave them any abuse for failing to do what they had said they would when promised. Of course, I paid my own emotional price for that cool approach; after the six months it took to wind up those jobs, I vowed I'd never do anything like that again. On the other hand, it might be said that this book grew out of that experience, since for the first time I came to appreciate "management" as a unique aspect of architectural practice.

Contract Preparation as an Executive Responsibility

Full and creative attention to preparing contracts can pay big dividends for the small design firm. As stated earlier, the principal's time is well spent on seeking ways to maximize compensation for the services being offered. This is the moment when a new client is open to considering possibilities that cannot gracefully be raised later, namely, that a generously drawn contract, by enabling the design firm to make a profit, will ensure attentive service throughout the job's duration. Garth Sheriff puts serious work into both his and the owner-contractor agreements. Regarding the former, he says, "An architect's services are valuable and should be fairly compensated for *while* the job is being done, not later."

In fact, most designers and architects do their own contract preparation. Often they start out using form contracts, but over time they develop their own versions based on needs that grow out of the nature of their practice. The process generally consists of revising existing documents over the years, adding clauses that respond to whatever recent losses they've suffered. Experience certainly plays a big role here; "once burned, twice shy" shapes every designer's attitude toward drawing up contracts, no matter how casually they claim to go about it. Whatever the process, it makes sense for an office to seek occasional review of its documents by an attorney.

The need has long existed in the construction field for a time-accounting system as responsive and capable of getting results (and assigning blame) as those available for financial record keeping.

"An architect's services are valuable and should be fairly compensated for *while* the job is being done, not later."

William Koster uses standard AIA documents with his own supplemental conditions. The Croxton Collaborative, which has ready access to legal advice, frequently calls upon it during contract preparation. Tom Forman at Chicago Associates Planners and Architects (CAPA) looks to insurance people for help in writing contracts and contract documents. Others, like Mike Pyatok, Roberta Washington, and Harden Van Arnam, who do a lot of work on subsidized housing, usually must accept contracts drawn up by public agencies, although sometimes there's room for negotiation. Requests for Proposals (RFPs) from government agencies also often spell out certain contract limitations.

Clearly, there is a wide variety of approaches to contract preparation. Each firm interviewed for this book had specific thoughts on which one is most appropriate. Although there is little agreement on any one method for this important task, there is no doubt that it merits managerial scrutiny each time a new job comes into the office. After all (assuming that your firm is reasonably productive), what you do at this point determines whether you make a profit or not, both on the new job and perhaps for the year.

This is the moment when, having an accurate grasp of the firm's financial picture, you find yourself fighting a little harder to get those extras included in the contract, not dropped at the last minute. Effective fee negotiation, covered in Chapter One, depends on offering your client a contract that will *more* than cover your costs. Then, when the bargaining gets intense, you know you can afford to give a little of it away without losing your shirt.

Many small offices, particularly those specializing in interior design, use a letter of agreement for their contracts. It has a relatively friendly tone that avoids the brusqueness of form contracts while still protecting the professional from exploitation, and for this reason it may be the preferred form of agreement when contracting with clients who are

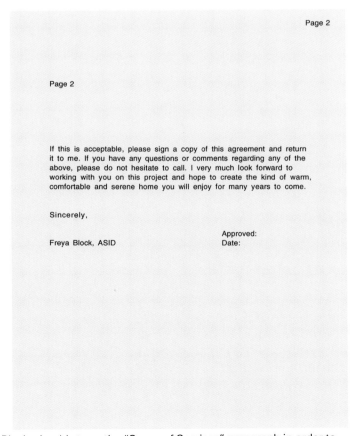

Letters of Agreement, such as this concise one developed by Freya Block, should stress the "Scope of Services" paragraph in order to help clients understand how the designer works, what documents will be provided, and to specify the extent of the proposed job.

unfamiliar with commissioning design projects. Even in a letter, however, the architect or designer must be very clear about the scope of services being offered. Nina Hughes emphasizes that, just as in more formal contracts, "scope of services" is absolutely the most important component for the architect or designer; fail to be explicit, and before you know it the job will grow, probably without provision for your compensation to keep pace.

Freya Block is one who defends simple contracts. She finds a two-page letter of agreement sufficient even for her commercial jobs. Even so, Block emphasizes that each letter is prepared specifically for the job it covers, and is designed to strengthen her relationship to the client, not defend against future litigation. Because her practice is focused on residential remodeling, Ellen Galland typically uses a one-page letter that gives both parties to the contract a variety of options. In addition, she feels comfortable offering clients inexpensive hourly rates because of her relatively low overhead and high productivity.

Nonetheless, for most design firms, printed forms—now available computerized—are a treasure to be prized. They represent an extraordinary accumulation of professional experience in dealing with design clients over the past century. From the design executive's perspective, AIA and ASID contract forms offer a time-tested, comprehensive overview of compensation methods, from which the most appropriate one for a specific project can easily be extracted, especially if software-based.

While some designers may be timid about making use of them, it is in the fine print of these forms that the difference between profit and loss often resides. By asking for a reasonable amount of compensation in each category (such as your work in coordinating

It is in the fine print of these forms that the difference between profit and loss often resides.

For more than two decades, the American Institute of Architects and the American Society of Interior Designers have worked together to develop effective designer-owner contract forms. Content of these documents is therefore remarkably similar even though the two societies have chosen different forms for its presentation. The AIA offers two versions: one based on a lump sum **(A171)** and another **(B171)** which allows the architect to fill in whatever mode (or combination of modes) of compensation work best for that particular project. The ASID "Residential Interior Design Services Agreement" is available in seven different versions:

ID120: Allows the designer to specify a variety of compensation methods.

ID121: A fixed fee agreement offering two options (Paragraph 2.3) for fees based on "Merchandise and Interior Installation purchased by client through Designer."

ID122: A short form fixed-fee contract.

ID123: Incorporating one of these Paragraph 2.3 options—allowing the designer to specify a Designer's fee which is a percentage of the Supplier Price—this agreement is designed to permit the designer to charge either a lump sum or an hourly fee for Design Concept Services while Project Review is a percentage of contractor's fees.

ID124: Similar to ID123 except that Project Review is handled on an hourly basis.

ID125: Makes use of the other Paragraph 2.3 option—allowing the designer to propose a Client Price for each item of merchandise or interior installation which includes an unspecified fee for services rendered—while offering the same options for billing Design Concept Services and Project Review as ID123 does.

ID126: Duplicates ID125 in every respect except that Project Review fees are billed on an hourly basis.

Both the AIA and the ASID documents are copyrighted; the latter are available only through ASID.

consultants' work) as well as for all possible reimbursable expenses, you seize an opportunity to claim a stream of income that would otherwise be lost. Given the tiny margins of profit on which our businesses often operate, what might seem a negligible sum to the client's fiscal department can be what puts this job in the black for you!

The Design Executive's Role in Contract Administration

In most small design firms, there may seem to be no distinction between the executive's job and the project manager's: They're done by the same person. Yet there is good reason to examine the difference between them, whether or not it is apparent in a particular office.

Perhaps because we are given so little management training as design and architecture students, we have trouble understanding the specific demands of hierarchical organization. It may also be because we're used to working in groups, with the team leader considered no more than the "first among equals." In dealing with corporate and institutional clients, however, the design executive, principal, or partner of the firm serves quite a different function from that of the project manager. Client contact at the executive level calls for a broader perspective than is necessary for the project manager, who by definition is focused on a specific job, no matter how large its scope may be. The project manager, having accepted a certain level of design quality as given in the immediate case, puts his or her attention into getting the work done on time and within budget, cooperating with a client representative who has the same general objective. The principal, on the other hand, must put his or her energy into making sure the "decision maker" is comfortable with job progress, often less in terms of specifics as in perceptions of the project's

The principal must put his or her energy into making sure the "decision maker" is comfortable with job progress.

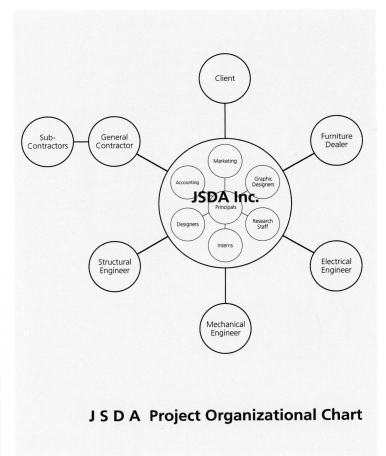

Janice Stevenor Dale visualizes "project organization" as a centrifugal phenomenon in which her unified firm deals with all the other project personnel, including the client, more or less equally. This concept is meant to maximize the efficiency with which projects are designed and carried out.

J S D A Project Organizational Chart

Glenn Garrison's comprehensive project management chart (opposite) defines the degree of responsibility from each member of a building construction team during every phase of a typical job.

The question of when to delegate authority to your associates may be one of the most crucial management decisions a designer has to make.

ultimate success. In other words, the executive's function involves a more political than pragmatic relationship.

It became clear during the interviews for the book that small-design-office principals experience what is to them an inexplicable tension as they struggle to do both of these jobs simultaneously. Mike Pyatok, practicing as he does while commuting between Seattle and Oakland, recognizes quite clearly his need for a senior person, perhaps a partner, who would handle the day-to-day project management, and is on the lookout for the right individual to whom he might confidently turn over these tasks. Roberta Washington is in a similar position. She can't quite bring herself to give up the responsibility for keeping up with the details on every job. "That's what I'm trained to do," she says, "not just to shuffle papers." Yet she knows this means she hasn't time to promote her firm, an executive function, as vigorously as she should.

On the other hand, there's Garth Sheriff, who for many years has happily turned the technical work over to his associate, Bill Bernstein, while he goes out and gets the jobs by socializing and working his political connections. Then, to make sure his clients (especially the residential ones) remain contented, Sheriff does all of the site supervision himself. It's a unique combination of the executive and the project manager roles.

For partnerships, the matter is more easily resolved because, by definition, there are at least two people, one to do the inside work and the other to do the outside work. In some cases, as in Cindy Harden and Jan Van Arnam's firm, they divide up the jobs, and each partner does both the executive and project management for his or her share, except when circumstances call for cooperation. The Croxton Collaborative's principals, Kirsten Childs and Randy Croxton, do something similar but find that sometimes when a large client—a corporate or institutional board, for example—needs attention, their joint presence often allows them to respond satisfactorily to contradictory demands.

Even for partnerships, however, the question of when to delegate authority to your associates may be one of the most crucial management decisions a designer has to make. Because of the schools' heavy emphasis on design as a craft, many of us find it hard to lay down that fat pencil and yellow tracing paper, let alone to allow someone else go out to the jobsite and oversee what's being built there. This tendency—trouble giving up responsibility—is one with which we can all empathize.

Nonetheless, it represents a basic organizational issue for the small-office practitioner. By delegating project management duties to someone else, the principal frees him- or herself to concentrate on the essential executive task—marketing. Lee Stout has done a conscientious job of building a "horizontal structure" within his interior-design firm. For him that means being able to get out of the office more often to keep in touch with his "core clients" and to find new ones. Obviously, a firm has to have a certain level of activity before it can justify such a division of authority. Unless, however, the principal is committed to carrying out such a restructuring as soon as possible, the chances of the practice moving beyond single proprietor status to that of "small design firm" are limited.

Managing Design Contracts

While designers and architects usually do a creditable job of administering the contract between the owner and the general contractor, an agreement to which they are not a party, frequently they are less successful at managing their own contract with the owner. It is not that they fail to deliver what they're bound to under the contract, but that they often deliver in a way that fails to earn them a profit.

Let's be candid: The service component of our fee rarely gets so far out of hand that we lose money on it. Productive manufacture of our tangible product—the construction

PROJECT RESPONSIBILITIES

Task/Position	Cl.	Prin.	PA	JC	D/D	Cons.	GA	Cont.
Marketing								
Identification	●	●						
Proposal Development	●	▲		■	▲			
Interview Preparation		▲	●			▲		
Interview			●			▲		
Initiation								
Project Budget	●	▲	●					
Client Contract	●	●						
Consultant Contract		●	▲			●		
Construction Budget	●	▲	●			▲		●
Schedule		●	▲	●			▲	●
Project Setup				●				
Team Manpower		▲	●			▲		
Project Delivery								
Design Presentations	▲	●	■		■			
Programming		●	▲	●	▲			
Site Analysis				▲	●			
Existing Conditions			▲	●	■	■		
Code Analysis				▲	●		■	■
Design Phases		■	▲	●	▲	■	▲	
Cost Estimates				●	▲		▲	●
Finalize Scope		●	▲	●				
Construction Documents		▲	●	■	●			
Approvals				●				●
Bidding		●		▲				●
Construction Administration								
Preconstruction Meeting			▲				●	
Field Visits					●		●	▲
Administration					●		▲	▲
Punchlist		▲			●		●	▲
Final Inspection/Sign Off				▲	▲	●	▲	
Construction Completion								
Follow Up				●				
Feed Back		■		●			■	■

● Full Responsibility
▲ Partial Responsibility
■ Assistance

Cl.	Client	D/D	Design/Draftsman
Prin.	Principal	Cons.	Consultant
PA	Project Architect	GA	Governmental Agency
JC	Job Captain	Cont.	Contractor

documents—is what makes the difference. No doubt about it, in our business profitability lies in cranking out those drawings and specs as efficiently as possible. And the primary obstacle to efficiency is not complexity or the level of development required by codes, but rather what we lovingly call "design."

Many principals of architecture and design firms make a conscious choice to ignore the question of managing design time. Judith Stockman, for instance, knows she sometimes is too exacting in developing and clarifying design concepts, but she insists on her right to do so. This attitude is widespread, carefully nurtured by our training process; it is the belief that design quality, more than anything else defines our work. Furthermore, the magazines we all skim so avidly give far less emphasis to the practical aspects of our fields than they do to visual effect, essentially for its own sake. Page after page of four-color photographs seduce us with their dazzling images. To produce similar results becomes our principal goal as practitioners, even though we acknowledge, at least in passing, that a penalty must be paid: Whatever the cost, design time shall not be abridged!

A noble sentiment. Frequently its consequence is that "design" tends not to be done by senior professionals, who, having mastered the technical complexities of their discipline, can quickly come up with workable solutions for the problem at hand. Instead, that task is very often put into the hands of recent graduates, whose understanding of construction methods and materials is rudimentary, on the grounds that "they bring a fresh eye" to the process. The resultant inefficiency is forgiven by the designer-executives when exciting

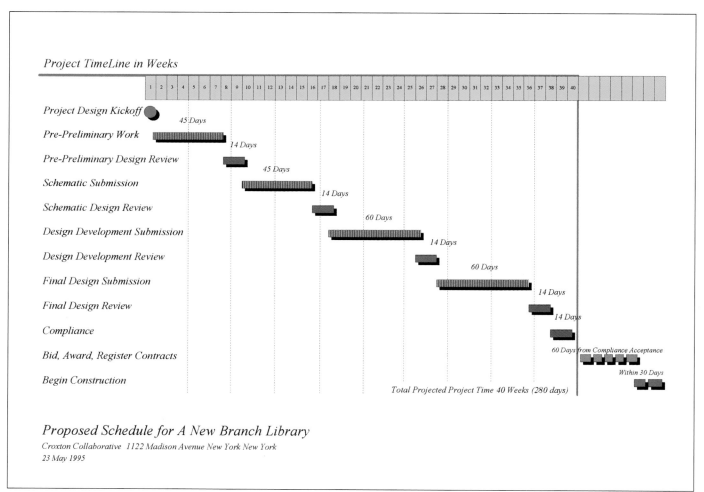

Project TimeLine in Weeks

| 1 | 2 | 3 | 4 | 5 | 6 | 7 | 8 | 9 | 10 | 11 | 12 | 13 | 14 | 15 | 16 | 17 | 18 | 19 | 20 | 21 | 22 | 23 | 24 | 25 | 26 | 27 | 28 | 29 | 30 | 31 | 32 | 33 | 34 | 35 | 36 | 37 | 38 | 39 | 40 |

Project Design Kickoff
Pre-Preliminary Work — 45 Days
Pre-Preliminary Design Review — 14 Days
Schematic Submission — 45 Days
Schematic Design Review — 14 Days
Design Development Submission — 60 Days
Design Development Review — 14 Days
Final Design Submission — 60 Days
Final Design Review — 14 Days
Compliance — 14 Days
Bid, Award, Register Contracts — 60 Days from Compliance Acceptance
Begin Construction — Within 30 Days

Total Projected Project Time 40 Weeks (280 days)

Proposed Schedule for A New Branch Library
Croxton Collaborative 1122 Madison Avenue New York New York
23 May 1995

Croxton Collaborative's attractive computer-generated Gantt or bar chart is very specific about the amounts of time to be spent on various stages of the design process for a proposed project and clearly states when the completed construction documents will be available for bidding.

sketches are pinned up and elaborate study models are displayed. Everyone in the office likes to see such virtuosity because it makes the place feel like "a real design studio," no matter how many hours it consumes.

This is not to belittle the esthetic potential of gifted young people. Rather, we should question how it may be used most productively in the prudently operated design firm. In fact, newly graduated individuals often experience the transition from school studio to professional drafting room as quite brutal; their ideals are harshly tested by the time demands of commercial practice. Those who supervise them, particularly project managers, must be sensitive to the dilemmas with which these junior colleagues grapple and be supportive of their emotional trials.

Even so, an unavoidable component of apprenticeship in our field is the need to come to grips with the stringent economics of design practice: If you can't bill the time, you've got to eat it. Thus, there's rarely time to indulge in conceptual (or pure research) activity. It's like manufacturing a product whose cost cannot be known beforehand. For a design firm to proceed on that basis is dangerous; not only is excess nonbillable time the source of constant financial uncertainty, but it almost guarantees loss of profitability.

The answer is to explain, at least to your professional employees, the economic framework in which your firm operates. It is important, for example, that employees understand that just because you bill the client at three times what you pay them, the additional income barely covers overhead expenses. Make especially sure to explain that any profit realized is likely to be plowed back into the business to keep it stable rather than be skimmed off by the principals. Many architecture and design school graduates have had no exposure to the fundamentally low-rent reality of our business.

> In particular, it is smart to share the financial constraints of a project with everyone working on it, especially the time budget for design and production:
>
> 1. Take the gross fee and subtract twenty percent of it, off the top, for overhead and profit.
> 2. Divide what is left by the percentage that you bill for each contract phase, traditionally—
> ten percent for programming,
> thirty percent for preliminary design and design development combined,
> forty percent for contract documents,
> and twenty percent for contract administration.
> 3. Translate those percentages into numbers of working hours available in the various job categories for each phase, based on your standard billing rates.

Make it clear to the juniors that the project manager is required to account for each of those hours on a weekly basis if the job is to generate positive cash flow for the office. If you can get that across to your employees, then you'll probably understand it a lot better yourself. Then the prospect of your firm making a profit from each commission may no longer be just theoretical but actually possible.

Facilitated Decision-Making

This cooperative approach to design-contract management can be used by principals of small design firms on a broader basis to improve performance by everyone on the project team, including client and general contractor. Building consensus through participatory techniques is not a new idea. On many construction jobs it is already being

Louis Begley on Time

Since 1959, when I became a lawyer, I have been trained to divide time into tenths of an hour, and to note on a sheet of paper, at the top of which I write the word "TIME," each such unit that I devote to work on a client's matter, to reading that continues my legal education, to charitable work my firm has taken on, to administrative chores, and to that nebulous activity that is said to have increased in importance as I have grown older, called "development of clients." The hundreds and thousands of hours spent on clients' affairs have been multiplied by dollar figures, which have also increased, and have been billed. That's what we sell, each lawyer's time, cut up into little segments of his life.

used in an informal way. Glenn Garrison, an architect with exceptional experience in construction supervision, is certain that by reexamining the way they approach project management, small design firms can make significant improvements in the normal day-to-day process by which their jobs get built. He bases his belief upon the principles of Total Quality Management, the methodology that drew so much press attention to Japanese industrial practices a few years ago.

As part of his Integrated Architectural Management consulting service, Garrison offers a program called Quality Improvement Process Planning (QIP) to small as well as larger design firms. He begins by holding sessions of TQM 101, which is, he says, "that introduction to 'top quality management' that none of us ever received in school." Garrison makes clear that the more open and transparent the management is, the more an office can benefit from these participatory techniques. In effect, he strives to broaden the sense of responsibility for quality design service to everyone in the firm. With the support of his clients, those who actually own the practices, he encourages all staff members to rethink their operating procedures, especially in collaboration with those they work with every day.

This sort of basic reorganization in a design office can happen only if the principals realize (out of self-interest) how cooperative management will benefit them. Sometimes, although the image of horizontal responsibility exists in a firm (that is, project teams that manage themselves), the principals resist sharing financial and other privileged information, fearing perhaps that their associates will demand more of the (probably nonexistent) profits. It's that sort of unresolved concern that Garrison seeks out and focuses on in his consulting work, striving to create an atmosphere of trust within the office. Recently Garrison has begun working as a consulting "managing partner" for a couple of small New York City offices, still another way to put his management expertise to work.

As an interior-design consultant, Laura Bohn often serves as the "practical ear" for the architects of huge residential projects when she is brought in by their sometimes bewildered and frustrated clients. Her practice epitomizes participatory design as she endeavors to domesticate these elaborate layouts without compromising their architectural integrity. Bohn also makes sure, as she administers the furnishings purchases, that clients aren't surprised by unusually large invoices or unexpected deliveries of furniture. By sustaining optimal cooperation, she helps both client and architect achieve their goals for the project.

Mike Pyatok, who spends much of each week running his Oakland firm from Seattle, has little choice but to spread responsibility for the work around and to foster a sense of ownership for decisions that must be made while he's away teaching at the University of Washington's School of Architecture. He uses extended daily telephone conversations as his principal management tool, talking with every person in the office, including interns, about what they're doing that day. He occasionally wonders if, were he normally there every day, his contact with everyone would be as thorough as it is at a distance.

Another circumstance in which participatory management pays off is with a firm's consultants, those specialized engineers, designers, and suppliers who nowadays provide a great deal of the contract document materials we ultimately furnish to bidders. Although there are exceptions, a frequent problem is the failure to convey to them the *intent* of a design scheme along with the programmatic information. If the consultant is approached as someone interested in the quality of the resulting project rather than just the supplier of technical drawings and specification data, his or her curiosity and imagination may be stimulated. As a result, the consultant may raise questions and, by doing so, resolve potential problems—to everyone's benefit—that the designer might have felt were beyond that individual's concern.

On-site project meetings also offer opportunities for facilitated decision making. The question usually is, "How do you benefit from the contractors' know-how without

Sometimes, although the image of horizontal responsibility exists in a firm, principals resist sharing privileged information, fearing that associates will demand more of the (probably nonexistent) profits.

Assuming that you provided a complete set of drawings and specs at the outset of the job, there's really not a lot to fear.

abandoning design control?" Assuming that you provided a complete set of drawings and specs at the outset of the job, there's really not a lot to fear. The contract documents give us the upper hand because they represent the owner's commitment to construction of the highest quality possible within the terms of the agreement. One way or another, everyone sitting around the table each Monday morning has accepted them as the "bible." Unfortunately, some individuals may be less than enthusiastic about that situation, either because they stand to lose money on the job, or simply because they think there's a better way to go about doing the work.

The architect or designer, therefore, is the one with the power either to bring those folks into full participation or to just let them sit there and stew. Often there is ego gratification in choosing the latter course—forcing them to go along no matter how unhappy they are. The wise project manager avoids such self-indulgence. In the closely related construction business, the disgruntled parties are likely to find a way to "return the favor," probably sooner than later.

So that makes it doubly smart to practice the golden rule with everyone you deal with on a construction site. Furthermore, openness on the part of the designer's representative builds enthusiasm for sharing ideas with the others. Nina Hughes believes that our leadership, as the source of the job's "road map," also obliges us to set a positive and respectful tone in human interaction. What may count even more is that giving everyone the sense of full participation in the job can really speed things up. It means people won't be afraid to ask questions, that those questions will be readily answered, and that promises to carry out decisions will be more sincerely offered if all negative feelings have been addressed and resolved.

Documenting the Contract Administration Process

Fully documenting project management means much more than just keeping track of the contract administration phase of a job. Starting with your first meeting with a prospective client, it pays to keep notes on what is said. And you should record all of the conversations that follow during the development and execution of the project. Of course, few designers and architects do that; in fact, as long as our contract documents generally convey the client's intent, we can get away with minimal correspondence. Up until the contract administration phase, that is.

It is generally a matter of office policy, especially for medium-sized and larger firms, to specify documentation methods for project managers as jobs get built, because the potential for confusion and—even worse, litigation—is so great. Small offices, especially if the principal handles most of the job supervision, often go at it in a much more informal way—and get away with it.

Nonetheless, the benefits of carefully recording the progress of a building project deserve consideration by every small design firm—and by every designer, for that matter. Having a project journal at hand, both in the office and on the jobsite, is essential. For jotting down those fleeting thoughts that often are so valuable later on, as well as for making more substantial observations on a daily basis as work proceeds, nothing beats a daybook, just as in Thomas Jefferson's time.

For the most part, though, what I mean by "documenting contract administration" is keeping the minutes of job meetings. There is no question that whoever takes down and distributes the minutes of a meeting controls everyone else's perception of what happened there. As for how designers respond to that, there's bad news and good news. Usually, designers sit through meetings either sketching details or perhaps sketching the person across the table from them, rarely writing anything down if they can help it. That's the

For the most part, "documenting contract administration" is keeping the minutes of job meetings.

bad news. On the other hand, our lettering facility makes it possible for us, if we choose, to provide everyone almost immediately with a legible summary of what was said. And, if a photocopying machine is available, everyone present can walk away from the meeting with the minutes in hand. Now that we have laptop computers, anybody can do something similar; and, I suppose, with E-mail they actually can be sharing the information as it happens with correspondents who are miles away.

Whatever communication medium is used, documentation of promises and time commitments is what matters most in job-meeting minutes. Reports on what has happened may be less important than those on what hasn't, particularly regarding trades or categories that are difficult to integrate into the normal flow of work. While it is good to avoid describing contentious exchanges, the minutes writer still has to capture the essence of the issues the various parties are debating. Personalities ought to be minimized whenever possible in favor of clearly stating the facts. That is especially important when it comes to schedule adjustments and other time-related matters. In the end, these minutes provide just about the only record there is of why a job has failed to keep up with the pace originally agreed to by all of the participants.

A serious effort to keep good job minutes can also help minimize unexpected cost increases. When questions about special-order components or complicated installation procedures—including proposed change orders—are raised in the job meeting, it's important to make note of their financial implications. In effect, the person taking the minutes can ferret out information on what these things will cost that would otherwise not come out, simply by asking for clarification "for the record." It is also an opportunity to deal with unresolved design and technical questions: "Just for the record, how will that item be handled?"

From the design executive's point of view, the value of good job minutes is that they help clients feel confident about the progress of their project. On bigger projects—those for corporate and institutional clients—there are often many people who rarely show up at the site but who avidly follow construction progress through job minutes sent to them by their architect or designer. Timely and clear minutes help to convey the designer's commitment to schedule and budget, assuming of course that in the job meetings the design firm's project manager vigorously pursues those issues.

This is not to say that our minutes should be put together with an eye toward such readers. Objectivity is always the best policy for the minutes taker. If as a design executive you feel a need to increase the client's sense of participation in the job, then perhaps you should consider issuing monthly job reports, based on the job minutes, that emphasize how well the job is going while avoiding reference to the specific technical and procedural issues that so often fill the actual minutes.

Project Management and Electronic Media

Keeping track of a project's budget and schedule has been made both easier and faster with computers than it was when all charts were drawn by hand and every calculation figured individually. For instance, today the cost of a change in components in a small construction project can be factored instantly into the entire spreadsheet. This was just a dream less than twenty-five years ago. And if something changed on a schedule in those days, you could only guess at what the consequences might be for the overall completion date.

Things are quite different today. Even the smallest design firm can precisely monitor both budget and schedule at every moment in a project's progress. In other words, electronic means have revolutionized project management, so that, nowadays, if there

Whatever communication medium is used, documentation of promises and time commitments is what matters most in job-meeting minutes.

When questions about special-order components or complicated installation procedures—including proposed change orders—are raised in the job meeting, make note of their financial implications.

Carl T. Brown Memorial Hospital ~ Medical Oncology Suite

BID COMPARISONS	Auto-Cost	Catron Const.	Under / (Over)	Hinsley/Nielsen	Under / (Over)	Jobu Industries	Under / (Over)
Selective Demolition	6,200.00	9,660.00	(3,460.00)	2,500.00	3,700.00	8,000.00	(1,800.00)
All Other Work (Barriers / Protection)	4,000.00	6,022.00	(2,022.00)	0.00	4,000.00	0.00	4,000.00
Earthwork / Concrete	22,260.00	-		0.00		1,744.00	
Earthwork		33,600.00		18,000.00		30,000.00	(9,484.00)
Cast-in-Place Concrete		12,246.00	(23,586.00)	11,750.00	(7,490.00)		
Metal Fabrications	2,000.00	1,575.00	425.00	2,200.00	(200.00)	5,500.00	(3,500.00)
Rough Carpentry	5,250.00	7,500.00	(2,250.00)	(in drywall)	#VALUE!	5,500.00	(250.00)
Architectural Woodwork	206,675.00	257,378.00		247,700.00		280,000.00	
Banquettes	10,000.00	17,106.00	(57,809.00)	2,200.00	(33,225.00)	8,000.00	(71,325.00)
Thermal / Moisture	10,500.00	-		-		(in drywall)	
E.I.F.S.		4,987.00		6,200.00		25,000.00	
Firestopping		(in sealants)		(in drywall)		(in drywall)	
Flashing and Sheet Metal		2,625.00		1,000.00		6,000.00	
Sealants		1,050.00	1,838.00	500.00	2,800.00	1,000.00	(21,500.00)
Doors / Windows	53,760.00	-		-		-	
Steel Doors & Frames		2,625.00		(in wood doors)		1,950.00	
Wood Doors (Pl Lam)		6,772.00		12,600.00		6,700.00	
Access Doors		787.00		(in wood doors)		0.00	
Aluminum Windows		(in glazing)		50,475.00		18,500.00	
Door Hardware		4,725.00		(in wood doors)		3,835.00	
Glass / Glazing		29,292.00	12,184.00	(in alum windows)	(9,315.00)	(in alum windows)	24,725.00
Finishes	84,065.00	-		-		-	
GWB / Acoustical Ceiling		53,295.00		42,375.00		68,850.00	
Tile		4,960.00		4,800.00		2,500.00	
Thin Brick		0.00		(in concrete)		10,000.00	
Resilient Flooring / Carpet		19,425.00		7,600.00		22,000.00	
Painting		10,646.00	(4,261.00)	7,260.00	22,030.00	7,250.00	(26,535.00)
Specialties	10,105.00	-		-		-	
Cubicle Curtain & Tracks	5,750.00	5,376.00		950.00		3,496.00	
Wall / Corner Guards		2,961.00		1,300.00		5,014.00	
Fire Extinguishers		829.00		(toilet accessories)		5,000.00	
Toilet Accessories		1,020.00	(81.00)	1,400.00	6,455.00	347.00	(3,752.00)
Specialty Equipment (Viewboxes)	10,700.00	8,902.00		9,300.00		20,000.00	(15,300.00)
Pantry Equipment		1,575.00	223.00	1,550.00	(150.00)	6,000.00	27,542.00
Plumbing	62,192.00	37,275.00	24,917.00	58,465.00	3,727.00	34,650.00	13,685.00
Fire Protection / Sprinkler	13,685.00	7,088.00	6,597.00	14,000.00	(315.00)	0.00	13,685.00
HVAC	83,631.00	89,250.00	(5,619.00)	80,000.00	3,631.00	79,600.00	4,031.00
Electrical (M.C.Cable Wiring)	103,125.00	119,260.00	(16,135.00)	92,875.00	10,250.00	101,048.00	2,077.00
Exterior Screen Wall Allowance	12,000.00	12,000.00		12,000.00		0.00	
Alexander Mock-up Deduction		0.00	0.00			0.00	
Subtotal 1	**693,898.00**	**771,812.00**	**(77,914.00)**	**689,000.00**	**4,898.00**	**767,484.00**	**(73,586.00)**
General Conditions 15%	104,084.70	39,000.00		51,000.00		50,000.00	
O & P		70,000.00	(4,915.30)	35,000.00	18,084.70	86,000.00	(31,915.30)
Subtotal 2	**797,982.70**	**880,812.00**	**(82,829.30)**	**775,000.00**	**22,982.70**	**903,484.00**	**(105,501.30)**
Payment Performance Bond 1 1/2%	11,969.74	11,000.00		15,000.00		19,200.00	
Total Construction Cost	**809,952.44**	**860,280.00**	**(50,327.56)**	**790,000.00**	**19,952.44**	**979,200.00**	**(169,247.56)**
Add Alternate - Conduit Wiring	21,000.00	18,000.00	3,000.00	18,000.00	3,000.00	0.00	21,000.00
Add Alternate - Dedicated Exhaust	15,000.00	12,750.00	2,250.00	14,800.00	200.00	0.00	15,000.00
Add Alternate - Building Mechanical	*NIC - 156000*	*NIC - 126809*		*NIC - 139000*			
Total Construction Cost	**845,952.44**	**891,030.00**	**(45,077.56)**	**822,800.00**	**23,152.44**	**979,200.00**	

Carl T. Brown Memorial Hospital
~Medical Oncology Suite
Change Order Request Summary 4/28/97

COR #	Approved	Pending	Rejected	Forwarded To C.T.B.M.H.	Calendar Days Added to Construction Schedule	COR Description
1	19400				0	Electrical conduit in lieu of BX / Per CTBMH
2	8561				0	Plastic laminate doors in lieu of paint grade / Per CTBMH
3	5308				0	Revisions to Drawings for Code Compliance / Per Joint Venture Architect
4		VOID			-	Void
5	5509			2/22/96	3	Rock Removal From Interior / Per CC [Concurrent with Related Work]
6	5491				0	Use Tile Instead of Linoleum @ Exit Cooridor / Per Prof. Building Owners
7	3510				13	Footing Re-Design @ Lin. Acc. / Per Joint Venture Architects
8			-450		-	Delete panel L1A (rejected for inadequate credit) / Per Joint Venture Architects
9						Dukane nurses call
10	3510			12/26/95		Custom Color @ Door Frames / Per CC
11						Exit Hardware @ Connector / Per Joint Venture Architects
12	2219			12/4/95	1	Pharmacy Window & Related Revisions; Lobby PL Doors Rejected
13			2985	12/4/95	-	New Pharmacist Door, Rejected Per CC
14	2190			12/29/95	0	Insulated Blankets @ Lin. Acc. Concrete / Per Contractor
15	537			1/2/96	0	Increase Slab for Medical Files / Per CC
16	9800	(approx. cost)		1/5/96	0	Winter Conditions @ Lin. Acc. Concrete / Per Joint Venture Architects
17	0			1/5/96	0	Fire Watch For Winter Conditions Heating (Approved Not Required)
18	1121			1/10/96	3	Snow Removal at Screened Soil Area
19	-			2/29/96		Snow Removal of General Area, Per Diem Costs
20				-		Suite 208, Plumbing
21		[236 Approved?]		-	1	Switch Added for Darkroom Light Fixture/ Per Contractor
22				-		Suite 306, Millwork
23				-		Suite 208, Sink
24		VOID		-		Void
25				-		Elevator Repair
26				-		Suite 309, Finishes
27				-		Suite 208, Add Floor Outlets
28			1725	1/29/96	-	Sitework (rejected - included under contract)
29	692			2/7/96	0	Additional Linoleum Borders / Per CC
30	0			1/30/96	0	Ceiling Modification @ Skylight / Per CC
31				1/30/96	0	Recessed Sprinkler Heads / Per CC
32	11359					Varian Requested Changes @ Lin. Acc / Per Joint Venture Architects
33	22939			2/13/96	No Note	Relocation of Existing Piping and Ductwork / Per CC
34				-		Suite 308 Finishes

Today's construction budget analysis programs furnish detailed and accurate data on most aspects of a job's cost. These examples from Croxton Collaborative's files offer data that is particularly easy to comprehend, made so in part through judicious use of color.

The human factor in project management hasn't necessarily been supplanted by the computer, merely isolated and recognized for its particular intransigence.

The burden is on the executive manager to understand what his or her technical staff is doing with these toys, not the other way around.

are problems maintaining the schedule or keeping track of the budget, everyone involved knows about them. Which is to say, the human factor in project management hasn't necessarily been supplanted by the computer, merely isolated and recognized for its particular intransigence.

Budget data are especially easy to "access," as we now say, our information-retrieval abilities having increased dramatically in the past couple of decades. Programs that monitor financial progress, such as Sema4, Harper & Schuman's CFMS, and Wind2, offer project managers immediate exposure to every detail of a project's budget. Both design-contract and construction-contract spending can be evaluated with today's sophisticated project management software.

In the design office, if staff members directly input their timesheet data into the data bank at the end of each day, managers can easily monitor and analyze the past week's production in time for Monday morning meetings with project team members. Most of the small firms examined in this book still use paper timesheets that are then entered into the computer early the following week. Janice Stevenor Dale is an exception; with consultants spread all over the Los Angeles region, she relies on communication via modems to keep track of how each is doing on her or his various assignments.

For general contractors and construction managers, both as they deal with bidding on contracts and then manage them, the benefits of electronic data processing are enormous. Not only are spreadsheets instantly revisable, but opportunities to explore alternatives for every budget component and to play with various combinations of those numbers offer flexibility in budget revision that has never before been possible. Architects and designers are sometimes hard-pressed, given these rapid possibilities for change—and often genuine improvement—in their documents, to intelligently process this data, to assimilate and evaluate its affect on design quality.

Time being more slippery than money, schedule accounting is also more of a challenge. Even so, many software programs are now available to help you cope with the problem: Sema4 is one of the more popular ones at present. New and ever more comprehensive schedule-monitoring programs come onto the market each year. In addition, there are those remarkable computer-based communication tools—fax and E-mail—that, when combined with the speed of these programs, offer even the smallest office unprecedented options for controlling the progress of its jobs. For many design executives, however, a veil of ignorance lies between them and these magical instruments. There's no doubt that older designers must learn to be comfortable using these assets. The burden is on the executive manager to understand what his or her technical staff is doing with these mysterious toys, not the other way around. As William Koster warns, "Watch out!"

Critical Path Method (CPM) was first developed in 1960, an early product of computer research. It was promoted to the building industry in the years that followed as a way to spot scheduling crises well ahead of time. The idea is to track the time sequence of several parallel tasks being carried out under a general contract, looking for those requiring the longest lead time to be completed. Once identified, these situations are then monitored with special care, thus avoiding delays in the other trades at a future nodal point. CPM is often linked with Project Evaluation Review Technique (PERT), a slightly more elaborate version of the same process. Both were management tools that were more admired than actually employed by small design firms prior to the computer revolution.

"Project modeling," a recent iteration of CPM, is another improvement in project-scheduling technique. In his book *The New Critical Path Method,* Dennis H. Busch makes it clear that the computer plays a crucial role in project modeling. This process moves beyond the predictive capability of CPM, permitting what he calls proactive project management. "Path time reserve," Busch's term for the product of CPM, means making sure that there is at least as much time in the schedule for a task as is actually needed to

complete it. He summarizes: "Attempting to control a project by monitoring schedule performance is a reactive methodology; managing time reserve is a proactive methodology."

Project modeling may represent a degree of sophistication beyond what design managers need to know. Projects within a design office often can be planned informally, because they're not all that complicated to carry out. Still, awareness of this methodology may be useful. Either as a member of an integrated designer/contractor/client team, or just as a professional wanting his or her general contractors to be more efficient, the designer or architect should recognize that computer-based means exist to effectively schedule and manage even the most complex project.

Management of Particularly Sensitive Issues

Occasionally, being a design executive requires you to take a normative position, that is, to set a moral standard or simply, as Spike Lee would say, "to do the right thing."

In terms of construction project management, fortunately, building codes take care of most judgment calls: Is this strong enough? Is this safe enough? Is this adequate enough? Almost everywhere we might work nowadays, codes insist on standards intended to avoid injury or death for those who use our structures. Of course, as architect Randy Croxton likes to say, "Meeting the building code just means you can't be sent to jail for what you specify or design." In other words, the code is only a minimum standard based on pragmatic experience. It is moral only in the abstract sense that it calls for a certain level of building quality in order to preserve human life and to serve human welfare.

Nonetheless, there are issues involving human interaction that require the project manager to examine personal behavior in terms of professional standards. One that designers seldom encounter directly is corruption at the building site. Sometimes it takes the form of money paid to building inspectors or suppliers to keep the job moving smoothly. Contractors usually deal with this, and we designers rarely hear anything. Thus, we can continue to say sincerely that we're against paying bribes, no matter what actually goes on under our noses.

Another interpersonal issue, less easily ignored, is sexism on the jobsite. Our female colleagues have dealt with it individually long before it had a name. They generally overcome the harassment (however good-natured, it's still intimidating and degrading) by ignoring it while making clear that they know more about what needs to be done than the man in charge knows. Eventually the whistling and the catcalls stop because this particular woman has proved she deserves to be considered "one of the guys." Roberta Washington is one architect who looks back on such incidents with a certain pride, having decisively shut the harassers up by identifying herself as the one who approved their payment requisitions.

Today, however, that challenge ought not be left to the individual woman professional to confront while stepping over piles of framing lumber. It is one that can and should be dealt with in job meetings. If that doesn't resolve the problem, then the design executive must insist that the general contractor intervene and stop it. As Roberta Washington reminds us, it comes down to management of contract finances, which the G.C. understands immediately. Given the contractual basis of construction today, including the legal constraints involved, sexism on the construction site may be easier to deal with than in the design office itself.

Sexism in the design office is usually more subtle, yet it demands executive attention no less urgently. When harassment or sexual discrimination surfaces, including homophobia, it must be denounced strongly and unequivocally by the firm's principals. This is best done by making it a matter of policy, which requires actually defining acceptable behavior.

Given the contractual basis of construction today, including the legal constraints involved, sexism on the construction site may be easier to deal with than in the design office itself.

Gender equity is worth striving for among us. It is a goal requiring good will and patience from everyone.

In many cases, design and architecture graduates have already experienced discrimination on their way to becoming professionals. It's a rare design school without faculty members, sometimes female themselves, who feel it necessary to challenge the commitment of gay and woman students in ways that straight male students may never even notice. It may be built into the very way we are trained—the charrette tradition and the macho notion that if you don't work until you drop, you're not a serious student. Furthermore, for the sensitive or shy person, facing a design jury can be even more formidable than completing the most demanding project.

Because a dark form of sexism does lie deep within our subculture, gender neutrality is difficult to achieve in a small design office. It is easy to fall back into patterns of bias learned in the larger society. Because skills vary, and because project teams and other working groups are often informal, thoughtless behavior that seems justified by pragmatic demands—such as a tight deadline—is sometimes not challenged when it should be. Gender equity is worth striving for among us. It is a goal requiring good will and patience from everyone. For managers, it calls for special vigilance and sensitivity, both as a matter of human resource and of project management.

CHAPTER FIVE

Design-Practice Dialogues

Chicago Associates Planners and Architects (CAPA)

TOM FORMAN, PRINCIPAL

QUALIFICATIONS: B. Arch., University of Illinois, Chicago Architects/Designers/Planners for Social Responsibility, Former President

FIRM BACKGROUND: Chicago Associates Planners and Architects (CAPA), 1963–present

PRACTICE SIZE: 2 principals, 13 employees

The skyline of Chicago looms behind members of CAPA assembled on the roof of its office building. Tom Forman is in the first row at the right.

A TRADITION IN DIVERSITY

In existence for more than thirty-five years, CAPA has managed itself as a collaborative. During that time, it has allowed its operating arrangements to evolve as membership, projects, and circumstances changed. Of its fifteen present members, nine are professionals, of whom three—including Tom Forman—have backgrounds in both planning and architecture while three others practice interior architecture. CAPA began as an architectural firm but gradually diversified into planning, interior design, graphic design, and eventually real estate development. Thus, the firm combines a broad range of practice with an organic approach to business structure.

Flexible leadership has been the key to the firm's open-ended development over time. A chronology of CAPA's stages begins with its founding in 1959 by Ed Noonan (who is still the business's owner of record) and a partner; during the sixties, a period of equal ownership, Europeans (mainly Swiss architects from Atelier5) led the office; in the seventies, CAPA reconstituted itself more along traditional lines in response to adverse economic conditions (that's when Noonan reassumed ownership); since then things have been managed on an ad hoc basis, encouraged and prodded by Noonan and Forman as necessary, but with a strong emphasis on cooperative effort.

Openness in organizing the firm's activities, what CAPA calls "organic collaboration," continues to be their hallmark.

FACILITATING INDIVIDUAL GROWTH

The intention has been to facilitate individual professional development within the firm's ongoing practice, for the support staff as well as for the young professionals, most of whom came on board as students. When Forman joined the office in 1963 (also as a student)—during the "Swiss days," as he calls them—the project load was split up under an "umbrella management" concept: Everyone on the staff was assigned to several different project teams, sometimes leading one while serving as a technician on others. And everything was discussed during what Forman remembers as "interminable, European-style staff meetings." For the young professional, this amounted to a graduate-level course in management. Openness in organizing the firm's activities, what CAPA calls "organic collaboration," continues to be their hallmark. For instance, the firm has no policy on work hours—some folks follow a five-day schedule, while—especially in the summer—others put in four long days and take three-day weekends. During the "Swiss days," says Forman, the office motto was "Your work is your life," an attitude possible, he notes, because they were all men and most had wives who took care of the rest. "Nowadays, you don't find that attitude at CAPA."

CAPA has a tradition of hiring undergraduate architecture students who then continue on with them, quickly becoming full members of the collaborative. In recent years, many of the new employees have been graduate students, and their interest in staying with the firm has tended to decrease because they often have more options than the undergraduates had, including more highly developed computer skills. The firm now uses paid internships as a way of indentifying potential employees. Once in a while, someone comes to them and almost insists on being hired. Not long ago, Whitney Weller, a young woman with a Columbia master's degree in historic preservation and a broad background in community-based development, did just that. Having learned of the firm's work, she recognized that CAPA was the place to synthesize her varied experience. After a six-month-long "interview" (Forman's word), Noonan and he agreed that such commitment would be to the firm's benefit and offered her a job.

LIVELY OFFICE CULTURE

In recent years, CAPA's innovations in structuring support functions have been especially noteworthy. Realizing in the early nineties that computerized word processing was rapidly replacing the secretary role there, Forman saw that he could handle the hard-to-keep-filled front-desk jobs, and even the office manager position, by hiring "very bright folks with professional interests outside of our fields who were looking for part-time gigs" but who had minimal secretarial skills.

So he has turned to theater people, with which Chicago abounds. Melanie Dix, an actress, has turned out to be a natural at managing not only CAPA's office building but the architects and planners as well. "It's Melanie's job to facilitate the office culture while still being relatively free (thanks to CAPA's tradition of loose work schedules) to carry on her own professional life," says Forman. "The human resource issue is always, 'How do we help the brightest and best to satisfy their own curiosity while still moving the office's collective work forward?' It's a delicate balance in management terms."

It is what Ed Noonan likes to call the "CAPA way," a set of behaviors that also focuses a lot of energy on initiating and nurturing client participation in the work. This is another way to define "organic collaboration." Tom Forman estimates that the number of people at CAPA is probably fifteen percent larger than is actually needed for the firm's usual work load, but it is this conscious overstaffing that allows for the relaxed and generous attitude toward individual professional development. As a result, Forman himself had time to serve as national president of Architects/Designers/Planners for Social Responsibility (ADPSR) for four years.

"**T**he human resource issue is always, 'How do we help the brightest and best to satisfy their own curiosity while still moving the office's collective work forward?'"

This CAPA interior incorporates a mezzanine conference room to increase useable floor area in a high-ceiling loft building.

The office is arranged in "constellations" in which each person, understanding the resource that each of his or her collaborators offers, calls upon colleagues as needed in a natural way—long office meetings are definitely a thing of the past. Efficient office operation at CAPA, however, does involve daily communication among the staff about workflow. "It's a matter of fine-tuning," says Forman. Although not everyone there is as comfortable as he is with the informal management style that has evolved, it seems to pay off with clients: Both community groups and individual residential design clients feel they get a good deal of attention from this service-intensive approach.

RESPONSE TO FEE CUTTING

Professional compensation is a matter on which Tom Forman has vigorous opinions, especially in these days of endemic fee cutting, with prospective clients "shopping fees" as never before. "It's ruining things for all of us," he says. "Rather than cut fees, we make sure clients know exactly what they're going to get from us and urge them to find out what the other outfit actually intends to provide for that low fee." Since CAPA has been around for years and has done a wide variety of projects, the firm has no trouble clarifying clients' budget and schedule expectations for them.

CAPA can use its database to negotiate construction contracts before design even begins, especially when a developer is involved. On the other hand, when dealing with upscale residential clients, all of whom seem to have read Tracy Kidder's *House*, Forman proposes an outline specification to arrive quickly at a realistic contract estimate. He finds that this process, usually offered for a nominal fee as a "feasibility study," effectively breaks through unrealistic economic expectations that clients often bring to an architect.

Forman finds that the AIA form contract, with its five stages, more often than not fails to cover the way his jobs actually proceed. He mentions the new matrix format of AIA contracts favorably but feels that its complexity "drives clients to their lawyers." In his experience, clients usually accept CAPA's contract terms without legal advice. As for his own favorite source of advice and comfort on contract documents, Forman turns to his insurance underwriter rather than his lawyer. "Insurance companies are finally getting around to training us, their clients, in what to include on drawings, in specifications, and in contracts. It's a matter of managed risk."

The cost of professional insurance, in CAPA's experience, depends on the broker. It has ranged from $40,000 down to $20,000 in recent years, because their broker has helped them differentiate between projects that involve liability (the architectural ones) and those that don't (planning jobs). Since the insurance premium is a function of billings, that distinction cut CAPA's bill in half. The firm constantly works with its broker to find the best deal for future coverage, recognizing that professional insurance, as one of the firm's biggest fixed costs, can make or break its profit picture.

Tryon farm is a rural residential community project planned, designed, and developed by CAPA.

This Chicago complex is an
example of CAPA's inner-city
low-income housing work.

CONTRACT STRATEGIES

CAPA "swings back and forth between hourly rates and lump-sum fees" as the most appropriate form of compensation. Developers like the fixed-fee approach, so CAPA makes use of its database as well as its personal experience to name its price, finding that in many cases the computer is less efficacious than informed memory. When requested to work on an hourly basis, the firm offers a five-tier rate. It is based upon their projection of what is needed to return a fifteen percent annual profit to the firm and is double-checked against what other Chicago offices are charging.

Retainers, according to Forman, are especially important when prospective clients are just dabbling. In his experience, developers often look for up-front help but aren't willing to pay for it later if things don't work out. So when he is approached, he doesn't waste time spelling out the particulars. Instead, he often bases the amount of compensation he requests on an estimate he makes on the spot. He calculates the value of the work involved before the first bill could be sent, and then asks for fifty percent of that amount. For community groups and those he has worked with before, that may be waived; for former clients who haven't paid promptly in the past, it definitely isn't.

Because CAPA seems to be prospering, the firm feels no need to promote itself in any direct fashion. They report that eighty percent of their work comes in through direct repeat business or referral from former clients. The remainder is the result of responding to RFPs and through competitive interviews. One reason for so little interest in marketing the firm is that, over the years, Ed Noonan has chosen to put much of his professional effort into real estate development. The firm also owns its three-story building, which returns a profit. Fees from in-house development projects generate up to one-quarter of CAPA's income each year. The firm puts money only into things that generate fees and/or equity; "they are investments selected to support the professional practice, not conflict with it," says Tom Forman.

For years the firm has set its fee for contract administration at ten percent but is now questioning whether that may be too low.

COUNTING ON COMPUTERS

Nonetheless, that professional practice still faces many of the same financial management demands that any office does. With as many as six government housing and/or social service facility projects under way at any given time, CAPA has the same problem with delayed fee payments that others do. Borrowing money is "a constant battle." Banks require proof of ten to fifteen percent profit from a firm like CAPA before they will provide financing. The main value of accountants to CAPA, according to Forman, is to help us "show good paper to bankers and real estate investors." He also consults them on investments. Yet the issue of accrual versus cash accounting—with the former making a firm's financial position look far better than it really is—raises the same question for Forman as for others who do government jobs: "Is it fair that architects are required to bankroll the development of these projects, given their value to society as a whole?" Having once had ten government jobs all awaiting payment simultaneously, CAPA has reluctantly limited the amount of subsidized housing work it will take on, simply because the firm feels it can't afford to finance such jobs.

CAPA's first use of computers was in its accounting process, based on proprietary software. Their accountant now comes into the office every three months to obtain the information he needs for all financial statements directly off the computer, the office itself having prepared the monthly reports. The accountant also serves as counsel on matters such as capital purchases, employment expansion, and various tax requirements. This process enables CAPA to keep current on all jobs, billing the hourly-rate projects monthly. By making sure all time sheets have been entered by month's end, not only are bills sent out promptly, but reports on how much time has been spent on each project to date can be made available to those managing them.

Employees enjoy sunlight and abundant greenery as they dine in this CAPA-designed atrium cafeteria.

Project management at CAPA makes use of a three-year-old electronic database, broken down trade by trade, to predict construction costs. This spreadsheet, which begins at the schematic phase as a careful estimate of costs, gradually becomes a record of actual expenses as the job proceeds through construction. These data are stated both in square footage and cubic footage figures. While this study is conducted primarily to determine costs, information on how long it takes to carry out various stages of building is being recorded as well.

CAPA now also charts the amount of hours it spends on contract administration. Increasingly they have jobs that, at some point, are suspended or delayed: Of thirty-five current projects, CAPA has fifteen that were stopped for three to twelve months due to funding glitches, bureaucratic delays, and/or slow agency approvals. Recommencement of such jobs creates additional costs. For years the firm has set its fee for contract administration at ten percent but is now questioning whether that may be too low. With all the problems that seem to complicate the construction phase these days, they have decided to find out exactly how much time is required so that they can appropriately increase the amount they charge for that service.

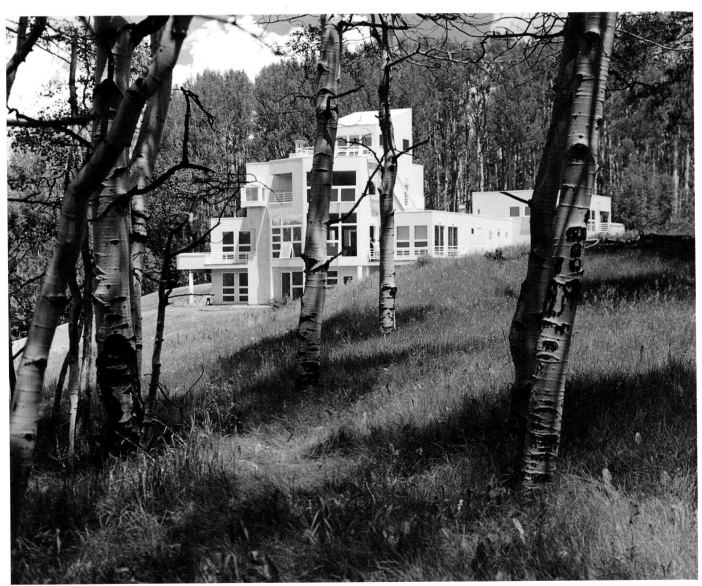

CAPA takes on the design of the occasional private residence but only after clarifying the unrealistic financial expectations such clients sometimes bring to the process.

Croxton Collaborative, P.C.

RANDOLPH CROXTON AND KIRSTEN CHILDS, PRINCIPALS

QUALIFICATIONS: Croxton: AIA

B. Arch., North Carolina State University

Childs: ASID

Design and Arts degree, Edinburgh College of Art and Architecture

FIRM BACKGROUND: Croxton: Croxton Collaborative, 1978–present

Wolf Associates, 1974–77

I.M. Pei and Partners, 1968–74

Childs: Croxton Collaborative, 1985–present

Ehrenkrantz Group, 1979–85

Armstrong Childs Associates, 1973–79

Richard Meier Associates, 1971–73

Skidmore, Owings & Merrill, 1969–71

PRACTICE SIZE: 2 principals, 10 employees

Randolph Croxton and Kirsten
Childs, Principals

ONWARD AND UPWARD

Since its founding twenty years ago, the Croxton Collaborative has continued to reinvent itself. Over the past decade that pace has accelerated.

Here are some of their recent innovations:

- "Green design" as specialization
- Strategic use of public relations
- Management decentralization
- Business reorganization
- Comprehensive computerization
- Dramatic new office location
- Excellent benefits program

Known primarily for its provocative design work on the national headquarters of both the Natural Resources Defense Council and the Audubon Society in New York, this firm met the construction downturns of the late eighties with vigorous measures. In addition to their widely recognized efforts toward energy conservation in architectural

design and the specification of environmentally sound building materials, principals Randolph Croxton and Kirsten Childs have made many other changes in the way this firm operates. Together they have made it a totally different business from what it was ten years ago, offering a number of lessons for other architects and designers.

Probably the most outstanding aspect of the Croxton Collaborative's restructuring lies in its evolving marketing program. Faced with the same depressing prospects as most other firms in 1989, they decided to hire a publicist. The intent was not just to achieve general publication or name recognition, but, in their words, "to leverage their investment in the intellectual equity of the firm by increasing their professional credibility, thereby generating greater income in the long run." This was to be part of a strategic change in the firm's direction—emphasizing values, priorities, and process.

PROMOTING "GREEN DESIGN"

Croxton and Childs, who had by then completed the NRDC job and were beginning work on Audubon, saw it as a way to share the research-based approach to design that they were developing with a wide audience—environmentalists and environmentally concerned institutional managers, as well as professional colleagues. The result was remarkably thorough coverage of those two jobs, particularly Audubon House, whose many unusual features combined to make it an attractive media story. "Differentiation from the pack," says Croxton, "that's what has kept the firm alive."

As many readers already know, for those projects the Croxton office proposed unprecedented (at least by commercial standards at the time) energy conservation standards, backed up with thorough research and authoritatively presented to the respective boards of directors. In the same way, they proposed environmentally sound choices for building and interior materials—thoroughly checked out for negative ecological consequences—which the two agencies welcomed, particularly when Croxton was able to achieve them within "market-rate" construction budgets. Even when some choices raised initial construction budget figures, these clients accepted them because the life cycle analysis confirmed long-term savings. This was the story told over and over again by enthusiastic journalists who found the Croxton Collaborative approach to building design worthy of publication. Of course, the exceptionally attractive visual materials that documented the process, readily offered to them by the firm through its publicist, didn't hurt either.

Today Croxton and Childs insist that they remain "generalists" with little interest in specialization. Yet their success as "green designers" has lead to subsequent commissions for highly sophisticated building types, such as scientific research laboratories, as well as work for the federal Environmental Protection Agency, that under normal circumstances would never have been offered to a small firm. Croxton tells of giving a lecture on their work after which an insurance executive came forward to say that he wished he had known about them before his company had recently built some half-a-million square feet of recently office space. The good news was that they were contemplating putting up an equal amount in the near future: Would the Croxton Collaborative be interested?

Most of their work now comes to them through former clients, especially projects with environmental design potential. The firm long ago realized that its strength lay in its ability to maximize service to clients. When Childs joined Croxton Collaborative in 1985, she brought the NRDC along with her, having already done several interiors for it. "NRDC and Audubon are our strongest advocates," says Childs. "They have the spaces to show, and they believe in what we're doing." Both Childs and Croxton are better at having dinner with former clients to keep interest alive, they admit, than following up on new leads. "We should spend more time with those former clients who are less likely to recommend us on their own," Childs adds.

Faced with the same depressing prospects as most other firms in 1989, they decided to hire a publicist.

"Differentiation from the pack has kept the firm alive."

When choices raised initial construction budget figures, clients accepted them because the life cycle analysis confirmed long-term savings.

MANAGEMENT DECENTRALIZATION

Croxton and Childs have found that one benefit of having principals of both genders comes during interviews with prospective client boards or designer selection committees of those boards. "Our male-female dynamic helps in dealing with the complex agendas of interview committees," Croxton notes. "We never know which direction the discussion will go, but no matter what, one of us can satisfy their concerns. It gives us the depth that a sole practitioner can't offer." The firm's strong interrelationship of architecture and interior design is also an important factor in winning jobs. To emphasize their teamwork, both of them sign initial client correspondence. Furthermore, says Childs, "we're careful not to contradict each other in public!"

Since its beginnings, the Croxton Collaborative has been a sole proprietorship, with the "collaborative" part of the name describing its design process rather than its business structure. Recently, however, the firm became a professional corporation, a process that took almost two years to complete. His main motivation for making this change, says Croxton, "was to facilitate eventual ownership transition and to insulate individuals from liabilities [equipment and office leases, accidents, etc.] other than professional ones." As for the value of having a design firm that will be passed along to others, Croxton says, "like a shark, a design firm can't ever stop. Only by bringing younger colleagues 'up to speed,' by gradually turning responsibility over to them—vesting them with authorship—can a senior partner step aside without the whole thing coming to a halt." If that's properly done, he contends, then the new owners can afford to buy the retiring person out while still realizing an ample return for themselves.

Croxton Collaborative's design for The Audubon Society's national headquarters in New York City has been highly publicized. Photos: ©Peter Mauss/Esto (above), ©Jeff Goldberg/Esto (right)

The Natural Resources Defense Council headquarters by Croxton Collaborative, also in New York City, includes space-saving bicycle storage within the office itself. Photo: Marco Ricca

Randy Croxton is proud of the interactive structure his strongly held principle of design collaboration has fostered. Now it is becoming a management process as well. Slowly the firm has been developing a hierarchy beyond the two principals. It began as a project management technique; Lauren Reiter, who has been with him for thirteen years, served as project manager on the Audubon House job. Now she and two others, Ron Gable and Richard Price, are assuming further management responsibilities. Price, for instance, is now in charge of all human resources decisions, countering a tendency by the older principals to pull staff off assigned jobs to deal with short-term tasks and assorted crises.

BUSINESS REORGANIZATION

The gradual sophistication of this firm's approach to running itself is clearly illustrated by its history of financial management, a chronicle that spans three eras. Until 1981, for the three years he operated the business out of the ground floor condominium office in the town house where he lived, Croxton paid the bills and noted deposits in a checkbook, careful to "keep a true balance." After a 1982 IRS audit, he began employing a full-time bookkeeper and working with an accountant for tax purposes in order to better control petty cash.

Until 1981, Croxton paid the bills and noted deposits in a checkbook.

Environmentally conscious design doesn't preclude elegant detailing, as these corporate offices by Croxton Collaborative clearly demonstrate. Photos: Otto Baitz

At about the same time, contemplating a favorable low-rent lease on a Madison Avenue property (which the firm would inhabit for the next sixteen years), he went to Arthur Young, a major accounting firm, and requested a retroactive financial statement. With that documentation, he secured a $100,000 loan that was entirely used to remodel the second floor of the Madison Avenue building, which had once been a stable. As a result of the savings in rent, that loan was entirely paid back within six years. Relatively low rent has continued to pay dividends on the decision to plow everything into that 1981 remodeling job.

In mid-1994, as a consequence of its newly acquired contract with the EPA, the Croxton Collaborative underwent a federal audit that, Croxton says, "brought our standards up to a stunning level!" Now the firm uses Sema4, a computer-based spreadsheet program that enables them to track all payables and receivables as well as time logged to date on every project, along with the ratio of billable to nonbillable time for each staff member. They can now project future profitability. This program has "pushed the wall of darkness six months further out," as he puts it. In addition, Croxton now consults with Joe Roher, formerly with a major New York City architectural firm, to review its financial plans every three weeks; among other tasks, Roher updates their ongoing eight-months' cash-flow projection.

Although its design contracts vary a good deal, the office prefers to be compensated on an hourly basis. They try to avoid both lump-sum design contracts and those based on a percentage of the contract. Croxton has an enviable relationship with an attorney that allows him to obtain frequent counsel on contract matters, so his approach to contracts is more flexible and relaxed than it might be for other firms. He quotes legal advice received early in his practice: "First, get as large a retainer as possible; second, bill immediately; and third, if you don't get paid, stop working." When Childs and Croxton must explain to a prospect why they won't work for market-rate fees, they find that their widely publicized commitment to research-based design helps them make that case; they can show that "environmentally conscious design creates a dramatically increased return on investment for every building dollar spent, through productivity gains as well as maintenance and energy savings," as Croxton puts it.

COMPREHENSIVE COMPUTERIZATION

In addition to its computerized word processing and financial management arrangements, the Croxton office makes intensive use of electronic media for design, drafting, and other visual purposes. Virtually every member of this mature staff is computer-literate. Because of the flexibility that this level of "universal skills" makes possible, the office sees itself responding more quickly to change than a larger, hierarchically organized firm might be able to do.

In the period prior to 1988, the firm fluctuated in size from ten to more than twenty people. Croxton saw that beyond about fifteen people "the quality of the working experience changed radically." Since then the size of the staff has stayed below that point. Croxton and Childs say that because of the computer productivity has soared and the firm is now doing much more work than it was capable of doing a decade ago. For example, by means of the Lotus Organizer program, the appointment schedule for everyone in the office can be accessed in order to plan joint meetings, while Sema4 permits immediate assessment of current work loads.

The office also employs an HP Deskjet 6500 plotter that offers an unlimited color range. This tool has facilitated the firm's virtuosity in computer-generated graphics, a technique that they frequently use to illustrate their elaborately documented research presentations. An associated laser printer quickly and inexpensively prepares computer-generated full-color portfolio display sheets that have helped Croxton

Garth Sheriff + Associates

GARTH SHERIFF, PRINCIPAL

QUALIFICATIONS: B. Arch., University of Southern California
President, Architects/Designers/Planners for Social Responsibility (ADPSR)
Board of Directors, Show Coalition

FIRM BACKGROUND: Allen & Sheriff, 1977–84
Sheriff + Associates, 1975–77, 1984–present

PRACTICE SIZE: 1 principal, 1 full-time employee, 2 contract employees

Garth Sheriff, Principal
(center), Bill Bernstein (left),
Roy Shacter (right).

OUTSIDE INVOLVEMENT

Sheriff + Associates definitely operates like a big office—except that there are usually no more than five employees working there at any given time. "My goal is to give my clients large-firm quality using a small senior staff," says Garth Sheriff, a native Angeleno who still lives just a few miles from where he grew up in Manhattan Beach. He maintains a spacious office not far away, at least by L.A. standards, in a dramatic Corbu-style building.

"I wear four different hats at any given time," says Sheriff. "My architectural hat; my ADPSR [Architects/Designers/Planners for Social Responsibility] hat, which has involved various roles over time; there's my Show Coalition hat, which is the largest nonprofit in L.A., encompassing the entertainment industry and the arts; and finally there's my newest hat, as a documentary filmmaker, working through the ADPSR Media Center for the Common Good." He calls this synergy his "larger world strategy for public relations."

This combination of entrepreneurial and architectural activities, with a strong liberal political focus (he's also active in national Democratic Party politics), characterizes Sheriff's unique approach to professional practice. It involves a good deal of "true pro

bono, stand-alone time," as he puts it, "which is not directly related to Sheriff + Associates," rather than being financially supported by the firm. Yet he is an architect who promotes his firm at every opportunity, so it hardly matters which hat he is wearing.

SELLING CAN BE FUN

Marketing seems to come naturally to Garth Sheriff. He always greets people with a big smile and conveys through his body language a responsiveness to their interests; that's his style. "Rather than just make people aware that I'm an architect by profession, I inquire within each of the arenas in which I'm active where prospects might be found." And it pays off: Sizable jobs have materialized recently through both Show Coalition and ADPSR connections. Sheriff + Associates has always worked hard on outreach to potential clients, including experimentation in the past with elaborate promotional brochures

"Design for Success," the concept that Sheriff + Associates markets to its commercial interiors clients, sometimes leads to dramatic results. Photo: Jack Boyd

"**F**rom the first moment of contact you must emphasize technical mastery in order to succeed."

"**A**rchitecture, by its nature, is a 'hair on fire' profession, meaning that immediate problems often consume the principal's attention."

based on a multispecialization approach. In general, Sheriff has a good history of following up on leads; right now, however, he feels that he could benefit from computerized "personal information management," although he currently uses the Franklin Planner, a paper-based time management system.

"Selling is a wonderful mystery," notes Sheriff. He speaks of the importance of considering oneself as "already chosen" by a prospect—particularly one who has been referred to you—and proceeding with professional assurance to advise the client on how best to approach the job. "From the first moment of contact you must emphasize technical mastery in order to succeed." While he concedes such an approach doesn't apply to situations where many firms are being interviewed, Sheriff believes that when you are a short-list candidate, it can help to build client trust if you focus on solving their problem rather than elaborating professional qualifications.

In recent years, custom residential design has been Sheriff + Associates' primary focus, a specialty that benefits from what Sheriff calls his "high-intensity personal relationships" with clients. So, through wide-ranging personal contacts he gets the job and negotiates a good fee; then he "sets the design vision" before turning the work over to his senior staff, who complete the project's technical documents under his direction. Finally, to keep client confidence strong, Sheriff makes sure he gets to the jobsite frequently. While he cares a good deal about how buildings get built, he's not so taken with "the craft of drafting." He concentrates on the service needed to realize the product, counting on his longtime associate, Bill Bernstein, and others to micromanage the jobs. Essentially, they do about three-quarters of the work.

DESIGN FOR SUCCESS

In fact, Sheriff + Associates is consciously structured to facilitate its principal's multifocus activities, not to inhibit them. He conceives of it as analogous, from the service perspective, to a large firm with a highly competent senior staff and almost no other employees, with the exception of short-term drafting help for large projects. This is coupled with his view regarding efficiency, that management "involves juggling, but dealing with the balls only on the way down. Architecture, by its nature, is a 'hair on fire' profession, meaning that immediate problems often consume the principal's attention." Sheriff usually finds himself mixing pro bono and design work during the day, often returning at night to focus, "laser-like," on the architectural tasks.

Sheriff + Associates has specialized in several fields over its twenty-two-year history. During the eighties, the firm did roughly one-third of its business in retail design, usually national accounts involving franchise stores. For this type of work, Sheriff devised a marketing program called "Design for Success," emphasizing the contribution of distinctive design to retail sales. Another third of the projects were general commercial projects, with the rest being housing, including some development work for big homebuilders like Kaufman and Broad. Not only did opportunities in these areas of large-scale practice drop off in the late eighties, but Sheriff found himself frustrated by the limited possibilities they presented for design elaboration. Thanks therefore to its ongoing custom residential commissions, Sheriff + Associates has continued to thrive, despite the recent economic turmoil in Southern California.

SHARED RESPONSIBILITIES

One important reason for the firm's ability to produce consistently high-quality projects without the principal's full attention is Bill Bernstein, the "core individual of the firm," according to Sheriff. Having come to L.A. after graduation from Ohio State, Bernstein was hired as Sheriff + Associates' first employee in 1976. Sheriff believes that "Bernstein is firmly a product-oriented guy who moves comfortably between design, construction

Designing residences suitable for Hollywood moguls fits naturally into Garth Sheriff's multifocus approach to professional practice. Photos: Jack Boyd

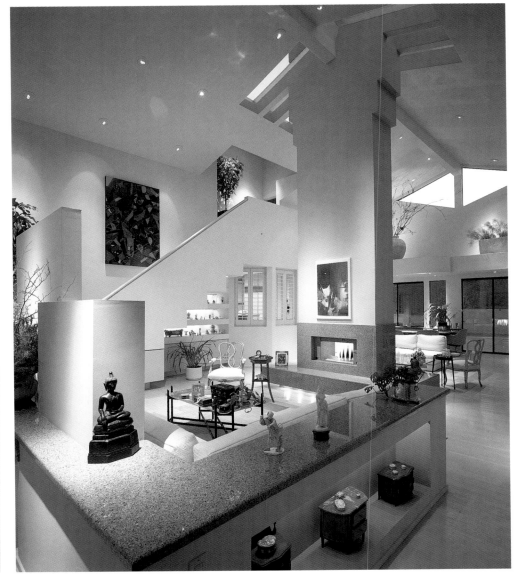

"I only offer free services, such as analysis of a prospect's budget or scheduling requirements, when they help me to better understand the project."

documents, and client relations." He prefers to leave the business stuff to somebody else while, as project architect, he manages jobs and directs others to crank out the drawings. "Bill likes the stability of our arrangement," comments Sheriff, "which offers him autonomy, flexible hours, and project authorship along with good remuneration. The pleasure of working directly with clients, engineers, vendors, and others while overseeing the building process is what satisfies him." As a result of this long-term, symbiotic relationship with Sheriff, Bernstein is in effect able to practice without fiduciary responsibilities. Other senior-level associates who work as "consultants" as the firm's project load fluctuates are Roy Shacter and Alex Vassil, both of whom now work independently as well.

In practical terms, the office is run collaboratively. Sheriff believes in empowering his staff to organize their own work patterns. He likes to manage "by walking around," spontaneously creating "minipartnerships" with his colleagues; as he does so, he solves technical problems with them rather than imposing the answers. He sees it as "a tool to prod individuals to develop their own architectural thinking, a way to make detailing an intense experience and to keep employees productive."

Although Sheriff claims to be fascinated with computer technology, CADD plays no role in the practice at present, since, as he puts it, most of their projects are "one-off." Word processing is used for specifications, schedules, project management reports, and most accounting. Personnel records are modest, partly because neither health care insurance nor a retirement plan is offered. Time sheets are not computerized, and

Customer feedback helps Sheriff + Associates refine their approach to the high-profile retail stores they design for national chains.
Photo: Jack Boyd

Sheriff prepares paychecks manually. Instead of a salary, he pays himself by frequent "draws," thus taking profit over the entire year. He makes plain how he manages the firm's income: "I use as much of it as possible to enrich my life style, and only as much as necessary to make the office work."

TOUGH ABOUT MONEY

Profit is as important to him as the quality of the product his firm offers. Financial management is not something with which he is unfamiliar, having completed half the credits toward an MBA at the University of Southern California. "My ideal is to have two months' gross cash flow in reserve," he says, "but since that's rarely the case, debt collection has to be amiable but firm and assertive." He feels that since architects' and designers' work is usually phased, getting paid is easier for them than for those who can only offer a completed product. "Thanks to the sequential structure of our contacts, we have power over delivery of the desired project conditional upon delivery of the agreed-upon fee. It's a matter of attitude—if architects value what they give, then they aren't going to be timid about collecting what's owed them."

Sheriff also considers himself a firm negotiator when it comes to working out client contracts. "I only offer free services, such as analysis of a prospect's budget or scheduling requirements, when they help me to better understand the project. And I do feasibility studies when they're requested of me on an hourly basis." If the scope of an architectural project is not established, he'll do the programming and design phases on an hourly basis, but in most cases he likes to work for a fixed fee. Assuming the scope is clear, and using percentage of construction cost as a guideline, Sheriff carefully spells out for the potential client the comprehensive services he'll provide in that case for the proposed lump sum (which increases only if the scope of the project increases). He continues: "I consider myself very aggressive in requiring that the fixed fee be in phased payments, with large chunks in each phase. That's part of my general philosophy that an architect's services are valuable and should be fairly compensated while the job is being done, not later."

He begins by requesting a large retainer, typically twenty percent, which he then pays back as each phase of his contract is completed. Thus, both preliminary design and design development are typically billed at twenty-five percent with twenty percent off, or twenty percent of the total fee. If at any stage the job is stopped, his firm is still ahead. The advantage of this approach becomes especially clear at the contract administration stage, the fee for which Sheriff + Associates divides into equal payments over the scheduled construction period. If those payments falter, he just stops going to the job. This tough position grows out of his experience that, given the positive feelings that flourish at a project's inception, "if a client is balking at giving you a retainer that you've already promised to give back as the work proceeds, doesn't that fact tell you money is going to be a constant problem here?"

DESIGNER AS "PARENT"

After the challenge of running Sheriff + Associates, Sheriff's "second most important job" is "parenting a universe of interested parties, each of them with doubts and concerns. It's my greatest strength and greatest frustration." Clients, of course, stand first in line here, given the amount of risk they are dealing with as a project proceeds. But he believes contractors and vendors also "respond to a judicious combination of guidance and approval, similar to that which a parent provides to a five-year-old trying out a diving board for the first time." Sheriff and his wife, Lauren, who is an aircraft industry executive, also enthusiastically share the parenting of two young daughters, a process he calls "adventures in child management."

"My ideal is to have two months' gross cash flow in reserve, but since that's rarely the case, debt collection has to be amiable but firm and assertive."

"If a client is balking at giving you a retainer that you've already promised to give back, doesn't that tell you money is going to be a constant problem here?"

Still, Sheriff admits that sometimes he needs parental assurance, too, especially when he's out looking for commissions. For the most part, though, he finds the practice of architecture empowering, a process so open-ended that endless "growth changes and career metamorphoses" are possible. All of his present endeavors have, in effect, resulted from this search for the next possibility. He thus has no plans to retire but imagines himself moving on into other fields, such as filmmaking as it relates to architecture, as time passes.

No matter how large the project, Garth Sheriff believes that firm negotiation is crucial when it comes to working out client contracts. Photos: Jack Boyd

ALEXANDRA GARRISON

Glenn Garrison, Principal

"Integration of design, technical development, and project management must be substantially more effective than in the past."

Glenn Garrison, Inc.

GLENN GARRISON, PRINCIPAL

QUALIFICATIONS: B. Arch., University of Texas

M. Arch., Yale University

M. Arch. in Urban Design, Cornell University

NCARB, Registered Architect in New York and Illinois

Loeb Fellowship in Advanced Environmental Studies, Harvard University

FIRM BACKGROUND: Philip Johnson/John Burgee Architects, P.C., 1970–84 (Associate 1976–80, Principal 1980–84)

Kohn Pedersen Fox Associates, Executive Project Manager, 1985–91

Glenn Garrison Incorporated, Integrated Architectural Management Consulting Services, Principal, 1992–97

PRACTICE SIZE: 1 principal

MANAGEMENT AS AN OUTGROWTH OF DESIGN

Glenn Garrison is an architect with a strong commitment to design who, over a long period of time spent working in prominent offices, found himself deeply involved in the management as well as the design of many large, complicated, and high-profile projects like the IDS Center in Minneapolis and the NASA Headquarters in Washington, D.C. It is his conviction that "integration of design, technical development, and project management must be substantially more effective than in the past," given the demands of present-day architectural and building practice.

A gentle and unassuming person, Garrison has had a career full of impressive achievements. He estimates that he has had direct responsibility for perhaps two billion dollars' worth of construction over his twenty-five years in practice, during which time he has developed clear principles for how design practice can be carried out to everyone's satisfaction. Today he shares this wisdom with others by acting as a management consultant. He is particularly proud of the many distinguished buildings for which he served as "project architect," pointing out that "project manager" does not take into account the central role he played in the design development of such precedent-setting projects as those he did while at Johnson/Burgee, including the Pennzoil Building in Houston, the Crystal Cathedral in Garden Grove, California, and the PPG Center in Pittsburgh. In these cases, his contribution to design and detailing played an important role in the project's design quality.

QUALITY MANAGEMENT PROGRAMS

Garrison's prescription for achieving this heightened level of collaboration between the parties involved in building design and construction is based on the principles of Total Quality Management (TQM). "This concept, used by manufacturers and other corporations with complex operations for many years, has not been as fully utilized in construction as it might have been," says Garrison. "Architects have been particularly slow in responding to this operational business philosophy, an approach originally conceived in the United States but first put to active use in Japan."

"Integrated Architectural Management" is Garrison's own version of TQM. It "incorporates top-to-bottom cooperation (within a firm) through teamwork, building a stronger, more effective organization, and it leads to improved marketing ability, client satisfaction, and profit through increased productivity, better communication, more efficient decision making, and higher employee motivation." He offers four categories of consulting services: Management Planning, Project Management, Educational Programs, and Quality Improvement Process Planning (QIP). These, in turn, are each

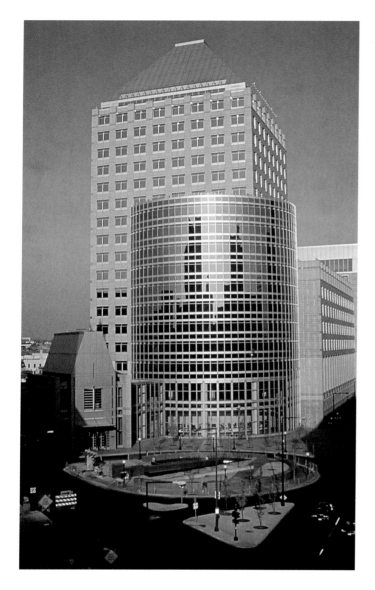

broken down into four or five specific analytic operations that may be pursued by the office that has retained him.

Garrison refers to TQM as a "horizontal corporation," meaning that hierarchy is replaced by teamwork. This is a practice Garrison finds "more common today in nonarchitectural corporate settings than among the design practices that serve them." While this is due partially to a lack of interest in management education on the part of design schools, Garrison feels it is also the result of the architectural profession being less open to change than it might be. Yet that reticence is evaporating as large clients demand that quality management programs be provided by their architects and designers.

APPLYING QUALITY MANAGEMENT PROGRAMS TO DESIGN FIRMS

"The most important source of interest in comprehensive improvement of a practice is top management, naturally; and the more openly a firm is structured—that is, the more decision-making has been decentralized—the more likely it is that the Quality Improvement Process (QIP) will take hold," observes Garrison. That is because, for QIP to be more than a superficial exercise, considerable time and money must be devoted to in-house education and discussion about reorganization of the way the business operates.

Garrison calls this TQM 101—the introduction to top-quality management that most architects and designers never had in school. In order for appropriate change to occur, the entire practice is examined, "including the mailroom," by the people doing the work. As a result of investigations like this, Garrison finds that "self-selection by interested individuals begins to build a management-

Coordination of large-scale construction operations, in Glenn Garrison's opinion, is a perfect application for the principles of Total Quality Management.

oriented group within the office." But he stresses the necessity to introduce TQM concepts to everyone for it to truly take hold.

When he goes into a firm as a consultant, Garrison sets up "Task Teams" made up of those actually involved in the various operations being examined. People are encouraged to take responsibility for the process in their own work areas. Often, he says, their sense that things aren't working properly proves to be overly pessimistic, but the small adjustments that come out of their team's analysis help them to feel more in charge and increase their productivity. "As a result of comprehensive self-study," Garrison finds, "everyone's enthusiasm for the firm's prospects increases dramatically."

MANAGING HIGH-TECH, HIGH-PROFILE PROJECTS

In 1989 planning for the NASA Headquarters building began. It was carried out by a team that included Boston Properties, the contracting firm of McDevitt Street Bovis, and the New York City architectural firm of Kohn Pedersen Fox, using QIP methods.

Design responsibility for demanding projects such as Houston's Pennzoil Building helped to shape Glenn Garrison's ideas about design practice management.

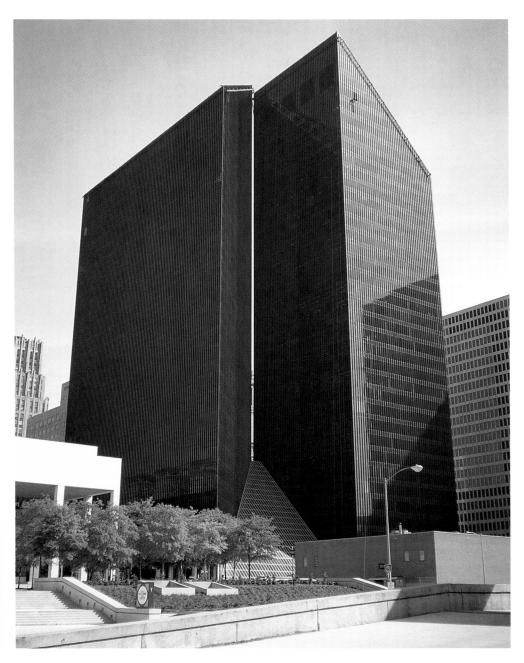

Management growth truly proceeded from the design impulse toward the practical, fueled by a strong desire to see the project built.

Garrison, as KPF's representative, was responsible for overseeing architectural design and production. He also became part of a jobsite quality-planning program team led by the general contractor. His project management tasks included listing daily priorities and work tasks with the owner. "The NASA Headquarters building quality program helped maintain an accelerated schedule which brought the job in two months early with corresponding budget savings," Garrison wrote in an October 1992 *Progressive Architecture* article. "It also led to an innovative model for increasing the effectiveness and cooperation of the project team—owner, architect, and contractor."

Some of Garrison's noteworthy projects while working at Johnson/Burgee—including PPG Place, the Crystal Cathedral, the Pennzoil Building, and the IDS Center—were jobs for which he had design as well as technical responsibility. All share one characteristic: Each pushes glass technology in an unprecedented direction. The crystalline clarity of each is due to Philip Johnson's esthetic inspiration, to be sure; but as every design professional knows, in order to construct such visions there is an enormous amount of detailed technical work to be carried out and coordinated.

That's Garrison's contribution. In part, it is his commitment to visual quality that deserves commendation. Beyond that, however, in the case of these technologically innovative buildings, it is also a matter of patiently managing the design process until elegant refinement of detail is achieved. In the end, that is what sparkles in the sunlight.

NASA Headquarters in Washington, DC was completed two months ahead of schedule by employing Quality Improvement Process Planning, says Garrison.

In this way Garrison gradually became a master of management because much of what he sought to accomplish happened in meetings with contractors and suppliers rather than on the drawing board.

Thus, his management growth truly proceeded from the design impulse toward the practical, fueled by a strong desire to see the project built. On the Crystal Cathedral, probably one of the most fascinating pieces of architectural sculpture of the eighties, the functional constraints against realizing such a building were monumental. In addition to extraordinary program demands (television and drive-in ministry facilities were as important as good sightlines and acoustics for the 4,000 seats actually provided), a visually minimal structure capable of resisting both earthquakes and high windloads (the Santa Anas) was called for.

The Crystal Cathedral in Garden Grove, California, is a dramatic example of Glenn Garrison's ability to handle complicated glazing technology. Photos: Tim Street-Porter (right)

Long empty, this building has been given new life by Harden Van Arnam as Friends House in Rosehill, a permanent residence for fifty formerly homeless people living with AIDS. Photos: ©Jeff Goldberg/Esto

studied four ramshackle Manhattan tenements over a two-year period before getting community approval to use the fifth building they found. The struggle finally came to a successful conclusion under Harden and Van Arnam's care. For each property, HVA prepared, at no charge, preliminary floor layouts to check out its single-room-occupancy potential.

"It's a totally ad hoc business," Harden says, "but we do what the nonprofits' representatives ask of us." Once in a while HVA does turn down a group whose intention seems to them to be doomed, either because no funding is likely or because of internal

Three distinct groups share this Harden Van Arnam-designed residence: single mothers with children (transitional housing), single adults, and mentally disabled people. Photos: Brian Rose

organizational problems. They find scatter-site rehab projects particularly trying, especially when the fee available barely covers the cost of their professional work. Nonetheless, when they accept jobs like that, they give them as much attention as they give to clients who offer a normal fee. Van Arnam and Harden calculate that about one-third of their commissions come from former clients, probably half from "word of mouth," and the other sixth are jobs that developed from free work they've done in the past. They have been referred for several new construction projects through the New York City Housing Partnership, a for-profit outfit that pays well and provides a twelve percent retainer.

PUTTING PEOPLE FIRST

One of the most pleasant aspects of this practice, in Harden's and Van Arnam's opinions, is dealing with their clients. Frequently they are people who do this work as volunteers or minimally paid employees themselves, and run the community-based nonprofit housing sponsorship organizations for whom HVA works. Harden notes that women often bring a nurturing approach to the challenging process of creating livable dwellings from the impersonal mandate and structure of government programs. "Particularly in the area of funding, these groups need a lot of guidance, so we do whatever we can to help," she says. "We offer a high level of service," adds Van Arnam, "so in the end there aren't many problems. To us, it's a people-first business."

Not surprisingly, HVA has no business plan. When asked what they would do if government funding for low-income housing work dried up entirely, Van Arnam says they would first go to other government agencies to present their credentials and then, if necessary, would seek private commissions, but not for residential jobs. Whenever they're asked to do residential work, even by members of the many nonprofit boards they've worked for, they invariably refer the request to other architects. Harden and Van Arnam believe that "wealthy people are just as bad at paying their bills on time as the government agencies, and they have no excuse. Spending after-tax dollars can be painful," Van Arnam understands, but he prefers not to share the pain.

Whether they are trying to put an acceptable face on these precarious financial arrangements or upholding their considered philosophy, Harden and Van Arnam vigorously disavow any interest in making a lot of money from their practice. They insist that they're having fun doing such work, and—besides—it's their privilege to do it. Even more extreme, while making sharp comments about a society that allows economic inequality to worsen, they appear to be satisfied with their fiscal situation. Furthermore, as Harden put it, "both of us have similar goals regarding money, and that's important for the business to work as it does. We'd rather enjoy life!"

INFORMAL BUSINESS PROCEDURES

Harden Van Arnam runs on very simple bookkeeping: Each principal takes a regular draw, and at the end of the year, after all bills are paid, they divide up whatever is left between them. Just before tax time, Harden manually documents the previous year's income and expenses for use by their accountant. She's thinking about setting up their annual totals on the office computer, but insists that keeping books regularly wouldn't change or improve their financial management.

As for benefits, there is a retirement account that allows Harden and Van Arnam to deposit up to fifteen percent of the firm's annual income. They make a monthly payment and then make up the difference at the end of the year. A profit-sharing provision allows them to add up to ten percent of the total each year as well. In addition, they carry a $1,000,000 errors-and-omissions policy that includes minimum liability and basic Worker's Compensation. For this they pay about half of what it cost them at the beginning of their practice.

Women often bring a nurturing approach to the process of creating livable dwellings from the impersonal mandate and structure of government programs.

"**W**ealthy people are just as bad at paying their bills on time as the government agencies, and they have no excuse."

Harden Van Arnam managed to achieve many playful details in their design for this children's developmental center in spite of a very modest construction budget. Photos: Brian Rose

Family arrangements figure prominently in both Harden's and Van Arnam's daily schedules.

With the principals trying to run jobs and draft at the same time, HVA's productivity can be seriously impaired.

Both partners have working spouses. Harden's husband, Don Bussolini, is an architect who has a salaried position, which allows Harden to be covered by his health insurance policy. Van Arnam's wife, Loretta, continues to run the general contracting business they started together, where she employs twelve to fifteen people. Family arrangements figure prominently in both Harden's and Van Arnam's daily schedules. Harden's husband's regular office hours enable him to pick up their son, Christopher, from nursery school most days; she's grateful for that, given the open-ended nature of small-office practice. Van Arnam and his wife, who works out of their home, have complex obligations as well, since they are raising a niece with the help of their daughter. Because of family obligations, both Harden and Van Arnam have to be creative with their daily schedules.

The degree of financial informality on which HVA operates is manageable because the office is so small. "Our expenses are fairly constant," says Harden, "so we know what we've got to bring in each month." Most of the time, they do the drafting themselves manually, proud of the remarkably thorough, even beautiful sets of drawings they produce. Only billing, correspondence, project cost estimates, and specifications are done on the computer. Nonetheless, Harden finds herself fascinated by the computer's potential to help working mothers. Having recognized the advantage of being able to draft on a computer at home in the evening, she has begun to master it. For his part, Van Arnam has taken a CADD course but finds drafting by hand "just too easy and enjoyable to give up."

Among other strong opinions that they hold about the state of the architectural profession these days, they lament the fact that an office like theirs cannot afford to hire permanent experienced professionals to help do the work. With the principals trying to run jobs and draft at the same time, HVA's productivity can be seriously impaired. Yet Harden and Van Arnam have trouble affording people who can take complete responsibility for preparation of contract documents, let alone any sort of project management. So when necessary they opt for freelance drafters, who sometimes have absolutely no understanding of what they're asked to draw. Even graduate architects require considerable guidance, given HVA's focus on renovating tenements and other masonry-bearing-wall buildings, a structural system with which they may not be familiar. Van Arnam also feels that, moving from office to office as they do, they often fail to develop experience in handling a complete project.

GETTING THEIR JOBS BUILT

Harden and Van Arnam each do the contract administration on their own jobs, occasionally visiting the other partner's projects to keep up with their progress. They try to eat lunch together every day to discuss project management and other business issues. Each does the necessary buildings department work for his or her jobs, along with attending obligatory community board and other approval-process meetings.

Documenting contract administration is handled differently by each partner. Van Arnam prepares no reports but chooses to communicate any questions or pressing issues by writing a letter to the general contractor with copies to the client and agency representatives. These have the virtue of highlighting his specific concern and focusing everyone's attention on resolving it, regardless of what else may be under discussion at weekly job meetings. Harden uses the traditional method of weekly reports that list everything that was discussed at the prior meeting. But she has also developed a technique of listing there everything that *hasn't* been resolved over time, with the name of the person whose responsibility it is to do so. It's similar to a punch list because it readily invites review in a way that a body of written text does not. Van Arnam considers HVA to be very effective at construction administration. "We deal with everything,

resolve all problems, and at the end of our jobs, everyone is happy, talking to each other without animosity, ready to work together again. That's just good solid management."

In spite of their best efforts, however, they find it hard to deal with government agencies' erratic schedules and open-ended processes. "It's hurry-up-and-wait," Harden says, "and most of the time, no one takes into account the problems stopping creates for us when it's time to restart." Contracts for projects funded by the NYC Housing, Preservation, and Development Department (HPD), their major source of commissions, are also problematic. There is never a retainer, and architects must wait until contract documents have been approved—and often until after the closing—before they receive the bulk of their fee (which runs from 5.5 to 7.5 percent of the general contract amount on those projects). As a result the firm usually must "front" a large portion of the production cost for almost all of its jobs.

As far as Van Arnam is concerned, the HPD contracts have little substance. If the nonprofit can't come up with the fee, or if it folds before the closing, then the architects are left with nothing, no matter what payment schedule has been agreed upon. Harden feels that the only issues worth negotiating in these contracts are liability and protection against the general contractor negotiating independently with the client to weaken the quality of the specs. As for following the job under construction, they've often found that HPD doesn't care whether the architect does it or not. Furthermore, they don't see any way that the profession is ever likely to organize in order to change these terms.

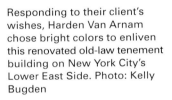

Responding to their client's wishes, Harden Van Arnam chose bright colors to enliven this renovated old-law tenement building on New York City's Lower East Side. Photo: Kelly Bugden

BETH GREEN STUDIOS

Nina Hughes, Principal

Hughes Group, Ltd.

NINA HUGHES, PRINCIPAL

QUALIFICATIONS: ASID

B.F.A. in Interior Design, University of Michigan

FIRM BACKGROUND: Hughes Group, Ltd., 1984–present

Mascioni & Behrmann, 1982–84

Griswold Heckel & Kelly, 1969–82

PRACTICE SIZE: 1 principal, 1 part-time employee

MASTERING NEW SKILLS

"Getting myself CADD-knowledgeable really made a dramatic change in my life," says Nina Hughes, principal of Hughes Group, Ltd., space planners and interior designers. "When I'm doing a project for one of my bank clients," she continues, "I get their base drawings on a diskette, and after I'm done, I send them back another diskette with all the plans right down to cabinetwork details. Yes, I have even learned how to do cabinetwork drawings on the computer."

Among the older designers and architects (those over forty) interviewed for this book, Hughes is unique in that she does almost everything in her practice on the computer, including drafting and design. As a result, her pleasant Manhattan office with its four computerized work stations is probably larger than it needs to be. However, early on in her business, in 1984, it was barely adequate to contain her staff. Nowadays, as she candidly admits, Hughes Group, Ltd., which at one point grew to five full-time and two part-time employees, is now a "virtual office" with almost all of the other people involved located elsewhere. In fact, it is a working model for what Nina calls "the lean and mean design firm of the future." She defines that as "cutting expenses to the bone, yet not feeling sorry for yourself; there aren't going to be a lot of staff jobs in these small offices, and those that remain will be multipurpose positions requiring full computer literacy."

A CLIENT-CENTERED COMPANY

Computerization is not the only exemplary aspect of how Hughes operates her business. Her dedication to client service would be worth talking about even if she still used a T square to draw up her plans. "It's fun to help clients grow and to change people's life styles, where they end up in interiors they couldn't have foreseen. A client has to be involved in the design process; it can't just be my vision. If it's only that, the design is a failure."

Hughes sees the designer's main job as nurturing and protecting clients. "My commitment is to them and to their project. Even so, I handle them carefully, because occasionally they get confused, not aware that they've made a ninety-degree turn. Then you have to help them think things through until they're clear. After all, the design process may be just one of the things they're doing in a busy day, and someone—their designer—has to be there for them when things may not be going as well as they expect. That's what drives this client-centered company."

Although she does some residential work, her mainstay is provision of space-planning and facility-design services to large corporations and institutions. It is with these clients that computerization is essential, because Hughes's ability to respond rapidly and accurately to their space-planning needs makes all the difference. Using a modem, she can tie into their computer network and acquire data on their facilities by downloading existing documentation. It enables her, drawing on vast experience in office layout, to respond quickly to their programmatic needs. She admits, "Field checks are still necessary, but basically the electronic system works."

"**A** client has to be involved in the design process; it can't just be my vision."

Another project she found fascinating to work on was a small-scale medical facility located in a low-rise suburban office building. In order to fit a cosmetic surgeon's bewildering variety of space needs into 1,000 square feet, Hughes actually observed him and his staff during several operations before she began design studies. As a result, she made judicious use of diagonal geometry in her scheme to maximize the operating room, provide secondary circulation, and meet complex plumbing requirements within rigid physical constraints.

Nonetheless, Hughes looks at specialization as "a marketing ploy." She believes that a good and properly trained designer can design almost anything. "However, clients need the security of having a specialist. So I market my specialties, which includes historic preservation." Having studied, among other things, cold-calling techniques with a business coach, Valenti, Smith & Associates, Hughes knows how to look for new commissions. When she sees that the firm's work load may be falling off six months into the future, she devotes one morning a week to calls, mostly to people she knows, and stays at it until she gets results. "Marketing for me can't be done long-term," she says, "but with CADD, and the way it has lowered my overhead, I actually don't have to promote the firm as actively as I did before."

TOTAL COMMITMENT TO COMPUTER LITERACY

One project that kept Hughes Group busy for more than three years was the space planning and interior design for the New Jersey State House Annex in Trenton, a preservation

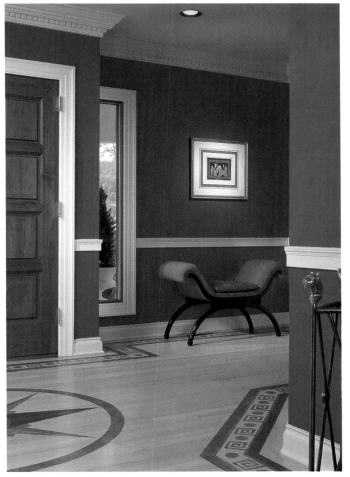

Dedication to client service, especially on residential jobs for people who have never worked with a designer before, is a hallmark of Nina Hughes's practice. Photos: Tim Lee

project of over 100,000 square feet of space. "If this small firm had not had sophisticated computer capability, we could not have done that project," says Hughes. Completed in 1995, this job involved fourteen separate furnishings contracts, each of which generated a substantial volume of specifications material. In addition, the entire design process was carried out and all contract documents were produced by a computer-literate core staff of five, plus two or three freelancers when needed.

Hughes took an introductory AutoCAD course in the mid-eighties at F.I.T. After that she began urging her employees to take such courses, underwriting the costs as a staff development expense. Since then, Hughes has taken every opportunity to develop applications of computer technology for her practice and to sharpen her own skills at using them. She does so with the help of her tutor, Phil Gaunt of the Pratt Manhattan Center, because this is the only way she can find time to do it. Praising the computer as a design tool, something few designers will do these days, she says, "Once you get familiar with CADD, it changes the way you think about design. For instance, it's much faster

"**O**nce you get familiar with CADD, it changes the way you think about design."

Computerization enabled Hughes Group Limited, a small firm, to manage restoration of more than 100,000 square feet of space in New Jersey's State House Annex (this page and opposite). Photos: James D'Addio

"**I**n the long run, computer literacy is a matter of survival for the small design firm."

than yellow tracing paper for coming up with options and variations on a space-planning problem, all of which can be saved. It also makes the design less sacred, in part because you invest less physical energy in the process!

"In the long run, computer literacy is a matter of survival for the small design firm," Hughes asserts, and urges fellow principals to find someone who can help them acquire comprehensive computer skills as soon as possible. In addition to its CADD versatility, her small practice is a showcase of diversified applications for financial and project management. To record time sheets, Hughes uses the Timeslips III program, which identifies tasks by project number and twenty-five major billing categories. The time data can be customized to serve specific functions, including on some versions the ability to prepare invoices. She finds that, for her purposes, it is easier to use than Sema4.

Working with her accountant, Hughes makes use of Quicken, a program that allows her to project costs and estimate the firm's expenses for twelve months, which she feels is long enough in her case. She also uses Lotus spreadsheets to account for cash outlays over the next year. Hughes doesn't attempt to predict how work will come in, but at the beginning of a fiscal year she takes the amount of money left over from the previous

Lively spaceplanning solutions by Hughes Group Ltd. are the result of its principal's experience in that specialty, combined with her adventurous approach to design. Photo: ©Christopher Lovi

year and makes an assessment of how far that will take her before she needs to get on the telephone. Once she does, she uses the marketing program ACT! to keep track of her efforts to promote the firm.

Human resource management is greatly simplified by the computer, if Hughes Group, Ltd. serves as a paradigm. There are no more permanent staff jobs; the computer-literate principal does everything without administrative or clerical help and can still carry a substantial design work load, especially with the on-call assistance of efficient CADD-skilled freelancers laboring elsewhere. "When you run a tight and lean organization," reports Hughes, "you can afford to pay consultants well because the overhead is so much lower than when people are sitting on chairs in the office." There isn't room for entry-level jobs, since Hughes finds that even computer-trained graduates require too much supervision.

WORKING FOR MONEY

"The business has to earn money in order to stay in business," she says when discussing contracts, "and you can't take a job when you're going to lose money. In almost all cases my fee is negotiated, based upon what I need to function, what the business needs to function, and what a client is comfortable paying. It takes a lot of money to keep the office going, although, thanks to computers, it's a lot less than it used to be."

At the same time, Hughes recognizes that her husband's support has been crucial in allowing her to practice at all. "For the first few years I drew no salary. Without him behind me, I wouldn't have been able to survive those early, difficult times." She looks around her cheerful office at its simple furniture—chairs from Bon Marché, tables from the Door Store, and that kind of gray-painted sheet metal shelving that comes unassembled—and reminisces about frugal purchases made thirteen years ago when she started on her own. "I've never borrowed, because when I needed it at first, my bank wasn't interested, and now that I could get a loan, *I'm* not interested," says Hughes. "All the investment has been our personal money. It would be impossible to start a design business today without collateral."

Hughes groups her commissions into three categories:
- Residential jobs, for which she offers a letter of agreement based on a design fee of between seventeen and twenty-five percent (decorating services are covered separately at $125 an hour), with a retainer of up to $1,500 requested of new clients.
- Large corporate contracts in which the scope of work is fully defined, so that a lump sum or an hourly rate with an upset figure is acceptable (retainers are never available).
- Smaller commercial projects, especially first-time clients, where the fee is always hourly, because "the discovery process takes a good deal of time," she notes.

Hughes Group, Ltd. has a noncontributory pension plan of the type called defined-benefit plan. The business makes a yearly contribution for each of its employees. They become eligible to participate after one year's employment and do not make contributions to the plan. When staff members leave the office, they receive a generous cash payment that is usually rolled over into their own tax-deferred account as a nest egg. Hughes chose this over health insurance because she discovered over the years that young employees seemed to have little interest in the latter. She is still in close touch with most of her former employees and calls on them when her work load requires freelance assistance.

"**W**hen you run a tight and lean organization, you can afford to pay consultants well because the overhead is so much lower than when people are sitting on chairs in the office."

"**I**'ve never borrowed, because when I needed it at first, my bank wasn't interested, and now that I could get a loan, *I'm* not interested."

SPEAKING AS A PROFESSIONAL

Hughes, a certified interior designer, has long been a prominent figure in New York design circles, having worked hard with other colleagues to get a New York State Interior Designer Certification law enacted in the early nineties. She takes her professional standing very seriously and feels strongly that improved education for interior designers and architects is a necessary step to raise society's perception—and thus its willingness to pay adequately for the services—of the design professions.

Scheduling and documentation of construction—both of them aspects of project management—are areas where Hughes serves the client's interest through scrupulous attention to process. They are areas where, not surprisingly, she sees the computer playing an important role. "We document heavily by memo. On the [New Jersey] State House project, I personally wrote nine hundred and sixty memos during the course of the work, and that doesn't include those prepared by four others on my staff."

Hughes Group, Ltd. carries professional insurance, renewed annually, that includes $1,000,000 worth of errors-and-omissions coverage plus a commercial package of general liability insurance with a completed-projects clause. The latter protects her firm if there is an accident and someone is injured after a project has been completed. Hughes notes that there are relatively few sources of insurance for interior designers, the major one being broker Albert Wohlers of Chicago, whom she found through ASID.

"To design well for a client-centered company, you have to be solid as a person," she states. "Working on so many levels—technical, financial, esthetic, even spiritual— you must be centered, loving and respecting your client. In addition, I've never experienced any gender-related problems on the work site, because I do my job well, treating craftsmen and tradesmen with respect. After all, they are the ones with the responsibility of building the design. When you deny dignity to others, you deny it to yourself."

In order to be sure this new surgery room met the needs of her client, a cosmetic surgeon, Nina Hughes actually observed him at work in his previous operating room. Photo: Tim Lee

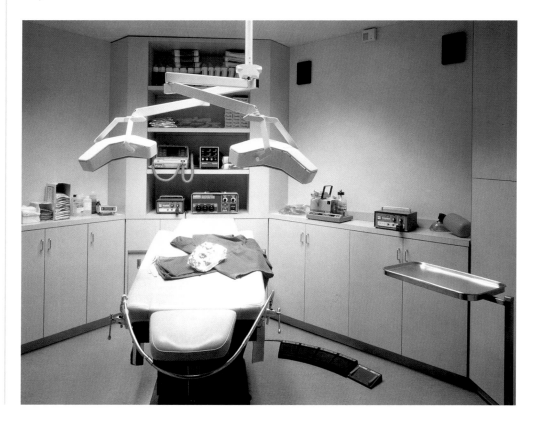

Janice Stevenor Dale Associates

JANICE STEVENOR DALE, PRINCIPAL

QUALIFICATIONS: B.F.A in Interior Design, Northern Illinois University
Graduate studies in Architecture and Design, University of Southern California
International Interior Design Association (IIDA), Board of Directors
Architects/Designers/Planners for Social Responsibility, Board of Directors

FIRM BACKGROUND: Janice Stevenor Dale Associates Inc. (JSDA), 1992–present

PRACTICE SIZE: 1 principal, 4 employees

Janice Stevenor Dale, Principal

THE VIRTUAL OFFICE

"Virtual office" is not a notion that frightens Janice Stevenor Dale. This Los Angeles-based interior designer has taken a good look at the concept and finds that it offers great business potential. Her own practice, cleverly organized to make the most of limited resources, includes a number of associates working on their own, far from her compact downtown L.A. headquarters. They communicate electronically as a matter of course.

In fact, one of JSDA's clients, Kinko's Copies, Inc., is also interested in the "electronic cottage" concept, and the two joined forces recently to produce a display booth promoting cyber-workspace at the Pacific Design Center in Los Angeles. As it is, Janice makes use of all applicable technology to tie her "virtual staff" together, including a link through her reprographics shop (and client), Ford Graphics, which offers many services—blueprinting, CAD plotting, messenger services—that the firm uses. "It all fits neatly together," she smiles, "a synapse of people working together to provide services in a new way."

FLEXIBLE, SMALL, AND RESPONSIVE

Innovative human resource management, therefore, is an important distinguishing factor in Stevenor Dale's approach to the business of design. Janice Stevenor Dale Associates is, in her words, "a virtual corporation—flexible, small, and responsive," that puts together project teams based on the varied experience of four or five professionals, most of whom for their own reasons wish to work only part-time for JSDA. Some people have family obligations that keep them from taking on full-time employment. In another case, a person with AIDS could put his CADD skills to productive use without having to travel every day. Others who tend to work in the office are recent graduates of either UCLA or Cal State Long Beach whom Stevenor Dale has identified while teaching as an adjunct faculty member of their respective interior design departments.

Recognizing that part-time employment has financial drawbacks for those who depend on it, Stevenor Dale has been careful to structure her policies to minimize them. Her pay scale is higher than normal—on an hourly basis—to take inevitable downtime and individual tax obligations into account. A major issue for such a loosely structured outfit, of course, is health care coverage. Because of discontinuities in staffing, the firm doesn't provide it, but Stevenor Dale has thought about the issue. She believes that by asking her colleagues to pay for their own coverage, they are more aware of the benefits of healthful living; besides, she says, in Los Angeles, Kaiser Permanente offers low-cost health insurance programs that make health insurance affordable for her young colleagues.

Stevenor Dale has also given thought to efficiency: "The challenge of our profession, of being remunerated fairly, is the control of hours invested in any particular task," she states. "Yet keeping people constantly motivated to perform at a speed required by business today is impossible, so you have to take employee stress patterns into account when mapping out the number of hours required for a job." By that she means such things as the tendency of staff members to slow down the day before holidays, or to avoid getting down to work in the mornings if she's out at an early meeting—common situations in office culture.

"The challenge of our profession, of being remunerated fairly, is the control of hours invested in any particular task."

"At the same time, I try to nurture independence," she says, "and to empower my employees, encouraging them to use me as a knowledge source. Yet whether they're working in the office or outside, I ask my people to hold their questions until they know we can talk—it's just a smoother way to operate." She also encourages productivity by making her colleagues aware of their responsibility for meeting project time budgets. Using computer programs that facilitate and document time budgets, she breaks the contract phases of various jobs into half-day chunks that suit the needs of her distant staff. These data make it easy for them to monitor their own progress, no matter where they are working. Even so, "clients today, because of the fax machine and modem-to-modem computers, expect you to work faster than the human mind can."

QUANTIFIED SCOPE OF WORK

Contract negotiation at JSDA is primarily the quantification of the scope of work. "Very often in a large project, we'll submit a list of tasks with the number of hours that go into each one of those tasks as part of the proposal," she explains. "If the client later asks us to do more, we have a way to renegotiate the fee; it doesn't guarantee success, but it works better than just putting a paragraph into the contract that isn't specific enough." She finds that although most clients are comfortable with this approach, others—law firms, in particular—balk at accepting such detail. "We include it anyway as an article of information; it still gives us a foundation for talking later."

Basing fees on the amount of involvement clients expect from her firm, Janice Stevenor Dale then carefully monitors time spent on design. Photos: Paul Bielenberg

The figures are broken down into the standard five phases of design, so "not only do they have a lump sum that we're proposing for each phase, but they have a number of hours that go along with each," she adds. "If a six-week programming allocation turns into a three-month exercise, then there's a legitimate reason to talk with the client about additional fees." In other words, Stevenor Dale assesses the per-square-foot fee for, say, a 60,000-square-foot job based on the scope of work (the amount of design involvement her client requires), thus coming up with a lump-sum contract total of $120,000 if it's $2 per square foot. That, in turn, is broken down into the five phases for the client's acceptance, specifying the number of hours JSDA will put into each phase; as the job proceeds, she bills on an hourly basis up to the amount negotiated for completion of each section. These computerized data, as noted earlier, are also made available to her staff to help them pace their work.

ACTIVE CLIENT PARTICIPATION

Among other strengths of her firm (including being five percent under budget on most jobs), Stevenor Dale makes use of her "mastery of the design process," something she notes was not taught to her in design school. She conceptualizes the process as "a series of interactive chunks rather than the linear process most designers think it is." As a result of her experience in pushing clients to keep up with necessary decisions as design proceeds, she has come to recognize that a certain flexibility toward meeting deadlines is important. Sometimes, she says, the client moves ahead on only some of the tasks within a design phase while asking to delay decisions on others past the agreed-upon deadline for that phase. In that case, she has learned to make assumptions that allow her to go on to the next phase with assurance that her prior work will not be overturned by subsequent client decisions.

EFFECTIVE PROMOTION AND SELLING

When it comes to marketing, JSDA presents an image of total competence to the corporate world. Stevenor Dale feels that "the clients' myth of needing a large design firm is breaking down. They've had the experience of working with large firms, and they know they don't get principal-level involvement throughout the project from them. We've got a significant advantage there." In addition, she avoids competing directly with those larger and established design firms by focusing on outreach to young, emerging businesses, not unlike her own, in fields that often require large-scale office space: law, insurance, and telecommunications, among others.

In these cases she endeavors to develop working relationships with key people who are likely to promote JSDA in circles to which she would never otherwise have access. "It's a strategy that has long-term benefits," Stevenor Dale says, "and I don't mind pursuing those outfits for small jobs if I suspect it could pay off in a corporate headquarters five years from now." She tells of doing a computer room layout for an important potential client on about four hours' notice in order to build trust with them. "Los Angeles is not a long-term sort of town, and I'm hoping to find and nurture whatever exceptions there may be."

Selling a job—getting the prospect to sign a contract—is something Stevenor Dale facilitates by researching clients' needs beforehand and responding during the interview process to the property questions (codes and other technical matters) they bring up. She tries to offer ways to reuse their present property whenever possible, but says, "It's important to have sources beyond the real estate business so you can help clients consider all of the costs and advantages of moving."

Public relations as an integrated component of marketing is also something at which JSDA excels. Very prominent in IIDA, Stevenor Dale especially enjoys sharing her deep interest in environmentally sound design with both that national organization and with

A certain flexibility toward meeting deadlines is important.

"**T**he clients' myth of needing a large design firm is breaking down. They've had the experience of working with large firms, and they know they don't get principal-level involvement throughout the project from them."

her clients. No matter where she's speaking or where her writing appears, those in the audience hear about what JSDA is up to. For instance, every three months her 250-strong client base gets a mailing that keeps them up-to-date. She emphasizes "the importance of letting clients know what you're doing when you're marketing over years—and not just a newsletter but a more personal statement."

JUMP-STARTING JSDA

"I borrowed from my own financial start-up fund to begin the firm, and today, three years later, we're debt free," says Stevenor Dale. "So it's very simple from a financial management perspective." She had put aside money while working at other offices, and when the time came, she was encouraged to go out on her own by Santa Fe Pipelines Inc. This engineering firm, which had earlier retained Stevenor Dale as a design consultant, offered her an "incubator" space in their posh downtown L.A. offices, the same space she had helped them plan; it came complete with AutoCAD 12 and large-scale plotting and blueprinting equipment, among other support facilities.

Now she has designed a new headquarters for them in Orange County, largely recycling an existing office layout. She is moving into a new space herself, reusing items from the exhibit JSDA did with Kinko's and picking up secondhand stuff that her landlord doesn't want to keep. "I've been building a savings account in order to cover my own tenant improvements and to cushion my three-year lease obligation during what may be difficult times

As a small firm, JSDA regularly competes with larger design firms and wins jobs based on the image of "total competence" it projects. Photos: Paul Bielenberg

As consulting interior designer to a large engineering firm, Janice Stevenor Dale got a chance to set up her own office within theirs. Photo: Paul Bielenberg

ahead," says this highly disciplined thirty-six-year-old principal. "I'm very frugal, and I never borrow. Furthermore, while I always put design over profitability, I make sure that what I bill my clients is more than I need to pay my staff and run the office. What's left is adequate profit for me, since I'm in this business because I want to create, not to make a lot of money."

The firm is incorporated, both to protect Stevenor Dale's assets and to make her professional standing clear to prospective clients. It has had errors-and-omissions as well as general liability insurance from the beginning. The firm gets a good price on its E&O policy ($1 million), and when she needs more for technically complex jobs, Stevenor Dale charges her client for the necessary rider. "I'm sure the cost of insurance will go up as insurers come to understand what the practice of interior design involves—the three-dimensional character of the work," she says with a smile. "That means the insurance is relatively inexpensive right now, but I'll be happy to pay more when they come to realize the complexity of what I do."

ADMIRABLE PROJECT MANAGEMENT

Stevenor Dale does all of the firm's contract administration, which she conceives as almost entirely a matter of collaboration, whether or not the firm is asked to work with a project management consultant. In her opinion, it begins with "explaining to the client the five-phase design process, how we determine the budget and the schedule, how we will involve others—technical consultants, the general contractor, and furniture dealer—in the project. At the conclusion of each design phase, we promise the client not only a design proposal but a projected budget and schedule as well. As the phases proceed, the unknowns in each case are reduced, which means that our standard twenty percent contingency figure at the outset tends to ratchet down five percent per phase."

"I'm sure the cost of insurance will go up as insurers come to understand what the practice of interior design involves—the three-dimensional character of the work."

JSDA uses CADD to visualize
interiors and, recently,
collaborated with one of its
clients, Kinko's Copies, on a
"cyber-workspace" exhibit at
the L. A. Eco Expo.

According to JSDA's approach, the general contractor is brought on board as
construction manager before the schematic design phase is completed and negotiation
on preliminary estimate and schedule begins. At this point Stevenor Dale issues what
she calls a "cartoon set" of drawings, brightly colored to differentiate the various trades,
a process that then facilitates "value engineering" by the G.C./C.M., a cost-benefit analysis
of the design in detail. In this way, she seeks to establish a "triangle of values"—budget,
schedule, design—for client approval. The design-development phase is intended to clarify
and settle all details. The goal is to allow the contract documents to proceed—AutoCAD
drawings, specifications, and furniture specs—with as little design input as possible
once schematics are finalized. The same process is followed with engineering consultants
and furniture dealers.

In California, certified interior designers can stamp their own documents, so once
those items are completed and plan check is received, the G.C./C.M. sends them out for
bids to three or more subcontractors in each trade. Stevenor Dale believes that this "gives
the designer more than usual control over selection of subcontractors than the traditional
practice of seeking bids from several G.C.'s." She further argues that by this method the
designer truly is "captain of the team by effectively serving the clients' needs and leading
the other team members."

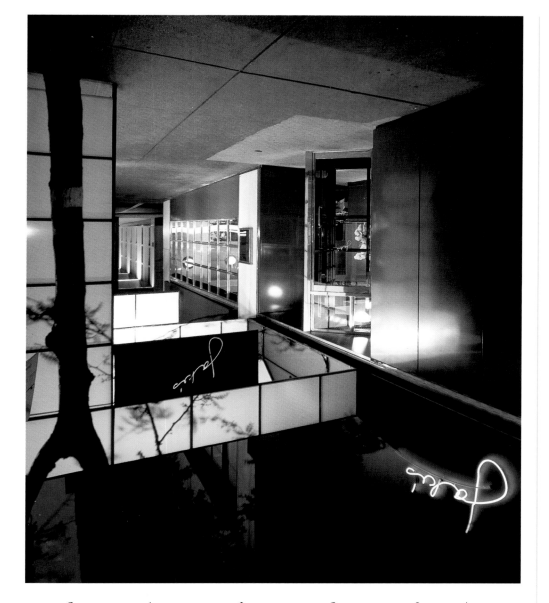

Judith Stockman and Associates

JUDITH STOCKMAN, PRINCIPAL

QUALIFICATIONS: B.F.A. in Interior Design, Pratt Institute
FIRM BACKGROUND: Judith Stockman and Associates, 1969–present
PRACTICE SIZE: 1 principal, 1 full-time employee, 1 consulting architect

OFF TO A GOOD START

Judith Stockman has had it both ways: as a high-profile interior designer in the seventies and eighties with a staff of thirteen or fourteen, busy designing one glamorous restaurant after another; and twenty years later, now a wife and mother, as a sole practitioner who has figured out how design and life fit together.

Not only did Stockman work in a big-time office in the years following graduation, but it was *her* firm. "What an adventure! In 1978, I started working with a wildly expanding client so the office was also growing wildly," Stockman recalls. "My dilemma was that I didn't know much about management, and I hated the feeling that I wasn't creating everything." Nonetheless, for thirteen years her firm cut a swath through the restaurant business that has hardly been equaled. The magazines couldn't publish her new jobs fast enough.

Judith Stockman, Principal

Within a few years after graduation, Judith Stockman enjoyed enviable success. Many of her exciting restaurant designs were built and published. Photo: Durston Saylor

Perhaps the culmination of Stockman's meteoric career was an opportunity, in the early eighties, to design the Museum of Modern Art restaurant.

Stockman intuitively knew what to do with her publicity.

During her salad days, jobs flew fairly flew into the office. Clients brought in other clients. Success followed success. Stockman now realizes, "Restaurateurs are superstitious, and they want to work with designers who have a track record of successes." This amazing sequence culminated in the Museum of Modern Art restaurant commission at the time of its expansion under Cesar Pelli's direction. "I had been recommended by Paul Goldberger to Philip Johnson, who then recommended me to MOMA for the job. It was all like a dream."

Taking the advice of a business acquaintance, Stockman decided it would be wise to diversify, not to depend solely on the restaurant industry for business. Upon the recommendation of a past client, she started working with developers on the design of lobbies, public spaces, and model apartments. Eventually the work for developers became the dominant work in the office, taking the place of restaurants almost completely. In 1984, Stockman decided to turn down the volume for a while so that she and her husband could start a family. She assumed it would be easy to get things going again later. But after the stock market crash of October 1987, business related to real estate development almost completely dried up. Since then things have gotten more competitive, and marketing—a challenge for Stockman—has become much more demanding.

MAINTAINING CONTACT

In the seventies and eighties, Stockman intuitively knew what to do with her publicity. She made use of all those magazine reprints by sending a package out from time to time to everyone she knew. When the slump came, however, she recognized that, with the exception of getting projects published, she knew neither how to promote her firm nor how to target prospects and make cold calls. As a result, getting the business moving again

Adapting skills once used to create romantic restaurants, Judith Stockman became expert at furnishing model apartments that convey an elegant sense of home. Photo: Langdon Clay

"In competitive periods, I can see the need to be aggressive in promoting and selling my firm's services. How else will anyone know about you?"

proved to be very difficult. Her earlier instinct—that one is more likely to be recommended by someone who knows the firm's work—still made sense. So she improvised by sending out other attractive items, "some sort of graphic display, a drawing or a beautifully presented list of recent jobs—anything to keep communicating."

More than twenty-five years into practice now, Stockman is keenly aware of other firms vying for the few projects available. "In competitive periods, I can see the need to be aggressive in promoting and selling my firm's services. How else will anyone know about you?" At one point, she collaborated with another designer who loved winning commissions but had little interest in carrying out the actual design work once the deal was closed. That's what she did. She speaks with awe of his creative, energetic pursuit of prospective clients. Another time, excited by a workshop on marketing that she had attended, she asked her assistant to put together a promotional campaign that included identification of potential clients. After nearly six months without results, they gave it up. Unfortunately, she hadn't been warned that such programs usually take eighteen months to pay off. Her lack of results may have been due to nothing but stopping too soon.

For an imposing 19th-century federal building renovated as an apartment building, Judith Stockman designed a lobby that evokes its massive solidity. Photo: Langdon Clay

Like most designers, Stockman's character, talent, and passion are much better suited to dealing with the design process than they are to aggressive marketing or the pursuit of the sale. "Not once have I educated a client about the process of design, the costs involved, and the necessary fees to do the best job," Stockman says. Now, she has learned how to sell her thoroughness by emphasizing that this is what makes her past work so valuable—attention to detail—and why it pays off later for the owner.

FINANCIAL REALITIES

Stockman typically charges a percentage of the construction cost as the design fee, except on residential furnishings, for which she bills on an hourly basis. In addition, she is adamant about securing retainers and rarely starts a project without one. She charges the equivalent of what she calculates will be her first month's expenses. Normally that amount is credited to the final payment, but occasionally on a large project, if asked by the client, she will give a rebate in stages as the design work proceeds.

Adequate compensation remains a big dilemma for her. Stockman laments the wholesale fee cutting that she sees in the interior design and architecture fields. "Clients will often shop for the lowest price, sacrificing experience and expertise." Working with developers has been especially tough. On proposed lobby design projects for which she had carefully figured her fee, maybe even trimmed out more than she was comfortable with, it turned out the developers could get someone to do it for half as much money. Unfortunately, she notes, the product of such bargain-basement deals is usually not only less creative design but also inadequate drawings and coordination.

"Shouldn't one's work be accepted for its own merits?" she asks even while accepting the fact that many potential clients need the extra boost that comes from having the designer recommended by someone important or the certification that comes from media approval. Even so, Stockman has never been comfortable about working with a public relations or press agent, even though she recognizes their value in helping a firm get more jobs and higher fees. "Do I want higher fees or more jobs? Maybe both." It's a problem with which many designers and architects continue to struggle.

Financial management is an aspect of professional practice in which she claims no background, having had no interest in it as a Pratt student nor any opportunity to learn about it as an apprentice. "Just being creative isn't enough," she can now say. "You must also be a competent business person." In her case, the question seems to center on

> **S**he insists on "the luxury of being able to practice her craft."

design-project management: How much time can you afford to put into design? Stockman acknowledges that she isn't willing to "just crank the work out." She insists on "the luxury of being able to practice her craft," which for her means studying the project until she has fully resolved all design considerations and carefully documented them. She has even had clients complain that, as fully detailed as they are, her working drawings will increase the bids for construction.

QUALITY OF LIFE

Although she prepares no business plan as such, Stockman does make projections for two or three months ahead. Occasionally she does an annual budget, but she has found that her big jobs proceed at an unpredictable pace due to client sales and financing patterns, making payment schedules difficult to forecast. Recognizing that her propensity for overdetailing keeps her from making a profit, she does make an effort to structure the amount of time available to the office for each project. "It's always good to know when you're giving your time away. I'm constantly pondering what could make a difference in the way I work that wouldn't be a compromise, a loss of passion or personality."

That concern is apparent in the quality of life at her firm today. "I'm trying for a mellow environment here." It's not the big, busy shop she once presided over. She recalls that while she was embroiled in that earlier scene, she turned her private office into a nursery for her daughter, an impulse toward creative management that eventually led

Highly refined architectural form characterizes Judith Stockman's painstaking approach to interiors, a commitment that often exceeds her budgeted time for design. Photo: Durston Saylor

Stockman to redesign her life. "Part of the reason why things are slower now is that a big chunk of my time is now dedicated to domestic concerns. When the day that's completed comes, then maybe I'll do more work and put more into practice."

Now she works with one assistant designer and a consulting architect. As she did in the seventies and eighties, she prides herself on keeping them satisfied by generously meeting their financial needs, providing interesting work (within normal working hours if at all possible), and making sure that they get credit when the projects to which they contributed are published.

ELECTRONIC POSSIBILITIES

Nonetheless, Stockman makes active use of electronic tools in her practice. Along with coming to rely on her Wizard electronic organizer, she has "mastered word processing," she says, using Microsoft Word. The office has used two spreadsheet programs, at first Excel and now Quickbooks Pro, for bookkeeping, financial projections, billing, and budgets. The latter program has enabled her to computerize time sheets and analyze data from former jobs (project types, amount of area, time spent on the project, contract information, and other categories), a process that she's been pursuing for two or three years in order to make sure she's setting her fees properly.

Capturing the accessible quality of food stands found in public markets a century ago, Stockman provides her client with an effective merchandising framework. Photo: Norman McGrath

Judith Stockman gave new life to this venerable hotel lobby by carefully restoring its surfaces and classical ornamentation. Photo: Langdon Clay

Stockman is actively seeking ways to incorporate electronic media into her practice.

Stockman is also exploring ways to use CADD in her practice, ever since she had computerized drawings prepared for one recent job. In addition, the architect she consults with delivers the working drawings he produces on AutoCAD. But for now, her original design concepts are generated by hand. One possibility she has now made good use of is digitizing photographs of her past projects and putting them onto a diskette; she therefore uses a homemade CD-ROM to promote her office. Stockman is actively seeking ways to incorporate electronic media into her practice both to facilitate management of her firm and by learning CADD herself, to expand its design and technical capabilities.

An opportunity to concentrate on design with all her passion and attention to detail has now presented itself. Stockman has joined forces with her husband, Gil Shapiro, co-owner of Urban Archaeology, to design a national chain of stores. Urban Archaeology, for many years famous for architectural salvage and restoration, is creating these stores to sell bathroom fixtures, fittings, and lighting that it now manufactures. In addition to designing the new stores, Stockman is selecting and designing tile to incorporate into the bathroom line. She is also designing some of the fixtures and fittings.

Laura Bohn Design Associates, Inc. (LBDA)

JOHANNA FIORE

Laura Bohn, Principal

Design consulting is an ideal form of practice: minimal liability, little obligation to produce contract documents, yet maximum opportunity to exercise design skills and ideas.

LAURA BOHN, PRINCIPAL

QUALIFICATIONS: B.F.A. in Interior Design, Pratt Institute

FIRM BACKGROUND: Laura Bohn Design Associates, 1996–present
 Lembo-Bohn, 1980–86

PRACTICE SIZE: 1 principal, 1 full-time employee, 1 part-time employee

FINDING YOUR WAY

In 1980 Joseph Lembo and Laura Bohn, who had worked together for John Saladino, the eminent New York City interior designer, opened their own office, Lembo-Bohn Associates. They attained an enviable international reputation of their own over sixteen years of practice. In April 1996, after months of careful planning, that partnership came to an end, and Joe Lembo went to work for Ralph Lauren's Home Furnishings Division. Bohn's new studio, Laura Bohn Design Associates (LBDA), continues to serve the old firm's clients but now offers only architectural and interiors consulting services. For Bohn, this development is one stage of a continuum of change that is the result of many years of active executive coaching undertaken with Lembo to improve and strengthen their design business. For Lembo, it ultimately meant leaving practice; for Bohn, it opened the door to innovative practice as a design consultant. Moving beyond that on the entrepreneurial spectrum, she has since formed a design-build consortium with architect John Reinitz and her husband, Richard Fiore, who is a general contractor.

In many ways, design consulting is an ideal form of practice: minimal liability, little obligation to produce contract documents, yet maximum opportunity to exercise design skills and ideas. Its management consequences offer valuable understanding of the possibilities for collaboration between architects and interior designers. Laura Bohn's experience provides instructive insight into this manner of doing business as a designer.

Bohn and Lembo started their practice the way most people do—with inadequate capital. They found a decrepit one-story flatiron building in Greenwich Village's meat-packing district, got credit to buy the materials they needed to replace its roof, and worked there without heat. "We had heavy maintenance expenses, but the place was unique," Bohn remembers, "and after about a year we were able to sublet part of the space to bring in some money." Lembo-Bohn always paid the people who worked for them but often didn't have anything left for themselves. Making use of Saladino's business methods, they muddled along as best they could, slowly building their design reputation as completed projects were published.

EXECUTIVE COACHING

In 1988, Bohn and Lembo began to work with Tricia Scudder, an executive coach. "She not only criticized our unprofessional standards," says Bohn, "but told us to quit gossiping about clients." She encouraged them to identify the strengths and weaknesses of their practice. A founder of the Executive Coaching Group, Scudder's techniques grew out of the Landmark Organization movement. She introduced Lembo-Bohn to the concept of personal integrity as a measure of business effectiveness. Essentially this amounts to speaking honestly and openly with associates and clients. When one is "out of integrity," confusion results and business is likely to suffer unless a clarifying conversation—usually not an easy task—takes place.

Lembo-Bohn came to realize that this has important marketing consequences. So often, Bohn notes, "designers just walk away at the end of a job, glad that it's over." Instead, Scudder taught them to complete the process by asking clients whether or not they are satisfied, sometimes using a questionnaire to make sure nothing has been

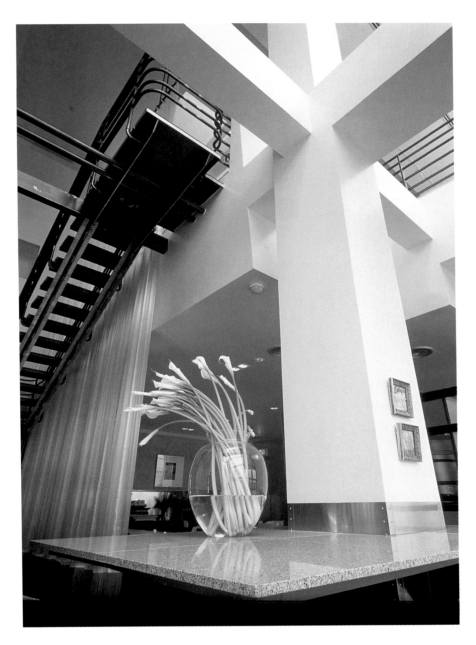

overlooked. If all is not well, especially in emotional terms, then the designer must make an effort to rectify things. Having conscientiously settled all accounts, the designer may then expect a positive, even enthusiastic response when the client is asked to consider referring friends and colleagues to his or her firm in the future.

In a larger sense, Scudder made them understand that the best way to manage clients is to focus on serving them. "In the early days we lost as much business as we held on to because of our egos," Bohn recalls, "but with her help we came up with a new motto, 'Give clients what they want.'" Scudder also introduced Lembo-Bohn to the idea of having a business plan, a mission statement, and other analytic tools in order to set up a measurable process ("If you can't measure it, you can't manage it") for acquiring new commissions. In fact, although she no longer needs to bring in jobs at the rate the partnership did, Bohn still keeps a very precise list of prospects she is following, including the dates on which she made her inquiry calls. "When someone I've been following up on finally says no," she says in a matter-of-fact tone, "then I stop calling."

MARKETING CONSULTANTS

As part of this businesslike marketing initiative, Lembo-Bohn worked with a number of consultants and specialists. They retained Mike Strohl, a publicist, who is paid a flat fee annually. He arranges for mentions of the firm, now LBDA, in the *New York Times*, quotes in magazines that potential clients might read, full-color pages showing completed projects in design magazines and coffee-table books; he also sets up showhouse opportunities. In addition, Bohn continues to work with Karen Fisher of Designer Previews, who shows the LBDA portfolio to those seeking a designer appropriate for their residential needs.

In the early eighties, Lembo-Bohn had a connection in Tokyo with Creative Intelligence Association (CIA), another agency that matches clients' needs with designers. CIA got them several lucrative architectural projects, five of which—wild and stylish—actually got built. They did the same in Saudi Arabia through another contact more recently. Making efficient use of their New York base, Lembo-Bohn got into product design by approaching various high-style vendors with ideas for new lines—fabrics, tableware, wallpapers, and the like—whenever they spotted a gap in product availability that, to their taste, needed filling. This foray into diversity, Bohn notes, produced steady royalties that went a long way toward smoothing out the financial ups and downs of their small office.

Finally, in 1994 Lembo-Bohn retained Martin Cohen, a business coach, to help them wind up their partnership in the most positive way. Lembo, reports Bohn, had always been the "money person" of the firm. He had grown tired of hounding clients to pay their bills and wanted the stable income that working for someone else would provide. By setting clear, measurable goals for the two of them, Cohen facilitated the process of collecting receivables, sharing the news with former clients, moving out of their old office, dividing up the furniture, and so on. With the innumerable details settled—as at the amicable conclusion of any long-term relationship—two partners headed off in different directions. In April 1996, Bohn says, "we shut the door for the last time and walked down Little West Twelfth Street with our arms around each other's shoulders."

The Lembo-Bohn studio thrived on turning high-ceilinged, open-ended loft spaces into comfortable living environments for their sophisticated urban clients. Photos: Todd Eberle

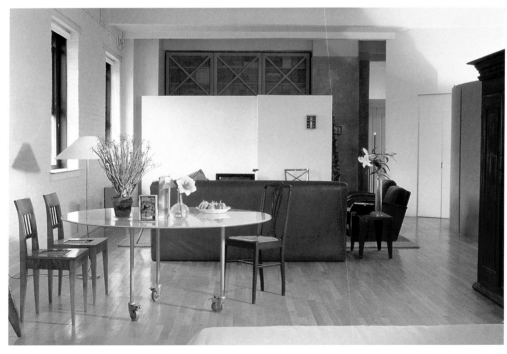

In retrospect, managed growth for Bohn has meant significant downsizing—to one assistant and a part-time bookkeeper—and for the foreseeable future she's going to keep it that way. No longer avid "to have a big firm someday," she prefers being able to take three-day weekends whenever she likes.

DESIGN CONSULTANT PRACTICE

These days she concentrates on serving as design consultant to affluent families building enormous houses in Connecticut, what used to be known as estates. These tend to be people who have already begun working with an architect on, say, a 15,000-square-foot residence. When the wife finds herself exasperated by the architects' lack of interest in housekeeping matters, such as including a guest closet near the front door, Bohn gets a call, often referred by another designer. Having received a thorough grounding in "interior architecture" at Pratt, she now serves as a facilitator between client and architect—"I become the 'practical ear.'" Her basic task is to revise and detail kitchen, bathrooms, storage, and other areas with daily functions within the grand architectural scheme; she often assists with choices of materials throughout the job. This rescue work—although "slow and demanding," in her words—pays handsomely.

For consulting work, LBDA charges a fixed design fee that starts at $5000 for analysis and design proposal sketches. To cover subsequent meetings with architects, and if working drawings must be prepared, there's an additional hourly fee. Purchasing of interior furnishings and furniture, perhaps the major component of these jobs, is done for thirty-five percent of the net cost. The owner pays all suppliers' bills directly, while LBDA actively monitors delivery. The designer gets about one-third of the design fee as a retainer, with the rest paid over two or three months after each of three design presentations is approved.

As a consultant, Bohn prepares little in the way of contract documents, has no contract administration responsibility, and does not to carry liability insurance, relying instead on the architects, who do. She does, however, take care to document her efforts fully, including her working meetings with the architects, and keeps careful track of her billable time and associated reimbursables.

Sometimes, for smaller, short-term consulting jobs, Bohn charges a lower design fee that includes up to five hours' worth of drawings, but for a higher hourly fee than on the big jobs. The client does his or her own shopping, and if further documentation is needed, LBDA asks $250 an hour to prepare it. These projects are intended to be short and sweet for everyone involved.

RESIDENTIAL DESIGN CHALLENGES

Bohn finds that management of residential projects is extremely challenging. "Designing a building in Tokyo was easier to do than a two-bedroom apartment in New York!" Residential budgets are never easy to gauge at the outset, she says, and they often increase dramatically. She thinks that this is because residential clients are frequently unrealistic about how much the level of quality they're seeking will actually cost to realize. Sometimes she'll discount her purchasing fee for a big-budget client, but no more than five percent. "Frankly, the handholding can be overwhelming," she confesses, noting that after years of taking residential clients around to showrooms, designers become exhausted by the process. Scheduling is another trying aspect of this work. "We can stick to the schedule for our own work, but that's as far as it can be carried," she says. The often long periods of delay involved in finishing up large residential projects is accommodated by storing the furniture and just waiting.

Financial management is thoroughly computerized at LBDA, with all contract and billing work handled by her part-time bookkeeper and an accountant who comes in every two months to review the books. In addition, almost all of the technical drawings

Adept at working with architects on large residences, Laura Bohn knows how to translate their ideas into comfortable, even cozy living spaces.
Photos: Jeff McNamara

the firm works with are CADD-generated by the architects, although Bohn normally marks them up by hand and sends them back to the architects for input into the computer.

Since there's no design liability, contracts for her consulting practice are very simple compared to those that were offered by Lembo-Bohn, although she still uses the same attorney. The lawyer, who specializes in real estate and construction matters, was also helpful to Lembo and Bohn when they made proposals to do work abroad.

A NEW CONSORTIUM

Bohn's new firm has also formed a consortium with her husband, Richard Fiore, a general contractor, and John Reinitz, an architect. This group recently moved into new offices in a loft building near the Empire State Building. As the result of working for a long time with Richard on real estate development projects (including her own apartment many years ago, her first published work), Bohn is enthusiastic about this method of forming capital. The group has an option on a vacant bank building not far from Lembo-Bohn's old office that they hope to transform into ten luxury cooperative apartments in the near future. Having been able to count on her spouse for support over the years when Lembo-Bohn was having trouble making a profit, Bohn recognizes the importance of her contribution to their joint retirement fund.

Juxtaposing sensuous furniture and opulent furnishings with spare geometric form, Laura Bohn satisfies her clients' need for rich surroundings. Photos: Peter Paige (above), Don Freeman (right)

Lee Stout, Principal

Lee Stout, Inc.

LEE STOUT, PRINCIPAL

QUALIFICATIONS: B.F.A. in Interior Design, Pratt Institute

FIRM BACKGROUND: Lee Stout, Inc., 1987-present

PRACTICE SIZE: 1 principal, 2 employees

SPECIALIZATION AND CORE CLIENTS

"Even though I didn't learn anything about managing people in school," says Lee Stout, "I got a great job right after Pratt that taught me everything I needed to know—about how *not* to do it!" Stout tells about working for a high-powered designer who readily brought desirable and challenging projects into the office, but then couldn't maintain staff continuity in order to complete them efficiently. Frustrated in his attempt to build a large-scale practice while remaining involved in the details of every design job, this designer alienated many of the people who worked for him. In addition, because of the way he imposed his design ideas on the clients, after their initial experience many of them never used the firm again.

"He taught me to live and practice in a different way," says this Manhattan-based interior designer. Proof of this is that after ten years of practice, Lee Stout, Inc. actively serves virtually all of the same clients who came to the firm in 1987, when it opened its doors. What he calls his "core clients," eight of them commercial and two residential, have not only continued to provide the office with work, but have requested a wide diversity of projects within the firm's specialties, which are small, innovative retail stores and showrooms for contract furniture and fabrics.

Refuting the design profession's widely held belief that specialization leads to boring and repetitive work, Stout enjoys talking about the wide variety of jobs that have come

In his New York showroom for Design Tex, Lee Stout plays the softness of fabric against this industrial loft building's massive structure. Photo: Norman McGrath

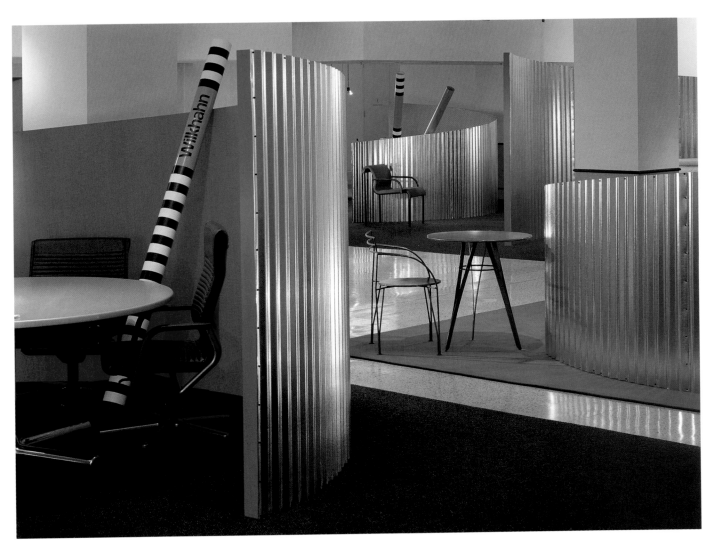

One of many NEOCON exhibits that Lee Stout has done for Vecta, this one from 1989 uses corrugated sheet metal to accentuate the furniture. Photo: Bob Harr, Hedrich-Blessing

to his supposedly limited practice. For Design Tex Fabrics, one of the core clients, he has not only designed several showrooms and their corporate headquarters, but also collaborated on the design of two upholstery fabrics. "It's up to the designer to study the needs of his corporate clients and then sell them on additional services that one's firm is ready to provide if asked," he says earnestly.

Still further evidence that Stout learned a lot in his postgraduate "research" is the fact that the same two colleagues who joined him soon after he decided to open his own office are still with him. Lynn Campbell and Cam Lorendo, whom Stout met while working at Knoll, now collaborate with him on every phase of the firm's projects. They have in effect built a truly horizontal structure within a sole proprietorship. Financial management is the only aspect of the business that this principal handles alone.

MARKETING = SATISFIED CUSTOMERS

Although many practices may well have a set of core clients, Stout seems to have made unusually effective use of the idea as an organizing concept for his office. He sees marketing management as keeping track of his "core list." Essentially, he is actively reaching out to a short list of ten—a far easier task than marketing a general practice broadly—and at the same time cultivating a more stable situation than firms that have just one or two major clients. Promotion of his firm therefore revolves around the public relations efforts of his clients. "When one of them sponsors an event, I'm always ready to help

support it as well." At the same time, he benefits from being associated with such outfits as Vecta, for whom he has been designing their NEOCON presentation each year since 1987. "When I go to NEOCON or some other industry show, I have a hard time walking through the halls because I run into so many people I know from the business."

So far, he says, the retail business continues to grow, and that—along with seasonal shows and openings in the contract furniture field—keeps the work coming in. When his established clients bring their friends to him for residential projects, he obliges them. In one case, a small residential job led to the design of a Manhattan private school, an institution that eventually also became one of his core clients and for which the firm has carried out many different design tasks. "Doing good work and keeping people happy invariably has led to new work," he contends, "especially since a lot of my clients are entrepreneurs, for whom making deals is a way of life."

CONTRACT CRITERIA

In fact, he has learned to be very careful about taking on new clients: "If I'm not sure I'll make money and produce a good project working for somebody I don't know, I'm fortunate to be able to say no." Another reason for which he may turn down a job is a proposed design and construction schedule that is unrealistically tight; he has learned the hard way to avoid stressful situations.

Since he usually works for companies and individuals that he already knows, almost all of the design contracts Stout enters into are for a lump-sum fee. That covers work only through the construction documents phase. For contract administration he charges an hourly fee, an arrangement that he claims no client has ever refused. "They want to be sure of the quality of what gets built." He structures payments under these contracts so that with each monthly payment a part of the job's profit is included, thus steady cash flow is assured.

> His standard letter of agreement, developed early in his practice and scarcely modified since, is usually three pages long and contains about twenty paragraphs. He includes several clauses that limit his firm's responsibility:
>
> - The client directly hires all engineering services (firms recommended by Stout), so Stout plays the role of an adviser on mechanical equipment matters.
> - The client also hires Stout's expediter, who reviews the documents, stamps them, and then promptly files them with the appropriate municipal agency.
> - Finally, when furniture is being purchased, Stout makes clear that he is acting only as an agent for the client and has no other involvement in the deal. He calls for fifty percent of the money up-front, passing along the billing with a fifteen percent markup for the service.

While he has signed form contracts as requested by clients in the past, he sees no reason for making use of more legalistic documents himself.

As for his retainer, Stout asks for ten to fifteen percent of the value of the total contract at the time it is signed. That figure is a somewhat higher proportion than normal because he bases it on the first four phases of a standard contract. Actually, in his case it represents twelve to eighteen percent of the fee. In addition, by building profit into each design phase, he receives that money earlier than most designers do. Noting that some colleagues use the retainer to cover furniture purchases, he questions that procedure, claiming that the purpose of the retainer is to provide cash flow until preliminary design work can be billed.

"**D**oing good work and keeping people happy invariably has led to new work."

Stout asks for ten to fifteen percent of the value of the total contract at the time it is signed.

Making judicious use of millwork, Lee Stout adds warmth and elegance to the ambiance of this brokerage office. Photo: Norman McGrath

A "compulsive saver," Stout had been putting money away for fifteen years before he began his practice.

BUSINESS PLANNING

Stout does not follow a formal business plan. Because of his concern for limiting the firm's liability, he has incorporated it and, with his accountant's help, makes sure the business keeps as little money in its accounts as possible. As a result, he feels comfortable carrying no professional insurance. Up to now he has been able to predict accurately the firm's work load at least six months into the future. Given certain seasonal projects that he can count on from old clients, like the annual NEOCON trade fair, that lead time has been sufficient.

The business's capital consists primarily of two separate apartments on the same floor of a midtown Manhattan loft building. He owned one of them before beginning his practice, and for the first year or so he "worked from my dining room table." When the second one came on the market, he bought it and turned it into his studio. Since he has found that clients have no interest in coming to see him, he has spent money only to make the office comfortable for those who work there, furnishing nothing that isn't necessary.

Stout considers himself a "compulsive saver"; he had been putting money away for fifteen years before he began his practice. Not only has the office never carried any debt, but he says he could retire tomorrow—that is, if he didn't enjoy being a designer so much.

PICKING AND CHOOSING

This is a practice that has chosen not only to stay small but to take on only small, special projects. "I actively avoid jobs of more than thirty thousand square feet," Stout insists. "Let those who can handle that scope go after them!" In effect, he focuses on commissions that are too small for other firms to do profitably. He tells of once turning down the design work for offices for a division of Warner Brothers. "When they asked in the contract for three sets of design alternatives to choose from at every stage of the design process, I knew it was going to be more trouble than I needed. And they had a tight schedule!"

Stout argues that the consequence of the firm's compactness is that productivity is extremely high. "Because all of us have about the same amount of experience, no one has to sit around waiting to get questions answered or drawings approved. Our part-time drafters also get prompt supervision." When the office is handling six or more projects simultaneously, he recognizes that distractions can slow things down. "That's when our mutual discipline and ability to focus become important," he says.

As a corollary, computers have a limited role in this firm; they are used only for processing specifications, billing, and other financial matters. CADD plays no part at present. Typewriters with memory are used for correspondence. The fax machine is

One of the off-beat jobs that have come to him from his core clients, this traveling photo exhibit offered Lee Stout a stimulating design challenge. Photo: Norman McGrath

Lee Stout specializes in showrooms like this one for Vecta in New York, and in elegant boutiques—Steuben at the Greenbrier in this case (below). Photos: Elliott Kaufman (right), George Mott (below)

heavily used, however. "We get more information by fax than by mail." Photocopying has generally brought the size of the firm's construction drawings down to fit its parameters, although larger-scale sheets are prepared, when appropriate, for ozalid reproduction.

CLIENT COLLABORATION

Basically, Stout responds best to what he calls "the innovative client," but he enjoys working with all of his clients on design development. Asking a lot of questions about the project's commercial potential (although not necessarily preparing a written program), he then presents a series of choices based on the client's response, progressing from a set of agreed-upon concepts to the details of the job over time. As the drawings get more technical, he points out to the client how the design's original pragmatic intentions have evolved through their joint effort.

He calls this process "strategic design," describing it as "the direct visualization of a client's marketing plan—an effective tool because they can check the results against their own sales goals." This approach pays off because, in Stout's opinion, "showrooms and especially retail stores can embody marketing objectives in their design." In the case of retail facilities, such as those he has done for Steuben, the effectiveness can be documented through customer reactions and traffic analysis. In fact, this client passes along data gathered by salesclerks and managers for Stout's review and consideration.

Showrooms are a little less easy to analyze after occupancy. Stout insists, however, that "by means of a dynamic, logical progression through the space, the designer can ensure that visitors come to a conclusion, perhaps unconsciously, that meets the objectives of the sponsor." Both lighting design, which he handles himself, and graphics are crucial elements for achieving that desired effect.

VISIBILITY

Lee Stout's work has been widely published in recent years, a fact that has never directly produced a new job. The main positive effect of it, in his opinion, has been that the affected client is pleased and feels that he made a good choice of designer. Of course, that can make a difference when it's time to commission the next store or redo a showroom.

Another consequence of frequent appearances in design magazines is that Lee Stout, Inc. draws a lot of résumés from recent graduates. In fact, in addition to Campbell and Lorendo, his two longstanding colleagues, Stout fills in with students from Pratt Institute as paid part-time employees when the work load makes that necessary. His executive style seems to be that of a "natural teacher," seeing management as one form of teaching. "By helping people understand your intentions, you gain their cooperation. Even construction workers willingly make changes when they have the design's purpose explained to them."

In his role as the principal second-year interior design critic at Pratt, which he has filled for several years, he has made it a point to keep an eye out for those with what he calls "outstanding physical skills"—good model-building, drawing, and sketching abilities. That's what he looks for in portfolios, too, believing that if someone shows facility with his or her hands, that person will probably turn out to be a pretty good designer as well. He mentions having known "volcanoes of creativity," students who couldn't draw very well, and wonders what becomes of them later.

> "**S**trategic design is the direct visualization of a client's marketing plan."

> "**B**y helping people understand your intentions, you gain their cooperation. Even construction workers willingly make changes when they have the design's purpose explained to them."

Michael Pyatok, Principal

Michael Pyatok and Associates

MICHAEL PYATOK, PRINCIPAL

QUALIFICATIONS: B. Arch., Pratt Institute

 M. Arch., Harvard University

FIRM BACKGROUND: Pyatok and Associates, 1985–present

PRACTICE SIZE: 1 principal, 9 full-time employees, 2 part-time employees

DEVOTED TO HIS SPECIALTY

Mike Pyatok teaches architecture three days each week in Seattle and practices architecture full time in the San Francisco Bay area, eight hundred miles to the south. Thus, he combines two passions, two aspects of his profession, in a way that seems to be both synergistic and symbiotic, accepting the commuting and its management challenges as a reasonable price to pay for such fulfillment.

In fact, a significant factor of the symbiotic relationship is that his tenured professorship at the University of Washington's School of Architecture helps to subsidize his Oakland office, an operation dependent on the minimal fees paid by government agencies to architectural firms that take on low-income housing design projects. Low-income housing is indeed the heart of Pyatok's professional commitment. Long before he established his practice in 1985, he was active in nonprofit housing organizations. He began working with them while teaching at Penn State and then at Washington University in St. Louis in the late sixties and seventies. Pyatok came to the East Bay in 1978 and soon got involved with Oakland Community Housing, Inc. He served on this nonprofit group's board from 1979 to 1990.

Thanks to the network formed by such community-based organizations (CBOs) around the Bay Area, marketing has been a straightforward matter for Pyatok and Associates. It has consisted in recent years of responding to Requests for Qualifications (RFQs) and Requests for Proposals (RFPs) about once a month. These come in from Northern California nonprofits as well as from groups around the Seattle area, where he has been teaching since 1989. Pyatok estimates that each response can cost from $3,000 to $5,000 in time and materials preparing submissions and doing the interviews, especially for the more complex RFPs.

The interviews themselves, often conducted before a large number of people, are a special challenge. Normally a quiet and undemonstrative person, Pyatok calls them his "initiation into performance art." He explains: "I'm getting to be more and more dramatic in my presentations. Teaching and lecturing have really helped me there. But reading the crowd is where the 'art' comes in. Based on clues I pick up from the room's ambiance, I decide whether to come on strong or not, and shape my presentation to suit it." He must be a pretty good performer, because the firm has received a great deal of work this way.

COMMITTED TO HIS CLIENTS

Participatory design is something for which the Pyatok office has become well known in the Bay Area. In order to stimulate involvement and to help their nonprofit housing corporation clients feel committed to the project design if the political going gets tough later on, these architects welcome the clients into the design process. Working sometimes with as many as fifty people, Pyatok organizes workshops that allow these groups to participate directly in making site layout decisions, planning residential units, and selecting architectural elements. Modeling kits are prepared by Pyatok's staff for such sessions—often attended by those who will actually live in the buildings—and the participants are encouraged to manipulate the design variables themselves until the

optimal solution for their site is determined. Although Pyatok admits to keeping a strong hand on the visual results, these untrained folks—as culturally and ethnically diverse as one might expect in this urban region—proudly recognize their contribution in the finished structures.

Working for nonprofit housing clients is more challenging than just pushing foamcore components around on a table, however. From a management perspective, "it requires a great deal of client support and guidance for fees that are usually about half the amount they should be," says Pyatok. "Recently I've been talking to a management consultant who says I put too much time into each job. But I can't help it; I love getting the positive feedback from the clients and those who live there, because our designs are so exceptional." So it's no surprise that, even though he can say construction budgets and schedules are always met by his office, the design and production budget is invariably exceeded. That vexing financial drain is somewhat balanced by commercial development projects—adaptive

Out of Mike Pyatok's participatory design sessions with his community group clients come some striking architectural forms (this page and opposite).

reuse of loft space, mostly—which make up about twenty-five percent of the firm's present work load. "I like working with old warehouse and industrial buildings, with their fabulous spaces," he says. "I've also hoped to expand into schools, but so far that hasn't worked out."

In addition to the Seattle commute, Pyatok travels elsewhere around the country, giving fifteen to eighteen lectures on his work each year. He has always believed it is important to publicize the firm and spends a good deal on professional photography (at $1,000 to $1,200 a day) to fully document its completed projects. That may help to explain why Pyatok and Associates frequently wins design awards. These projects also have generated considerable press coverage in the past few years. Recently, with Tom Jones and William Pettus, he completed *Good Neighbors: Affordable Family Housing*, a book on affordable housing that makes ample use of this material. Still, he worries that maybe money spent on photography ought to go into employee benefits.

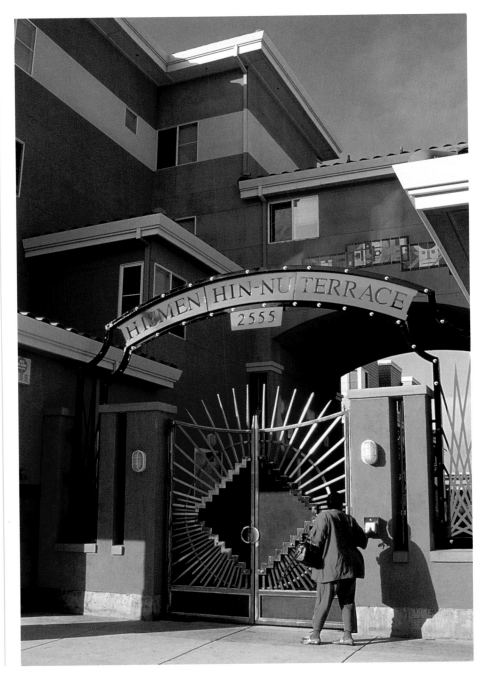

LONG-DISTANCE PRACTICE MANAGEMENT

It took Pyatok five years after he opened his office to get up to speed. Having taught design for a long time, he mostly spent those lean years entering housing-related competitions—and winning all of them. Eventually that paid off, both with a substantial commission for development housing in Bellevue, Washington, and with a number of nonprofit jobs. From the beginning, he has had a consulting relationship with Bill Olin, a Berkeley architect with forty years of contract administration experience, who gets the projects built.

But it wasn't until 1991, when he hired Meri Furnari, a person with a strong background in the nonprofit sector, to run the office that practice management became a conscious process. By that time, he had been teaching at the University of Washington for a couple of years, had two or three employees (mostly former students), and knew he couldn't go on trying to do everything himself. Meri has since moved on and Rachel Estrella is now doing that job. "Both Meri and Rachel have been devoted to this place; they've made it stick together!" he says with admiration. Nowadays Pyatok employs nine people, with Olin and a couple of others as project-by-project consultants.

It is Mike Pyatok's custom to design and build appropriate birdhouses as a present to the community groups for whom he has created low-income housing complexes.

Mike Pyatok makes sure that his affordable housing looks like houses that just about any family would be proud to live in.

When he's in Seattle, two or three daily telephone dialogues with everyone in the office, including interns, serve as a major motivational tool. He still resists acquiring a cellular phone, and he can't be reached during the fourteen hours each week he spends teaching design; that's a dilemma he hasn't resolved so far. A regular flow of sketches from the facsimile machine in his Seattle studio to the Oakland office reinforce points made during the phone conferences.

Pyatok readily admits that communications technology cannot entirely compensate for the loose structure that results from his three-day-a-week absence from the office. He maintains a tight hold on the programming and design phases but is less involved in production and contract administration. That leads to what he feels are problems in continuity and commitment to the projects on the part of consultants, who must earn at least part of their income elsewhere. Pyatok longs to set up a smoother production process than what he can afford at present on minimal fees from nonprofit housing clients. In short, he's looking for a partner who would not only be comfortable overseeing the technical phases but also help the firm stabilize its income by finding jobs among private-sector clients.

PEOPLE FIRST, ARCHITECTS SECOND

One thing that Pyatok laments is his inability, given present practice finances, to provide employees with more and better benefits. The firm offers no sick leave or vacation pay, let alone a retirement plan. Each employee organizes his or her own health care coverage to which the office contributes $125 per person each month. Although morale at Pyatok and Associates seems quite high, the principal frets that his "absolute perfectionism sometimes gets in the way of sensitive response to employees' needs. You can't treat your staff as harshly as you treat yourself!" The idea of expanding the firm also bothers him, since design control would necessarily have to be diffused.

Nonetheless, many young people seem drawn to Pyatok and Associates these days. Pyatok says he gets an average of five résumés a week. He looks for people, especially women and minorities, with solid experience but also with an exotic background or a passion for interesting hobbies. "The folks in this office are people first and architects second—they all do lively things outside," he reports with pleasure. Drawing skills are something he also seeks in potential staff members; he draws beautifully and believes the ability to design is integrally connected to one's graphic skills. In 1996 Pyatok hired an experienced CADD-fluent architect to set up a three-station network and train the staff to use CADD effectively. Pyatok, formerly unenthusiastic about computerized drafting and design, now has his own CADD-programmed laptop!

He is particularly interested in helping women and minorities build professional careers in architecture; two women-owned firms run by former employees, Betsy Yost and Rosa de la Sota, have been launched to date, and Pyatok has undertaken a joint venture with both of them. Firings have been extremely rare, he says, and in one or two cases, Pyatok has helped staff members anticipate coming slowdowns and make preparations to move on to other offices before being laid off.

SELF-TAUGHT MONEY SKILLS

Financial management is not one of Mike Pyatok's strong points, he claims, thus identifying himself as one of those designers and architects—there are hundreds of thousands in this category—who have learned what they do know about it by trial and error. He recognizes that without adequate capitalization, what he calls a "slush fund," there's not much chance his firm will ever make a profit. Furthermore, given the terribly small fees he was accepting a few years ago for the first nonprofit low-income housing jobs he took on, capital formation was impossible. In fact, as he candidly admits,

"**Y**ou can't treat your staff as harshly as you treat yourself!"

He looks for people, especially women and minorities, with solid experience but also with an exotic background or a passion for interesting hobbies.

Pyatok, formerly unenthusiastic about computerized drafting and design, now has his own CADD-programmed laptop!

This senior housing in Puyallup, Washington, designed by Mike Pyatok, bears a pleasing resemblance to an old-fashioned resort hotel.

"the office is subsidized by my teaching income, my self-supporting spouse, and the fact that we have no kids. That's what enables me to focus on the kind of clients I really want to serve."

Since 1995, however, Pyatok feels he's gotten a lot tougher on negotiating adequate fees and contracts that more realistically reflect the cost of producing a job. "I used to calculate the hours as though I was doing the work, and then I'd see, to my horror, how much longer it took my employees—who don't have the same honed skills—to do the same things." Pyatok has learned to insist on well-kept time sheets from his employees and, for his own part, is very careful about keeping an accurate record of his time. The results are daunting: He puts in an average of ninety hours per week altogether, including seven hours a week in travel to and from Seattle (half of which time is on planes, where he works on his laptop). In addition, there are a number of recent jobs in nearby California cities—Santa Rosa, Santa Cruz, and elsewhere—that require hours of driving to manage. Fortunately, he says, his wife, Fern Tiger, a strategic planner, is just as busy with her clients' projects as he is.

After ten years of practice, it has become clear to Pyatok that putting his business on a sound basis is essential if it is to survive. He understands that profit, essential for the small office's long-term health, is a function of adequate capitalization, something he has yet to achieve. Like Pyatok, most practitioners operate on a shoestring with little or no invested funds. Thus, what extra they earn often goes to pay interest on borrowed money. That is why Pyatok recognizes, and articulates it with commendable firmness, that he must soon stabilize the firm—he hopes with the help of an appropriate partner. This will include implementing more thorough accounting procedures, generating adequate capital, and formulating a business plan.

Roberta Washington Architects, P.C.

ROBERTA WASHINGTON, AIA, PRINCIPAL

QUALIFICATIONS: B. Arch., Howard University

M.S. in Arch. (Hospital and Health Facility Design), Columbia University

National Council of Architectural Registration Boards (NCARB)

Registered Architect in New York, New Jersey, and Connecticut

National Organization of Minority Architects, president

FIRM BACKGROUND: Roberta Washington Architects, P.C., 1983–present

PRACTICE SIZE: 1 principal, 11 employees

Roberta Washington, Principal with John Samuels, Associate

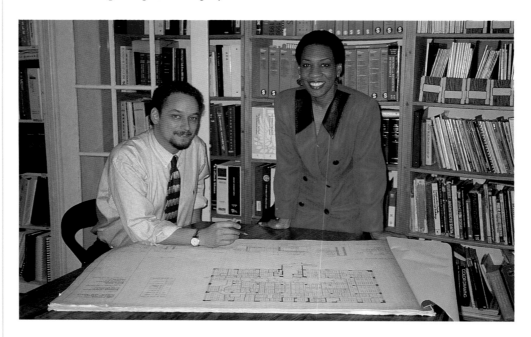

MANAGEMENT DEMYSTIFIED

Roberta Washington's commitment to low-income housing may distinguish her firm from others, aside from more obvious factors. Along with health facility and institutional design work, upon which she has focused for more than twenty years, her office has carried out dozens of imaginative, substantial renovations to solid but abandoned New York City housing stock. It has defined her practice as one that deals almost exclusively with government agencies, the professional management consequences of which differ somewhat from those of firms dealing primarily with private clients.

For what she has been able to learn about practice management through classroom instruction, Washington is grateful to American Woman's Economic Development (AWED), which offers comprehensive courses in running a business; this helps women designers to realize that practice is not so different in commercial terms from most other businesses. Also, in addition to information gleaned from books, she cites peer counseling sources such as NYC/AIA's Professional Practice Committee and the women's caucus within the chapter as important, as well as the Alliance of Women in Architecture, a separate organization (now inactive) that was instrumental in helping her to get registered. Washington says, "There's real value in networks, keeping in touch with people who are like you."

There is no question that hers is a specialized practice. For Washington, marketing means trying to increase the number of private jobs she does within the health, housing, and institutional fields in which she is already active and well known. Having worked with a business consultant to identify new directions, she then runs up against a problem

"**T**here's real value in networks, keeping in touch with people who are like you."

that many small-firm practitioners experience: Who's going to do it? Her marketing administrator does research on prospective clients, writes letters, and does preliminary follow-up; but Washington finds it hard to make time to actually visit those who express interest in her firm. It is an indication to her that perhaps she must reconceptualize her role as principal of this twelve-person firm, moving still further from the architectural work she loves to do toward executive status.

Negotiating fees appears to be an area where Washington has learned to be effective through experience. Currently she charges $100 to $180 per hour for her own time, with others on the staff billed at appropriately lower rates. She has wondered why she can't charge as much as some lawyers she has hired do ($250 an hour) but she finds that public agencies resist paying even half that amount to principals of architectural firms. Nonetheless, the complex client interaction demanded by jobs she does for government-funded nonprofit sponsors has taught her to insist on ever higher fees; this knowledge has enabled Washington to gradually triple what she was paid on her first such rehab project.

Renovating neglected but elegant old New York City apartment buildings into up-to-date, affordable housing is a specialty in which Roberta Washington has few peers.

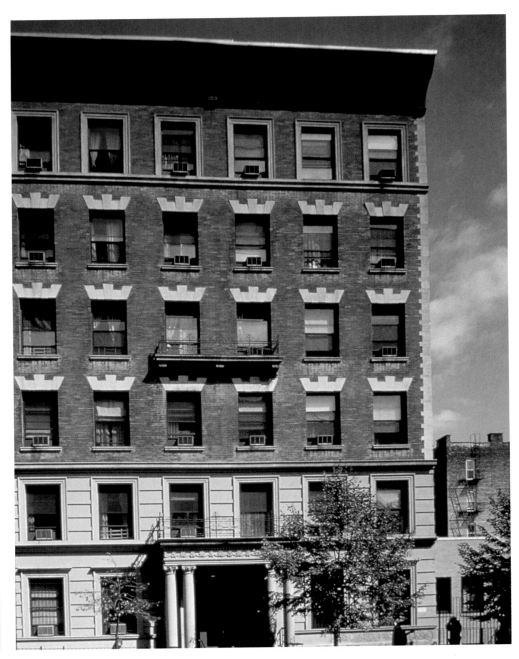

OFFICE COMPLICATIONS

Human resource management is another aspect of executive discipline that Washington admits she has learned about through experience. Perhaps because of her training in technical work, she has little trouble interacting with her designers and drafters and recognizing who among them deserves to be retained and promoted as time goes on. Although there have been some layoffs in the past (as she sometimes waits interminably for fees billed but not yet paid by government agencies), most of her furloughed technical staff eventually return to the office as work picks up. She reports that sometimes such individuals refuse to accept her dismissal of them and try to negotiate temporary part-time arrangements instead. At one point, during a two-month lull, she asked everyone to cut back to four-day workweeks and thus kept the office intact through that financial crisis.

Washington candidly admits that she often has a difficult time relating to her support staff. Ironically, while many also are black women, Washington finds that her professional preoccupations prevent her from communicating adequately with them. One secretary whom she particularly liked, upon announcing that she was leaving for another job, let

Integrating new commercial facilities into her renovated tenement jobs is about as glitzy as design gets for Roberta Washington's firm.

Roberta Washington's experience with low-budget design strategies enables her to do a neat, attractive job with this clinic waiting room.

Sexism as part of her professional life was an issue that Washington learned to handle early on.

her boss know that she had felt unappreciated. Washington was shocked. She suspects that, in addition to consciously taking time out to talk with and listen to staff, the solution may be to create a permanent position for an office manager. Fortunately, she adds, her senior associate, John Samuels, who spends more time in the office than she does, is good at supervising and relating to both technical and support staff.

LESSONS IN HUMAN NATURE

One specific lesson that Washington learned from AWED about office procedures relates to the way checks are written and logged in each month. "Don't let the same person who writes the checks open the envelope in which the bank returns them to you each month!" the AWED lecturer told her. Why not? you may ask. Not long after Washington began her practice, she hired a secretary to handle the bookkeeping for her. Almost every month the woman would report that "the bank had lost some of the checks." Eventually Washington began to look more closely at the situation, finally insisting that the bank envelope containing the canceled checks be handed to her unopened. When she looked inside, there were checks she'd never issued or signed. Taking advantage of Washington's inattention, her employee had embezzled almost $3,000 by that time! All was equitably resolved eventually, but here's one architect whose eyes had been opened to the importance of hands-on financial management.

Sexism as part of her professional life was an issue that Washington learned to handle early on. She tells a story about how she got the subcontractors on her first independent project to pay attention to her directions. They were refinishing a stucco facade in a way that didn't meet her standards. When she told them that, they just laughed. Then she told

When Roberta Washington and her colleagues, Hirsch Danios Architects, complete a large-scale renovation of solid old tenement housing, the entire neighborhood rejoices.

"**S**low paying is now a customary way of doing business."

them that she was the architect, and they still didn't take her seriously. Finally she said, "Who do you think signs the requisition for your payment?" "The smiles disappeared in a hurry," she reports with evident satisfaction. Washington has learned how to "act tough" when necessary and not worry about it afterward. This forcefulness is imperative, she says, and when hiring women professionals, she will accept a certain level of arrogance if it comes with exceptional competence. She says that she finds a lot of her peers often talk loudly, perhaps compensating for their frequent need to convince clients that they know what they're doing.

CREDIT CUTS BOTH WAYS

Probably the most important aspect of financial management to Washington has been acquiring and learning to handle a line of credit. She first became aware of this source of financing at an AWED seminar when a visiting accountant described how this process works. "The accountant I'd been using up to that point had never mentioned such an idea, so I asked this person to help me apply for one." It required considerable reorganization of her books, but the $30,000 line of credit that she eventually obtained has been essential to keeping her doors open. Now she has one for $75,000. Yet it hasn't been an automatic answer to all of her business needs: Lines of credit need to be repaid sooner or later. Recently, during a period of tight cash flow, Washington was also obliged to pay back what she had borrowed—with interest, of course. Not only was that burdensome, but just when she could have used some credit, that source wasn't available. In fact, the little she had managed to put into an IRA account was eaten up in the process. Much of the profits she has realized in recent years have gone to paying interest on the line of credit.

For any firm doing a significant amount of its work for government agencies, the problem of tardy payment is potentially disastrous. "Slow paying is now a customary way of doing business," she sighs. Washington tries to keep six weeks of payroll on hand,

and when reserves fall below that amount, she knows it's time to go out and collect on one of her overdue accounts, "another tough job," she says. That means putting much of her time for a week or two into pursuing one of her clients who has promised a check but not delivered. While she uses both accrual and cash accounting methods, she finds that the accrual picture is sometimes wildly misleading. "At one point last year, I was owed more than four hundred thousand dollars but had only three thousand in surplus cash on hand!"

COMPREHENSIVE COMPUTERIZATION

In her struggle to make a socially responsible architecture practice profitable—and Washington still believes it's possible—she has turned to the computer for financial organization strategies. Since 1991 she has been looking for a business program that suits her firm's needs and is now using Sema4, designed for architecture and engineering firms of up to ten employees. While she finds it difficult to set up this program to show various profit projections, it has otherwise proved useful and clear. Structured as it is to break jobs down into phases, Sema4 makes sense for architecture and design practices. Washington's current accountant works with Sema4-specialist bookkeepers who can take the time sheet data her secretary enters and prepare the office's monthly billings. They also run analyses of how closely drafters and designers are sticking to the number of hours allotted for each job.

Every now and then, Roberta Washington gets to do a loving job of historic preservation on a New York City landmark such as this, the Astor Row.

With so much public agency work, Washington sometimes struggles to get through the first stages of a project to the point where billing is possible. In addition, there is the difficulty of getting invoices approved and—not so surprisingly—of receiving final payment. Altogether, she finds this sort of treatment by municipal and state agencies unsettling: "I feel beaten up by them." Fortunately, her private clients and the architectural firms with whom she sometimes does joint ventures pay more promptly. Also, she does collect retainers from nonprofit organizations.

As for the use of CADD in carrying out her projects, Washington began by making a serious commitment to it by hiring two senior designers who were fully computer-literate. Earlier efforts to ease into it using temps taught her that only by permanent investment in staff could she significantly raise her firm's level of competency. Slowly, that is paying off. However, she says, "the first year was shocking! Some jobs took longer to do than it would have by hand." Now she points to drastically increased efficiency, even on her rehab jobs; in a single month one person did the working drawings for renovating a group of eighteen brownstone houses. Now everyone in the office is fully CADD-proficient, with the exception of Washington and Samuels; they intend to start classes soon.

TRANSITION MANAGEMENT

Project management continues to demand the attention of Washington's firm. Because so much of her work involves abandoned buildings, there are always factors that can't be predicted. In addition to hidden structural problems and complex client-architect interaction, the internal dynamics of government agencies themselves present a formidable challenge. When there are different individuals within the same department who must sign off on a project document, just getting them to agree can take a great deal of the principal's time.

As a result, Washington is much more ready to delegate project responsibility to senior staff members and builds project teams within the office. In some cases she steps back entirely from the ongoing work. This is another area where circumstances seem to be calling for a more elaborate management structure in the office. Having in the past encouraged fluid organization of her staff, Washington now finds that designating established senior project managers makes sense.

At present, either Washington or Samuels manages every major project the firm does. Sometimes clients insist on seeing her at meetings, but she has gradually handed off much of the responsibility for project management to Samuels and the others, aspiring young architectural interns (some with as much as six years of experience gained in her office). Sometimes she considers replacing herself in that capacity by hiring more senior people, thus freeing herself even more for purely executive tasks. She finds this transition emotionally troubling: "If I don't do the drawings any more, checking the dimensions and making sure the details are right, am I the architect I went to school to become? Am I still that architect if I just shuffle papers?"

In other words, the firm's success is moving the practice out of the small-office category into one where more formalized arrangements are necessary. At this point, Washington has some major projects under way that are at a standstill, waiting for political issues to be resolved. If that happens, she says, "it will be either an opportunity for us to grow—if we're going to grow—or else to solidify, in terms of knowing you've got a long-term project at a decent rate. That's always good."

"If I don't do the drawings any more, checking the dimensions and making sure the details are right, am I the architect I went to school to become? Am I still that architect if I just shuffle papers?"

Ellen Galland, Principal

An efficient practice is not a function of profit but of meeting people's needs at the least cost to them.

Rockwell Associates

ELLEN GALLAND, PRINCIPAL

QUALIFICATIONS: B.A., Vassar College

B. Arch., University of Illinois (Chicago Circle)

Architects/Designers/Planners for Social Responsibility, Former Treasurer

FIRM BACKGROUND: Rockwell Associates, Principal, 1980–present

PRACTICE SIZE: 1 principal, 2 full-time employees, 1 part-time employee

GETTING STARTED

Motherhood has played a significant role in the way Ellen Galland has grown as an architect and established her practice. After working as both a full-time and then a part-time apprentice after her first child was born, she was licensed in 1980. After she had her second child, she began an independent practice, working by herself at home. "Also, motherhood has been helpful in my ability to respond to the needs of families, how homes work," Galland notes.

Upon the birth of her third child, Galland hired her first employee, and soon after, the practice moved out of the house for good. The office is located in a renovated bread bakery on the west side of Evanston, the development of which Galland participated in as architect and co-owner. Rockwell Associates, which specializes in additions to and remodeling of the solid old houses found in Chicago's northern suburbs, has enjoyed a lively business over the past fifteen years. Her firm has done a number of stores, restaurants, and day-care centers as well. The jobs she likes best, she says, are "the small ones that often have trouble raising the money for design fees."

BUILDING CLIENT TRUST

For Ellen Galland, client relationships are the most engrossing part of practice. Perhaps because of the office's focus on small-scale domestic projects, perhaps because she is someone who constantly tries to imagine what her decisions will mean to her clients, Galland devotes herself to serving them more than many design professionals might be comfortable doing. In fact, her view of an efficient practice is not a function of profit but of meeting people's needs at the least cost to them. For instance, she understands that "overdetailing drives up the job cost; my market wants good design but not excessive fussing," so she consciously avoids that in her work—as a matter of efficiency. At the same time, she finds it "ironic that when it comes to the design of existing houses, people take what they can get, while, when they come to us, we have to squeeze in an extra bathroom no matter what the context—yet that's also why there's a market for what we do."

Marketing, as organized promotion to potential customers, is not a factor for this firm. "Most jobs come in through word of mouth," says Galland, and in the dozen years since she began her business there has always been more than enough work. Now employing three professionals, the practice has an established reputation: "Most of those who contact us are predisposed toward using us," she says. That means that about half of all serious inquiries turn into jobs, and almost all of these actually get built. In response to the occasional holiday card the office sends out, former clients write glowing reports of life in the home she renovated for them—sometimes many years before.

It's clear that Galland's responsive attitude to prospective clients has more than a little to do with such effective results. Since her clients "come with a certain level of trust," Galland rarely "fires" any of them; and while many bring attitudes and emotional problems to the collaboration that she finds distracting—sometimes even repugnant— she takes it as her task to satisfy their housing needs as best she can in spite of that.

This substantially remodelled house by Rockwell Associates, for a woman executive, has a lap pool in its living room (this page and opposite). Photos: Paul Schlismann Photography

In addition, former clients sometimes turn to her to rescue bigger jobs, as in one case where the original architect couldn't handle the project's complex human aspects. Yet, although she and her colleagues have contemplated going for larger projects through joint ventures (capitalizing on their minority status as a "women's business enterprise"), and even raising fees to discourage some of the smaller, messier ones that land in their lap, Galland ends up sticking with what comes in "over the transom." As it is, she almost always has to put new clients on a waiting list and feels uncomfortable when people have to wait more than a month or two for design to begin on their job.

MAKING A LIVING

Part of her exceptional record of client satisfaction is based upon reticence to overcharge them. She bills on an hourly basis but sometimes finds, as project development proceeds, that the estimate of fees (often consciously kept low, she admits) quoted at her initial meeting with the owners is being substantially exceeded. Then Galland faces the decision of whether to charge the full amount or something less; she decides based on whether or not "our time expenditure seems justified by benefits to the client." It's especially tough with those jobs for funding-starved nonprofit organizations that she likes so much to take on.

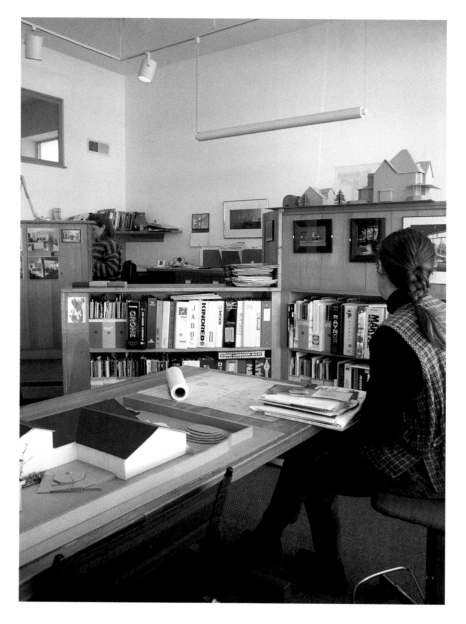

In a large, multilevel room, the three members of Rockwell Associates pursue their daily tasks while above them, on a mezzanine, is another small design firm. Photo: Marian J. Tweedie

The fact is that Rockwell Associates (her maiden name and, perhaps, an homage to her father, a prominent Chicago architect and planner in the fifties and sixties) can afford to charge minimal fees because her husband, George Galland, a successful attorney, "has been so flexible and supportive. I couldn't have built a practice like this without his help," she notes with evident gratitude. "If I were my daughters' sole supporter, I'd have to be a lot tougher on fees." This cooperation extends back to that period noted earlier when they were establishing their family while she practiced at home; "domestic management" demanded mutual participation. Where once Galland scheduled evening and weekend meetings with clients because her husband would be available to babysit, she now tries to avoid them.

Among other aspects of exemplary office organization, this staff rarely works overtime. That is partly because Galland's two colleagues, architects Marian Tweedie and Julianne Sheker, are themselves well organized and productive. Working together in one large multilevel room, which includes a conference table in the storefront window, the three women collaborate in teams of two on every project. There is no hint of hierarchy here. With characteristic modesty, Galland wonders out loud whether she could even produce a set of drawings by herself. Yet there is a quality of professional nonchalance about the office, reinforced by years of producing competent projects; it's as though nothing can possibly go wrong that hasn't already happened before—someone will know how to handle it. In fact, Galland has given a lot of thought to encouraging young female architects to build dignified careers for themselves. She has urged several former employees to go into independent practice, including Susan Regan, who now has a little office up on a mezzanine that overlooks her old boss's studio. "The office staff usually includes an intern from the Newhouse Program (Chicago public high school students), a college student, as well as a talented local seventh grader who comes in once a week after school," says Galland.

INCORPORATING TECHNOLOGY

Rockwell Associates is partially computerized at present. Billing and word processing are done on the computer. As for CADD, the practice is beginning to make use of its potential, even though house additions almost always vary significantly one from another, and their compact plans seldom involve the repetition that occurs in commercial space planning. Nonetheless, the office is experimenting. They've recently begun employing

voice mail to see if it will help those who are drafting to keep working smoothly, uninterrupted by random telephone calls. They find that it also allows people to leave long, detailed messages which can be returned in batches later in the day. There has never been any support staff, so everyone working here runs errands and does the daily office tasks.

Financial management is also highly informal. In fact, job records—time expended and amounts billed—are actually written by hand on the file folders so that clients can see what's going on when they meet with the architects. Galland's letter of agreement is also disarmingly simple—one page spelling out fees and scope of work, which she feels "gives both parties a lot of flexibility." Her hourly rates are remarkably low because overhead is also low. (The firm pays $450 in rent each month, in effect to Galland, who owns the building with a partner.) It's Galland's belief that by charging relatively little, her clients will be less likely to resent problems that come along: "There are so many ways nowadays that we can make mistakes!" So far, there hasn't been any litigation.

Nonetheless, the business side of this practice is not neglected. Time sheets are taken very seriously; she finds it hard to bill more than twenty hours each week of her own time, yet she keeps after the others in order to bill clients promptly each month. Galland often doesn't bill clients for site supervision. Since she tends to work with the same contractors, she feels that visits are essentially a formality; the work gets done in accordance with the drawings whether or not she's around. With new contractors, however, Galland pays much closer attention. As for retainers, she chooses not to ask for them but makes sure that clients are billed immediately after the design phase is complete. During particularly busy periods, she has been known to charge $60 for an hour's consultation in order to discourage those who are just shopping for ideas; usually she does not charge.

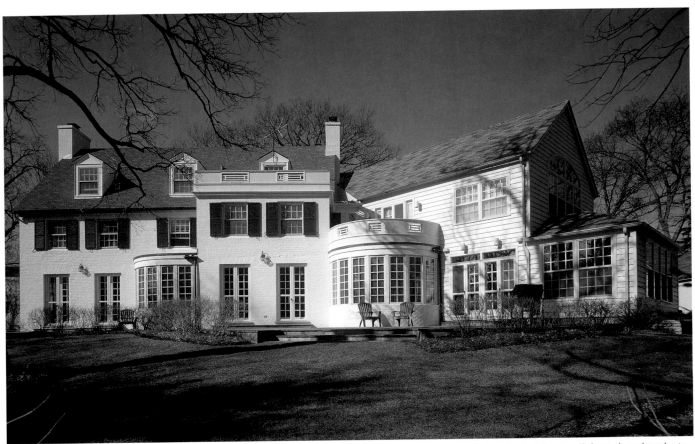

This addition to the Saranow residence in Winnetka, Illinois (guess which wing is the new one) is typical of Rockwell Associates' projects. Photo: Paul Schlismann Photography

At the same time, Galland recognizes the importance of profit in her practice. "It simply makes you feel better if you're spending time on something you're getting paid well for, especially if there's something else you'd rather be doing!" Through contacts in other Chicago offices, she makes sure that everyone in hers is being properly paid, especially in light of her strong feeling that women deserve dignified, satisfying careers. By keeping overhead low, by maintaining a steady stream of work, and by fostering productive working conditions, Ellen Galland has made Rockwell Associates a model of sustainable small-office practice.

This clever, neatly executed apartment renovation—a guest room/library—in Moscow is an unusual job for Ellen Galland's firm. Photos: Tatyana Makeeva

William B. Koster and Associates

WILLIAM B. KOSTER, PRINCIPAL

QUALIFICATIONS: B. Arch., University of Cincinnati
 Licensed Architect in Ohio, Michigan, and Indiana
FIRM BACKGROUND: William B. Koster and Associates, 1963–present
PRACTICE SIZE: 1 principal, 5 employees

PARTICIPATORY DESIGN

If Bill Koster has a message for his peers (meaning older architects and designers), it is to get serious about acquiring computer skills—fast! It's not good enough to hire young people who can perform magic on the screen, he says; as principal, you've got to understand what they're doing or else you're vulnerable to surprises—or worse, to consequences that could cost you big money. This insight grew from Koster's growing awareness over a period of years of his inadequacy when monitoring certain aspects of work being done by his computer-literate design staff. As a result, he has also focused on deepening collaboration with them in order to forestall serious miscommunication. Indeed, collaboration is a theme that runs through all of his work—with clients, employees, and colleagues.

As a firm that specializes in designing community facilities, and in particular the renovation of public libraries, Koster and Associates emphasizes participatory design as its primary process: "I happen to have a style of practice that involves my staff very deeply with the client and the client very, very deeply with the design of their own buildings." For over twenty years, Koster has helped the librarians and board of trustees of local public libraries give new life to more than a hundred turn-of-the-century Carnegie libraries located all over the Midwest. His collaborative approach has evolved from working with many highly knowledgeable clients—especially librarians, who can articulate very well what is needed in each case—and offering supportive design solutions to their problems. "Librarians are verbalists," he says with a smile. "We are visualizers."

William B. Koster, Principal

The Galion, Ohio, Public Library is typical of more than a hundred Midwestern Carnegie Library buildings that Koster and Associates have renovated over the past twenty years.

Celebrating still another new commission, the staff of Koster Associates watches its principal misbehave after having a glass of champagne.

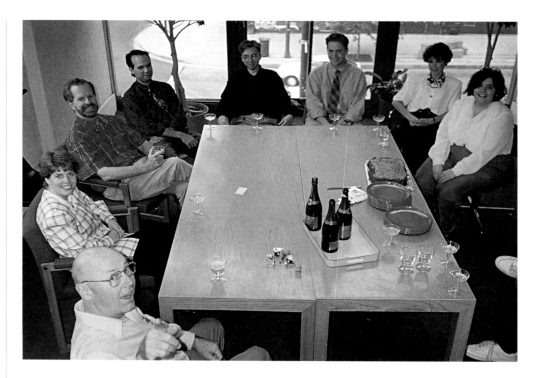

COMPLETE COMPUTERIZATION

In fact, Koster claims it was through this informal and open-ended method of running the office that its complete computerization was facilitated. His staff's inherent interest in CADD readily infected Koster, too. He cites these comparative figures: An architect working by hand can produce $68,000 per year in fees, while for an architect using CADD it increases to $110,000 per year. In his opinion, the commitment of a firm's principals, however, goes well beyond merely buying the hardware and software. Training time has to be factored into the office's budget in order to permit that sort of productivity to develop, which calls for as high a level of computer skill among executives as possible. To Koster, staff development is the major expense of computerization, although he acknowledges that the matter of hardware becoming obsolete as new programs appear on the market is also a significant factor.

The design process at Koster and Associates, as already noted, is largely CADD-based. The firm finds that because it provides computerized technical documents, bids on its jobs have been exceptionally precise over the past four years. This makes possible realistic budgets as design begins and accurate cost estimates as projects proceed through development. They also use computer-based design to facilitate consulting engineers' work by preparing sketches that put conceptual thinking for the various technical systems into the context of each job. Koster finds that cash-flow monitoring in general is wonderfully simplified by computer programs. "They take the drudgery out of financial management," he says, "which is important because you've got to have tight control over your cash flow. And, since the computer makes it speedy, you use it." He also finds that spreadsheet adjustments are easily made and that business predictions based on marketing data can readily be obtained.

BUSINESS PLANNING WORKS

That leads to an area of practice on which Koster has strong opinions: the importance of having and keeping current a business plan for the practice. "Most architects have no idea of how to look ahead, to put expenses into context, to plan for capital expenditures, or to anticipate the chaotic effect of suddenly losing a project." He goes on to say that

"**M**ost architects have no idea of how to look ahead, to put expenses into context, to plan for capital expenditures, or to anticipate the chaotic effect of suddenly losing a project."

you "begin with a marketing plan, that is, how much business you intend to generate. Next you plan how to handle that financially, and then you monitor it—this is where electronic equipment is so valuable. Major firms do it this way, but most small offices just manage by the seat of their pants."

Koster and Associates, which has long had a "board of advisers" that meets quarterly, prepares an updated business plan for each of these meetings. The plan begins with a brief statement of the nature of the firm's business and its markets, as well as a market forecast including thoughts on new areas to explore for work. Income projection charts for the next two years are the heart of the report. The vertical column of each year's matrix is divided into sections: projects under contract whose fees are more or less assured, and those for which the office has done studies or has had a promising interview, where potential fees can be estimated; the date when each job might proceed is noted. Horizontally across the top, three projection categories—Pessimistic, Most Likely, and Optimistic—indicate degrees of certainty. At the bottom of each of these columns, Koster totals up his estimates and subtracts from them his cost of doing business (which obviously increases); what's left gives a rough idea, within a range of possibilities, of potential profit before taxes in each case over the next couple of years. As jobs become more firm or, occasionally, definitely disappear, these figures are updated. The principal now has a clear idea, as much as twenty-four months in advance, of the amount of work that has to be generated in order to provide a profit in the near future. Koster emphasizes that profit should be annualized, not figured on each individual job, since even the so-called unprofitable jobs do bring in money, increasing a firm's gross income and spreading overhead costs.

Profit should be annualized, not figured on each individual job.

Galion Public Library's Young Adult Solarium is intended by Koster and Associates to seduce teenagers into becoming reading addicts.

THINKING LONG TERM

Promoting design services to public clients like libraries has special demands, according to Koster. Since public officials tend to change, and since they often interview architects for a particular project over a long period, he has learned that they tend to forget everyone but the last firm they considered. If he knows he was one of the first they talked to, Koster's method is to inquire when the library's board of trustees' meeting will be held, and the week before that date he sends them a short essay on some aspect of library design, just to keep his name in front of them. This kind of attention to the unique needs of his clients has won Koster high praise from some officials and, more important, their strong commitment to his firm even though sometimes a project may be delayed by failure of a bond issue to pass.

Now in his sixties, Koster has been giving thought to how he might transfer ownership of his firm to the young folks he has brought along. He feels that retirement for designers and architects is problematic. Because their firms basically have little or no value except for reputation and work in progress that can be transferred and built upon. After employees acquire it, there's no assurance that it will produce enough income to allow them to pay for it. He's thinking about asking those who take up his offer for a five percent royalty over five years as a way to pay off their debt, transferring stock in the firm over that period. Those who buy, betting they can build a future for themselves this way, risk being able to pay this amount. So far, in spite of his efforts to bring his staff into fuller understanding of the business, he admits they're not terribly responsive to the idea of taking over from him. Which is fine with him since he's not ready to retire just yet.

Two patrons of the Everhard Public Library in Wadsworth, Ohio, look for a lost contact lens near its light-drenched periodical reading room.

Select Bibliography

AIA Press. *The Architect's Handbook of Professional Practice, 12th Edition*. Washington, DC: AIA Press, 1994.

Articles on design firm management, *Progressive Architecture*. February, 1994–December, 1995. See pg. 11 for partial list.

Begley, Louis. "Time is Everything." *The New Yorker Magazine* (October 16, 1995): 156.

Busch, Dennis H. *The New Critical Path Method*. Chicago: Probus Publishing Co., 1991.

Covey, Stephen R., A. Roger Merrill, and Rebecca R. Merrill. *First Things First*. New York: Simon & Schuster, 1994.

Cuff, Dana. *Architecture: The Story of Practice*. Cambridge, MA: MIT Press, 1991.

Guideline Publications. *The Operating Manual for the Small Design Office*. P.O. Box 456, Orinda, CA 94563.

Gutman, Robert. *Architectural Practice: A Critical View*. Princeton, NJ: Princeton Architectural Press, 1988.

Hiam, Alexander. *Marketing for Dummies*. Foster City, CA: IDG Books Worldwide, 1997.

Jenks, Larry. *Architectural Office Standards and Practices: A Practical User's Guide*. New York: McGraw-Hill, 1995.

Jones, Tom, William Pettus, and Michael Pyatok. *Good Neighbors: Affordable Family Housing*. New York: Images Publishing Group/McGraw-Hill, 1997.

Morgan, Jim. "Architecture School: Liberal Education for the Eyes." *House & Garden's Building/Remodeling Guide* (March/April, 1981).

Nelson, Bob, and Peter Economy. *Managing for Dummies*. Foster City, CA: IDG Books Worldwide, 1996.

Peters, Tom. *Liberation Management*. New York: Knopf, 1992.

Pickar, Roger L. *Marketing for Design Firms in the 1990s*. Washington, DC: AIA Press, 1991.

Professional Services Management Journal. 10 Midland Avenue, Newton, MA 02158, 617/965-0055.

Sanders, Ken. *The Digital Architect*. New York: John Wiley & Sons, 1996.

Stasiowski, Frank. *Cash Management for the Design Firm*. New York: John Wiley & Sons, 1993.

Stasiowski, Frank. *Staying Small Successfully: A Guide for Architects, Engineers and Design Professionals. New York: John Wiley & Sons, 1991.*

Tiffany, Paul, and Steven D. Peterson. Creating Business Plans for Dummies. *Foster City, CA: IDG Books Worldwide, 1997.*

Vagts, Karen A. Managing AutoCAD: A Manual for Architects and Interior Designers. *Reading, MA: Addison-Wesley Publishing Co., 1996.*

Ward, Sol A. Urban Planning and Architecture and the Use of the Critical Path Method. *Chicago: Philosophical Library, 1971.*

Woodward, Cynthia A. Human Resources Management for Design Professionals. *Washington, DC: AIA Press, 1990.*

Wurman, Richard Saul, with Loring Leifer. Follow the Yellow Brick Road: Learning to Give, Take, and Use Instructions. *New York: Bantam, 1992.*

Index